JOHN HEDGECOE'S
COMPLETE GUIDE TO
VIDEO

JOHN HEDGECOE'S
COMPLETE GUIDE TO
VIDEO

Sterling Publishing Co., Inc. New York

To all would-be Film Directors

Conceived, edited and designed by Collins & Brown Limited

ASSOCIATE WRITERS: Jonathon Hilton and Ian MacQuillin
TECHNICAL CONSULTANT: Ian MacQuillin
EDITORIAL DIRECTOR: Gabrielle Townsend
EDITOR: Sarah Hoggett
ART DIRECTOR: Roger Bristow
DESIGNED BY: Bob Gordon
Reproduction by Colourscan, Singapore

Library of Congress Cataloging-in-Publication Data Available

10 9 8 7 6 5 4 3 2 1

Published in 1992 by Sterling Publishing Company, Inc.
387 Park Avenue South, New York, N.Y. 10016
Originally published in Great Britain by Ebury Press
This paperback edition published in1991
in Great Britain by Collins & Brown
as *John Hedgecoe's Complete Guide to Video*
© 1992 by Collins & Brown
Text © 1992 by Collins & Brown and John Hedgecoe
Photographs copyright © 1992 by John Hedgecoe

Printed and Bound in Hong Kong
All rights reserved

ISBN 0-8069-8694-8

CONTENTS

Introduction

We are fascinated by the moving image. If proof of this were necessary, then all we need do is look toward the estimated 300,000 movies that have been produced since the invention of the movie camera at the very end of the nineteenth century.

Added to this prodigious total are the countless dramas, documentaries, sports programmes, quiz shows and, of course, made-for-TV movies that have been produced since that magic box's widespread introduction in the 1950s. In terms of how we spend our time, watching television is our most absorbing activity after working and sleeping.

A most fascinating change got underway in the 1970s and 80s. This was marked by the introduction of the video cassette recorder, which, in turn, encouraged the now flourishing sales of video cameras and, in the last few years, of camcorders. The ease and convenience of being able to point the camera and shoot hours of material that can be slotted into the VCR and watched immediately without fuss or processing, has given the video camera that special appeal the film camera never quite enjoyed.

But those hours spent at the pictures and in front of the television have been a learning process, one that has turned us into sophisticated and critical viewers. Starting in the movie-producing centres, and insinuating itself every facet of the industry, there developed a 'language' of the moving image – accepted ways of presenting visual material. These are very often not consciously noticed by the audience unless the film-maker, by accident or design, breaks the 'rules' of this 'language'.

When you pick up a camcorder, the first thing you notice is how easy it is to use: all you need do is point and shoot. And watching those first results is captivating. Almost immediately, however, a self-critical process starts – our own results compared with those of the professionals we see every time

we switch on the television. Why didn't I notice that in the background? Wouldn't it have been great to have seen his reaction when she did that? If only I had shot that from a different angle. Why is the soundtrack so indistinct? All those zooms are giving me a headache!

While it is not possible, or perhaps even desirable, to replicate the work of professional movie-makers, it is nevertheless within the capabilities of every camcorder user to create entertaining, well-made, imaginative and perhaps even innovative tapes with a wide audience appeal.

In order to achieve these goals, Chapter 1 looks at different-format camcorders and what their controls do, how they are of benefit, and what the problems are. Camera supports, microphones and editing equipment are also covered. Chapter 2 is concerned with exercising creative control over the image by manipulating such things as exposure, depth of field, panning, tilting and composition, while Chapter 3 demystify some of the language of the moving image by showing what commonly used expressions mean in practice. Chapters 4 and 5 deal with refining the appearance and impact of your tapes by using lighting and special effects.

Chapter 6 is at the heart of good movie making, explaining the importance of preplanning – script creation, storyboarding, research and budgetary control. The longest part of the book is Chapter 7, which tackles a variety of subject areas, bringing together in a practical context the technical and aesthetic considerations dealt with earlier.

Rarely is it a good idea to screen a tape as it comes out of the camcorder. Almost always, improvements are possible by assembling the material into a different running order, shortening here, cutting there, adding commentary, graphics or music, balancing and fine-tuning. This is the post-production process, and is found in Chapter 8. And finally chapter 9 is a technical reference, covering accessories, filters, slide to video transfer, as well as a glossary of terms.

CHOOSING AND USING EQUIPMENT

This chapter examines the different formats of camcorder and the range of video equipment available, and provides an invaluable guide to choosing the equipment best suited to your needs.

The Camcorder

A CAMCORDER IS A COMBINED video camera and recorder, squeezed into one portable unit. Camcorders range from very basic point-and-shoot family machines to fully featured models that wouldn't disgrace a professional cameraman; from shoulder-mounted monsters to tiny palmcorders that weigh less than 1 kg.

What a camcorder does

A camcorder can be divided into two parts – the camera section and the recorder section – and most camcorders have a toggle to switch the camcorder between the two modes.

Camera mode

In camera mode, the camcorder records images which have first been transmitted through the lens to the imaging chip (CCD or charge-coupled device, see pp.18-19), where the light image is converted to an electrical signal. The CCD consists of around 400,000 silicon photodiodes or picture elements (pixels) which analyse the light image in terms of colour, brightness and contrast.

Television images or 'frames' are made up of a number of horizontal lines – 625 for the PAL and SECAM systems, and 525 for NTSC (see pp. 246-7). The frame is refreshed every $\frac{1}{25}$ second (PAL and SECAM) or $\frac{1}{30}$ second (NTSC). However, each frame consists of two 'fields' – one containing odd-number and the other even-number lines. It is this 'field' rate that the CCD uses to output the video signal, transmitting 50 – or 60 – fields to the recording section every second. That is why the standard shutter speed on camcorders is $\frac{1}{50}$ or $\frac{1}{60}$ second (depending on the television system used) and, under normal circumstances, slow shutters are uncommon in video.

Functions such as fast shutters, exposure control and titling facilities all operate in camera mode and many camcorders also have a record/review function that allows the last few seconds of recorded footage to be viewed.

The recorder

The electrical signal that is output from the CCD is transmitted to the camcorder's recording heads – similar to the recording mechanism in a video recorder.

The core of the recorder is the video head drum, a fast-spinning cylinder around which the tape is looped. It contains up to four video heads which magnetically 'write' the video signal onto tape during recording and then 'read' the recorded video signal for playback.

Sound is also recorded at this stage although, of course, the audio signal comes from the microphone, not the CCD. On VHS formats, mono sound is recorded separately from the video signal on the edge of the video tape. VHS stereo is recorded mixed in with the picture information as are both FM (frequency modulation) stereo and mono sound on 8 mm formats.

Playback mode

When set to the playback mode, the camcorder replays recorded video by instructing the video heads to 'read' the recorded signal. On some models, this is called recorder mode, although this is something of a misnomer, as the camera cannot usually record in 'recorder' mode.

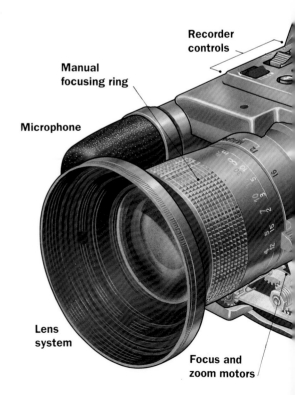

Recorder controls

Manual focusing ring

Microphone

Lens system

Focus and zoom motors

All modern camcorders can playback in-camera through the viewfinder and possess the usual tape transport controls such as rewind, fast forward, pause and play. Some of the more advanced models have slow motion and frame advance. All camcorders also have suitable AV connections to enable them to be played back directly through a television. These are usually supplied as part of the purchase package, but you may have to buy them as optional extras.

While the camcorder cannot usually record in playback mode, two specialist editing features do operate in this set-up. These are insert edit – with which the camera can record new material over old – and audio dub, an especially useful feature which adds a new soundtrack. However, audio dub is not possible on 8 mm camcorders. Both these features are found on mid-range camcorders and above.

Insert edit is made possible by a flying erase head – an extra video head inside the head drum which is now found on virtually all camcorders. This device enables inserted scenes to be joined together smoothly with the original footage without the one or two seconds of white noise picture break-up at the end of the scene that characterized older camcorders.

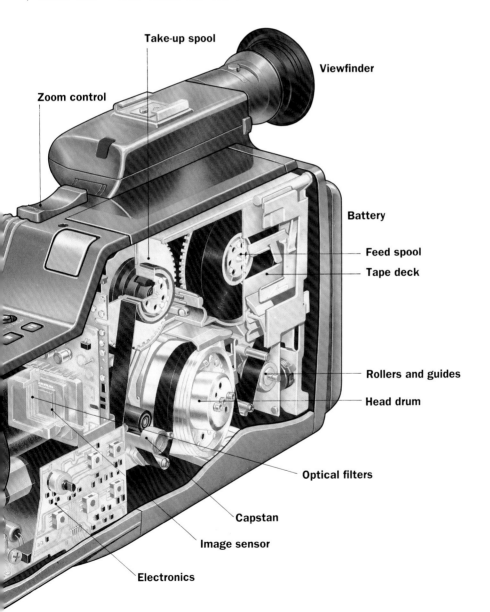

Take-up spool

Viewfinder

Zoom control

Battery

Feed spool

Tape deck

Rollers and guides

Head drum

Optical filters

Capstan

Image sensor

Electronics

Camcorder Formats

THE POTENTIAL CAMCORDER buyer is entering a minefield. Not only are there around 100 different models of varying levels of sophistication, but there are also six different formats. These use different formulations of tape which are, for the most part, incompatible with other formats. The choice can sometimes be bewildering. However, each format has its own idiosyncracies, its pros and cons.

Before buying a camcorder, you should think carefully about which features are important to you. 'Camcorder Features' (see pp. 16-17) outlines the different facilities available. Other factors to consider include portability, quality of sound and picture recording, ease of playback and tape running time. This section looks at the six formats currently available.

VHS-C

The C stands for compact. VHS-C camcorders (*right*) use exactly the same formulation of tape as VHS, but the tape is housed in a mini-cassette with a 30- or 45-minute running time. The picture quality is comparable with that of 8mm; but sound, both mono and stereo, lags behind 8mm's FM. However, audio dub (adding a secondary soundtrack – see pp.224-7) is possible with VHS-C camcorders (as it is with full-size VHS) since the sound is recorded separately from the video signal on the linear edge track of the tape. With stereo camcorders, subsequently recorded sound can be mixed with the original soundtrack. As they use basically the same tape as VHS, VHS-C cassettes can be replayed in video recorders by means of a special full-sized cassette adaptor. Alternatively, the camcorder can be connected directly to the television. Some video recorders can playback both full-size and mini VHS-C cassettes.

Full-size VHS

Full size VHS (*below*) is the oldest format, using the same three-hour tapes as domestic VHS video recorders. Once popular, full-size VHS is now on the decline. The picture quality of VHS is comparable with that of VHS-C and 8mm; sound quality is on a par with that of VHS-C. The advantage of VHS is that it is compatible with domestic VCRs: recorded tapes can be slotted straight into a video recorder without having to be copied or edited first. However, the large tape size means that the cameras are large and heavy.

Super VHS (S-VHS)

Super VHS (*above*) is an enhanced version of VHS and gives a much better picture. S-VHS can resolve very fine detail, such as individual human hairs, which escapes the low-band formats. To get the best from this format, compatible S-VHS televisions and VCRs (which possess an S-terminal) and dedicated connectors (called S-leads) are needed. S-VHS equipment is still very expensive, but an S-VHS recording replayed through standard leads still produces a far better image than normal VHS or VHS-C. S-VHS camcorders can record on and replay VHS tapes, but S-VHS recordings cannot be replayed in a normal low-band video recorder.

STILL VIDEO CAMERAS (SVCs)

An offshoot of camcorder technology is the still video camera (SVC). SVCs record 50 images onto a reuseable 2-in. floppy disk. The camera is then connected to a television (using standard video leads) and the pictures are replayed on screen. An image from an SVC replayed on screen looks like a still frame from video tape.

As the system is totally electronic, it is instantaneous: there is no complicated and time-consuming developing process. Moreover, images can be erased and the tape re-used, just like video tape. Hard-copy prints of the images can be made from a video printer, but these machines are prohibitively expensive to most snapshotters. The best way to save images is to copy them onto a video tape by connecting the SVC to a video recorder.

SVCs offer only the features and capabilities of a moderate compact camera at the price of an advanced SLR. SVCs have many of the features found on conventional still cameras, including sophisticated autofocus and autoexposure systems, and are portable and extremely easy to use. But the picture quality lags a long, long way behind film. However, many manufacturers are working on ways to improve picture quality and, when the price of the machines drops, the reuseable nature of the SVC disk and the fact that there is no delay while the images are processed will give them a definite advantage over film cameras. Despite being hailed as a great technological advance, they are not yet widely available. So far, their biggest use has been in the commercial and business sector where immediacy is a prime consideration. The demise of silver halide, predicted by many people when these machines were first introduced, is a long way off.

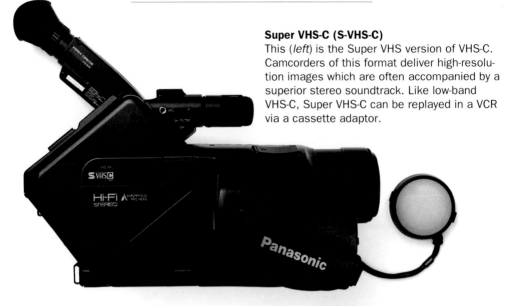

Super VHS-C (S-VHS-C)

This (*left*) is the Super VHS version of VHS-C. Camcorders of this format deliver high-resolution images which are often accompanied by a superior stereo soundtrack. Like low-band VHS-C, Super VHS-C can be replayed in a VCR via a cassette adaptor.

High-band 8mm

Known as Hi8 (pronounced 'high eight'), this is an enhanced version of 8mm comparable to S-VHS. Hi8 (*right*) delivers the same picture definition as S-VHS and Hi8, and S-VHS camcorders and VCRs use the same S-leads and connections. However, like 8mm (*see below*), Hi8 is totally incompatible with the VHS family of formats. A Hi8 camcorder can record and playback in both Hi8 and standard 8mm, but an ordinary Video 8 camcorder cannot playback high-band cassettes. PCM digital sound, although not yet widely available, allows the audio-dubbing of a secondary soundtrack. A PCM soundtrack is the only way this can be done on a Hi8 or 8mm camcorder.

8mm

Sometimes called Video 8, this is the most popular format (*right*). The picture quality is similar to that of VHS and VHS-C, although some people claim that Video 8 just has the edge over them. The FM sound of Video 8 is clearly superior to the sometimes hissy quality of the VHS formats. However FM sound is recorded intermingled with the video signal and cannot be replaced: 8mm camcorders cannot perform audio dub. 8mm tape is totally incompatible with VHS. The only way to view 8mm recordings is to connect the camcorder straight to the television as 8mm tapes cannot be played back on a VHS recorder. A small number of 8mm playback machines are available but they are very expensive.

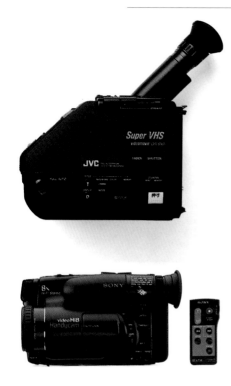

Palmcorders

These lightweight, hand-sized camcorders (*left*) do not constitute a format in their own right: there are VHS-C, 8mm and S-VHS-C format palmcorders. But because of their weight and portability, these marvels of miniaturization are becoming an important part of the camcorder industry. Although palmcorders are small, many of them still manage to include as many features as their more conventionally designed cousins.

However, there is a price to pay for this compactness: a trace of picture jitter on the recorded image. Jitter is a slight, but noticeable, vibration of the image – not so distracting that it should put off the casual family-video maker, but enough to discourage the dedicated amateur movie-maker.

VIDEO AND FILM

Video is an electronic medium. The light image is converted into an electrical signal which is written magnetically onto video tape. When replayed through the viewfinder or on a video recorder, the process works in reverse and the video signal is read and converted into a colour image.

A video movie can be watched the instant it has been recorded. In fact, most camcorders have review facilities for precisely this function.

Film, on the other hand, is far from immediate. Images are recorded in a chemical process, not an electronic one. When the film is exposed to light, a latent image is burnt onto the emulsion. This can only be seen with subsequent chemical development. Consequently, there may be a gap of a couple of weeks between shooting and viewing.

There are, of course, other differences between the two. Video tape is cheaper than cine film, it runs through the camera at a slower speed and so is more economical, and you can record over old video tape and use it again.

However, it is far easier to edit film than video. Rearranging scenes shot on celluloid involves cutting the film and sticking it back together again. Using relatively cheap equipment, it is possible to cut exactly to the frame.

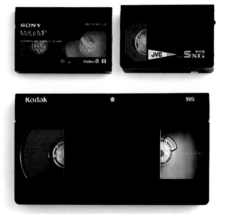

Video editing (see pp. 220-23) is a far more complex business. The equipment is expensive and it is only with recent timecode developments that frame-accurate cutting has become available to the consumer.

VHS tapes (*above*), which run for up to 4 hours, are now the standard domestic format. The compact version (VHS-C, *top right*) can be played back on a domestic VHS recorder by means of a special adaptor. There are also high-band versions of each (Super VHS and Super VHS-C). Video 8 tapes (*top left*) are the smallest tape format currently available and can run for up to 90 minutes at standard speed; however, they cannot be played back on a VHS recorder.

Camcorder Features

ALTHOUGH SOME MODELS look as if they've just arrived from a NASA laboratory, all camcorders have a full auto 'idiot' switch. Flick this on and all the camcorder's functions are handled with no input from the user. But creative overrides are there on most camcorders if you want to use them.

Age subtitles Some camcorders can be programmed to memorize a person's birth date so that their age will appear on screen at the press of a button.

Animation Found on many mid-range camcorders, this allows crude stop-motion animation effects. In animation mode, the camcorder will snatch around $\frac{1}{5}$ second (5 frames) of video.

Audio dub This is the facility to replace all or part of the original soundtrack with a commentary or sound effects, but it is dependent on the type of audio recording system used in the camcorder and this in turn depends on the camcorder format. With VHS and VHS-C (and the Super versions), mono sound is recorded on the linear edge track of the tape separately from the video image. This can be replaced during audio dubbing. VHS stereo is recorded with the video signal, so it cannot be replaced, but such a camcorder will normally allow this original stereo sound to be 'mixed' with the new audio-dubbed soundtrack on the linear edge track. Audio dub is not possible on the majority of 8mm and Hi8 camcorders since the audio signal is recorded mixed with the video signal and cannot be recorded separately. Only 8mm camcorders with PCM sound offer audio dubbing.

Automatic gain control (AGC) A camcorder has two AGCs – one for the picture and one for sound. When the light level falls below a pre-set level, the AGC amplifies the signal to give a better low-light capability. However, picture grain also increases to a sometimes distracting level. Similarly, when the ambient sound decreases, the audio AGC increases the volume of the quietest sound to an acceptibly audible level. Unfortunately, these AGCs can be disabled on only a few camcorders, so realistic night-time shooting and atmospherically quiet scenes are not usually possible.

Backlight compensator (BLC) This is the most basic form of exposure correction. Engaging the BLC opens up the camcorder's automatic iris to allow more light into the lens. It is used when shooting subjects silhouetted against a bright light but the auto-exposure remains in operation.

Character generator Basic alphanumeric titles can be created on some models (across the price range).

Date/time generator All camcorders can record the date and time at the foot of the screen.

Earphone socket A socket to attach an earphone to monitor the soundtrack is always an advantage, but it is vital with stereo camcorders.

External mic socket On-board mics on camcorders are notoriously poor quality. An external mic socket means that a separate higher quality or specialized mic (see pp.28-9) can be attached to the camcorder. Not all models have this facility.

Fader Found on all except some of the cheapest camcorders, a fader dissolves sound and vision simultaneously to black to give professional-looking scene transitions.

Fast shutters These are a great selling point on camcorders, although they are next to useless. Getting as fast as $\frac{1}{10,000}$ second, their only viable use is to freeze fast-moving subjects for sharp still playback. But the still-frame facility of many camcorders is often obscured by noise bars – horizontal picture disturbance across the frame. However, the main reason why fast shutters should never be used for general shooting is that they cause a very unnatural jerky effect. Video images are recorded at 50 or 60 images per second. Two of these 'fields' combine to form a $\frac{1}{25}$ or $\frac{1}{30}$ second 'frame' so that video is replayed at 25 or 30 frames per second. This replay speed is invariable, even if the image has been recorded at $\frac{1}{1,000}$ second. Instead of 1,000 images per second, there are still only 25 or 30 images per second: 975 images are missing. So an image recorded at $\frac{1}{1,000}$ second has to be held still on screen for $\frac{1}{25}$ or $\frac{1}{30}$ second

until the next image arrives. It is this that causes the characteristic strobing of fast shutters. The higher the shutter speed, the worse the strobing.

F-stop control This, the most efficient form of exposure control, is found on only a handful of top-of-the-range camcorders. Their ability to lock the exposure reading (autoexposure is totally deactivated) makes them the first choice for the serious video-maker. The relationship between f-stop and shutter speed is exactly the same as for SLRs (see pp.40-41).

Insert edit This makes it possible to record new video over old. Any camcorder with a flying erase head can do this roughly, but for accuracy, one with a dedicated insert edit facility is needed. With this, you can pre-set the point at which you want the new material to end and the camcorder will stop automatically.

Interval recording Interval recording snatches a few seconds of video at pre-set intervals to condense events – such as the sun arcing across the sky – into the space of a few seconds.

Line input Only a few camcorders boast this feature which allows them to record direct from another video.

Macro All current camcorders feature a macro facility for extreme close-ups. On some the macro facility is achieved by turning the zoom ring to beyond the shortest focal length; on the newer, more sophisticated cameras, the macro setting is controlled automatically. Macro images are reproduced on screen at a ratio of larger than 1:1.

Manual iris A manual iris dial lightens or darkens an image in small increments. However, the automatic system will continue to function. It is more versatile than a backlight compensator, but not in the same league as a full f-stop exposure lock.

Manual level control Another feature that is only available on some top-of-the-range camcorders, the recording level of each channel can be set manually, giving full control over the soundtrack. Camcorders with manual level control can disable the audio AGC.

Programmed autoexposure This sets both aperture and shutter speed, as opposed to just the aperture, to obtain the correct exposure.

Because of the problems associated with high-speed shutters, its usefulness is questionable.

Remote control Many camcorders are supplied with an infrared remote control which operates the tape transport controls and some camera functions such as zoom and fade.

Self-timer This allows the cameraman to get into the shot before the camcorder begins recording. On some models, the self-timer will pause after a short interval; on others it will carry on recording until it is turned off.

Sound There are five types of sound recording found on camcorders. Analogue FM (frequency modulated) mono is found on most 8mm camcorders. The better Video 8 and most Hi8 models possess FM stereo. Both analogue FM and FM soundtracks are recorded with the video signal and so cannot be replaced during audio dubbing. VHS formats use linear mono sound; this is not as good as FM mono but, as it is separate from the video signal, it can be replaced at a later stage. Stereo VHS camcorders use a system called VHS HiFi; similar to FM stereo, it is recorded mixed with the video signal. PCM (pulse code modulation) digital sound, on which audo dubbing can be performed, is not yet widely available.

Title superimposer This memorizes handdrawn graphics or titles in any one of eight colours and records them over a scene at the press of a button.

Time code Confined to semi-professional camcorders, both S-VHS and Hi8 use their own time codes which lay down a number on each recorded frame of video. This gives unparalleled accuracy in the editing process.

Twin speed Most camcorders have two recording speeds. Standard play (SP) gives the highest picture quality but long play (LP) doubles the available tape running time at the expense of picture grain.

White balance pre-set/lock While all camcorders handle white balance automatically (see pp.36-7), most also have some form of manual override. Pre-sets give predetermined colour temperature settings for daylight, tungsten and, sometimes, fluorescent light sources. Some models have a lock which allows the white balance to be set manually to match the lighting conditions precisely.

Lenses

ALL CAMCORDERS are fitted with a zoom lens. This gives a range of focal lengths in one lens body, from a standard focal length, with a perspective very similar to that of the human eye, to a very long telephoto which condenses perspective and makes the subject look larger. It is best to think of camcorder zooms in terms of their focal length although they are usually referred to by their focal length ratio, such as 6 x or 8 x – the maximum focal length divided by the minimum.

Camcorders convert light to an electrical signal using a charge-coupled device or CCD (see opposite). There are three different sizes of image chip – $\frac{1}{2}$ in on most camcorders, $\frac{2}{3}$ in on some older models, and $\frac{1}{3}$ in on the many new palmcorders. Each of these sizes affects the way the focal length of the lens is designated.

Camcorders with a $\frac{1}{2}$ in CCD usually have a 9-54 mm zoom. This gives exactly the same optical effects as an 11-88 mm zoom with a 2/3 in chip and a 7-42 mm zoom with a $\frac{1}{2}$ in chip. Without knowing what chip size a camcorder uses, it is impossible to gauge the capabilities of the lens. The table (*right*) enables you to compare focal lengths of camcorders with different chip sizes.

CHIP CONVERSION TABLE

If you want to convert to a larger chip size, read the vertical axis first; if you are converting to a smaller chip size, read the horizontal axis first. For instance, if you have a camcorder with a $\frac{1}{3}$ in chip, and you want to know what the equivalent focal length is for a $\frac{1}{2}$ in chipped camcorder, then multiply your focal length by 1.3. If you want to go the other way (from $\frac{1}{2}$ in to $\frac{1}{3}$ in) then multiply the $\frac{1}{2}$ in focal length by 0.75.

But all these figures are meaningless to the video novice or person schooled in stills photography. To equate a camcorder's focal range with that of a 35mm stills camera, some simple maths is required. For a camcorder with a $\frac{1}{2}$ in CCD, multiply the focal length by 5.4: a 9-54 mm zoom becomes 49-292 mm. The factors are 4 for $\frac{2}{3}$ in CCDs and 7 for $\frac{1}{3}$ in chips.

	$\frac{1}{3}$ in	$\frac{1}{2}$ in	$\frac{2}{3}$ in
$\frac{1}{3}$ in	X	1.3	1.7
$\frac{1}{2}$ in	0.75	X	1.3
$\frac{2}{3}$ in	0.6	0.75	X

Telephoto
For really long telephoto work, such as birdwatching or wildlife videography, you'll need a super-telephoto extension (*right*) with a magnification of 4 x or 5 x. The magnification factor is the maximum focal length of the lens divided by the minimum.

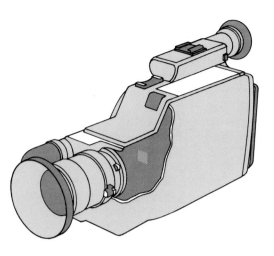

CCD (charge-coupled device)
Images are transmitted through the lens to the imaging chip (CCD or charge-coupled device), where the light image is converted to an electrical signal (*left*). The CCD consists of around 400,000 silicon photodiodes or picture elements (pixels) which analyse the light image in terms of colour, brightness and contrast.

Wide-angle effects
There is no true wide angle on most camcorders. The minimum focal length of most camcorder lenses gives a standard field of view. Only a few have a moderate wide angle.

For almost all camcorders, the only way to get a true wide-angle effect – when shooting a crowded scene indoors or a sweeping landscape, for example – is to use an add-on converter lenses with a magnification factor of 0.6 x or 0.5 x. A 0.5 x converter (*right*) will halve a camcorder's 9 mm focal length to 4.5 x – the equivalent of 25 mm on an SLR.

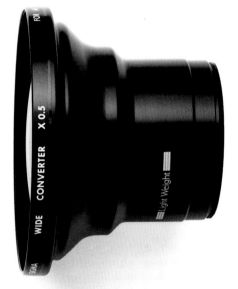

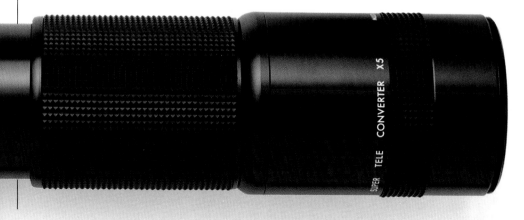

Hand-holding a Camcorder

WHEN YOU FIRST BUY your camcorder, after a quick look at the instruction manual you will probably be eager to turn it on and start shooting. Modern camcorders are so easy to operate, they allow you to do just that.

Although they are easy to use, you should not, however, expect technically expert results unless you follow some basic guidelines on how to hold the camcorder steady. No matter how much attention you pay to the composition, lighting, pans and tilts or editing, an unsteady, jerky image is no pleasure to watch.

Basic principles

To hold the camcorder as steady as possible you should aim to keep your body relaxed while, at the same time, making it into a stable, supportive framework.

A basic stance is to place your feet comfortably apart with your weight evenly distributed between them, and with your elbows tucked in close to your body. Tuck your elbows in without hunching your shoulders. This rapidly sets up muscle tensions within your body, which are then translated into

minute tremors that inevitably will be transmitted to the camera. Likewise, when you have placed your feet apart, you should not lock your back and spine into a rigid mass with the muscles in your buttocks tensed. Again, fatigue will set in and results could be less than you hoped for.

If you have time, go through a short, two-to-three-minute relaxation routine before starting a shoot, gently shaking and relaxing your feet, legs, arms, shoulders and so on. And if you feel yourself tensing up while you are shooting, it might be better to stop for a few minutes until you have worked the muscles free.

Improvized camera supports

In many informal shooting situations, and even for some more scripted ones, hand-holding the camera is fine. If, however, you need rock-steady images with pin-sharp clarity, especially if shooting extends over a lengthy period of time, you will have to try to improvize some sort of camera support. This could be a conveniently positioned wall, the bonnet of a car, or the back of a solid seat or heavy bench.

Basic position
Stand with your feet apart with your weight evenly distributed between them (*right*). Tuck your elbows in to your body and support the weight of the camera in the palm of one hand. This will leave your other hand free to operate the camera controls. The more relaxed you hold yourself, the better the images will be.

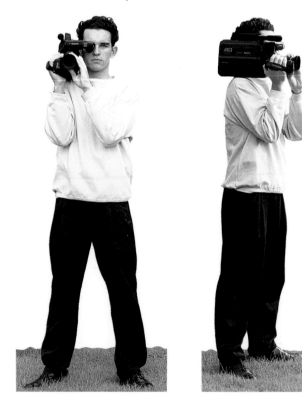

High-angle shooting

Often you will want to vary your shooting position, perhaps by adopting a high camera angle (*right*). In such a case, you will need a firm pair of steps. Some of them are quite lightweight and easily transportable.

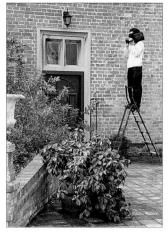

Low-angle shooting

To give an unusual view or to get the camera down to the level of the eye-line of young children (see pp. 128-35), you might need to lie stomach-down on the ground (*below* and *right*). Use your elbows like the legs of a tripod to support the camera. Make sure there are no stones, twigs, or other sharp objects on the ground.

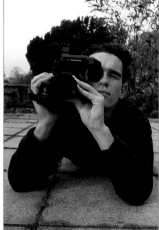

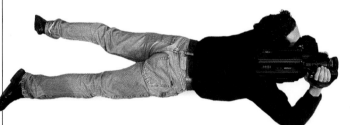

Improvized support

If the action is flowing past your camera position, a convenient and readily available improvized support, especially for lengthy shooting, is an ordinary chair (*below* and *right*). Sit with your legs astride the back of the seat and rest your elbows comfortably on the top of the back rest.

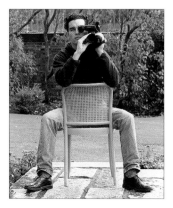

Uneven ground

Trying to obtain steady images while moving over uneven ground (*above*) is always a tremendous problem. And the higher you hold the camera, the more accentuated any movement becomes. To help smooth out the bumps, hold the camera lower down, more at waist level, with your arms slightly splayed out acting as counterbalances. In order to direct the camera properly from this position, you will need to mount a small monitor on top of the camcorder. This technique requires a few rehearsals before the final shoot.

Panning

One successful method of carrying off a hand-held pan is to 'roll' your body over a good, solid support such as a wall (*right*). First, stand as usual with your feet comfortably apart. Make sure you position your feet so that they are pointing in the same direction the camera will be after the pan (you don't want to have to shuffle your feet around while actually shooting). Now, as you keep the subject in a consistent position in the viewfinder, pivot the top of your body around, swivelling from the waist, using the wall all the time to support your weight.

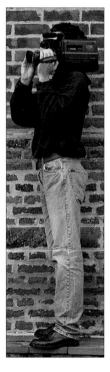

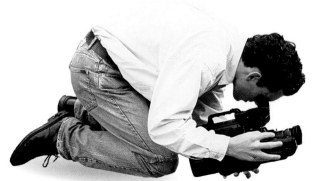

Low-level tilts

For a reasonably smooth action, you can place the back of the camera on the ground (to act as the point of pivot) and then move the camcorder either up or down for a low-level tilt (*left*). If the surface of the ground is abrasive, protect the case of the camera with a piece of cloth or any other type of firm padding.

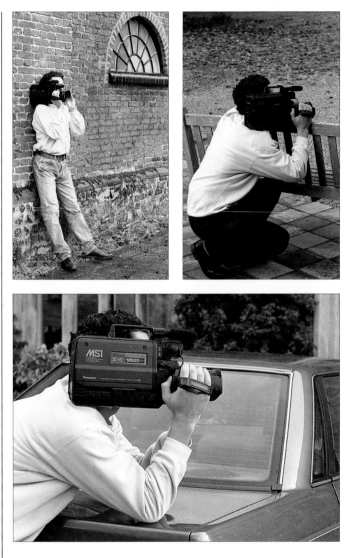

Windy conditions

When you are hand-holding a camera one of your worst enemies is the wind. Gusty conditions can rock and buffet you unexpectedly, making steady pictures very difficult indeed to obtain. So what can you do? First, find a solid, immovable object against which you can brace yourself – a wall is ideal (*far left*). If a wall is not available, a heavy, solid-wood bench makes another good support for the camera (*left*), as does the bonnet or boot of a car, using your arms braced like the legs of a tripod (*middle*). If there is literally nothing you can lean against or use as a support, then try to make your body as compact as possible, lowering your centre of gravity to increase stability further. Kneeling is a good way to achieve this. You can either rest your elbows on your raised knee to take some of the strain (*below*) or rest the camera directly on your knee, steadying it with both hands (*below left*). In either position, you will be much more comfortable if you place some sort of padding under the knee in contact with the ground.

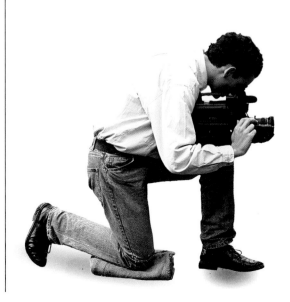

Choosing a Tripod

THE IMPORTANCE of a good-quality tripod cannot be overemphasized. Often what distinguishes the output of an amateur videomaker from that of a professional is the steadiness of the camera work. Most of us shoot videos in order to be able to show them to other people. This will be less than an enjoyable experience if the images are juddering and weaving all over the screen.

Points to look for

First, don't make the mistake of buying a lightweight tripod. It will certainly be easier to carry about, but its lack of weight inevitably means that sturdiness, durability and flexibility have all been sacrificed somewhere along the line. Remember, too, that in the camera store you will be trying out different models on a smooth tiled, wooden or carpeted floor; out in the field, the terrain will be a lot more testing.

Tripod legs are of two main types: tubular telescopic and U-channel telescopic. With the tubular type, you loosen off a knurled retaining ring to release the telescopic legs and tighten the ring again to lock them into position. U-channel models work in much the same way except that they tend to have a clamping system to release and tighten the legs. Once adjusted and locked there is not much to choose between the two types. However, the tubular-legged models are generally smoother in operation and easier to adjust when you need the legs to be different lengths on an uneven surface.

The other important feature to look for is braced legs. Cheaper models invariably are unbraced, or the struts themselves flimsy, and you should not consider buying these.

Apart from making the legs longer or shorter, the other way of altering the height of a tripod is via an adjustable central column. Again, there are two types. Very inexpensive models have a retaining screw that you simply tighten against the column when it is at the right height. Better models employ a ratchet system and crank handle, which allows you to move the column up or down smoothly with no chance of it slipping and perhaps jarring the camera.

Steadicam

When the terrain is sufficiently uneven to rule out the possibility of using a dolly for a tracking shot, yet completely steady images are essential, you could consider using a Steadicam (*right*). This rig consists of a series of hydraulically controlled joints that smooth out the most extreme camera operator movements – the camcorder literally floats in front of you on its specially dampened platform, even when walking down stairs, for example. It is expensive, however, and unless the results you want are absolutely critical, and you will use it often enough to justify the cost, then it is probably best to consider renting rather than buying.

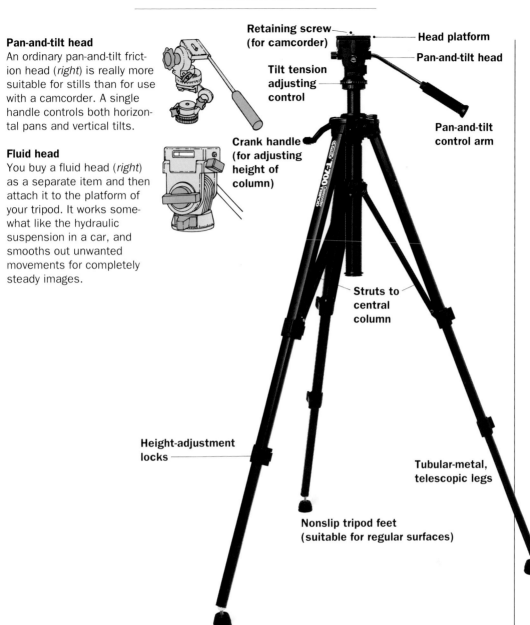

Pan-and-tilt head
An ordinary pan-and-tilt frict-
ion head (*right*) is really more
suitable for stills than for use
with a camcorder. A single
handle controls both horizon-
tal pans and vertical tilts.

Fluid head
You buy a fluid head (*right*)
as a separate item and then
attach it to the platform of
your tripod. It works some-
what like the hydraulic
suspension in a car, and
smooths out unwanted
movements for completely
steady images.

Retaining screw
(for camcorder)

Head platform

Pan-and-tilt head

Tilt tension
adjusting
control

Pan-and-tilt
control arm

Crank handle
(for adjusting
height of
column)

Struts to
central
column

Height-adjustment
locks

Tubular-metal,
telescopic legs

Nonslip tripod feet
(suitable for regular surfaces)

The really critical part of any tripod is the head. For highest-quality work the best option, but it is an expensive one, is a fluid head, which can cost as much as the cheaper model camcorders presently available. These heads are, as their name implies, fluid-filled, and the moving parts literally float within the casing. The fluid is a type of oil known as hydraulic fluid, and the head works in much the same way as the hydraulic suspension in a car, with you pushing the pan-and-tilt control arm against the pressure of fluid inside.

Better-quality fluid heads are adjustable for tight or loose action. If, for example, you were panning or tilting slowly over a few feet only, then you would want a tight action. In other words, the pressure of fluid would be so high that only the most deliberate of movements would have any effect at all. Thus the chance of any unsteadiness in operation or slight jiggling of the tripod itself being transmitted to the camera would be nil. If, on the other hand, you were panning a fast-moving racing car, then you would need a loose action to keep up with the action.

As a compromise between friction heads and fluid heads, there are what are described as 'fluid-effect' heads. These are really friction heads, but the moving components are extremely finely made of low-friction nylon. In operation they have that peculiar 'spongy' feel of a fluid head, and results are perfectly acceptable for most amateur requirements.

Using Tripods and Other Supports

In THE MAJORITY of shooting situations, the steadier the image your camcorder produces the better and more professional it will appear on screen. So, choosing the right tripod is probably one of the most important accessory purchases you will make.

The versatility offered by modern fluid-head tripods, with their easily adjustable legs and centre columns, gives you considerable freedom to carry off extremely smooth pans and tilts, as well as tracking shots, in a great range of difficult circumstances. More commonly available, and less expensive, are fluid-effect heads. Although not as good as proper fluid heads, they are adequate for all but critical work.

A side-effect of using a tripod is that you tend to produce more considered, better-thought-out sequences of images. Perhaps this is because you are less inclined just to 'grab' at shots. Of course, there will be other times when grabbing at images is the best approach if you are not to miss some spontaneous piece of action.

There will be times, however, when it will simply not be possible to use a tripod – when shooting from inside a moving vehicle, for example. But even in this unpromising type of situation, there are several ways in which you can overcome the problem of excessive camera movement. Some of the most simple are shown on these two pages.

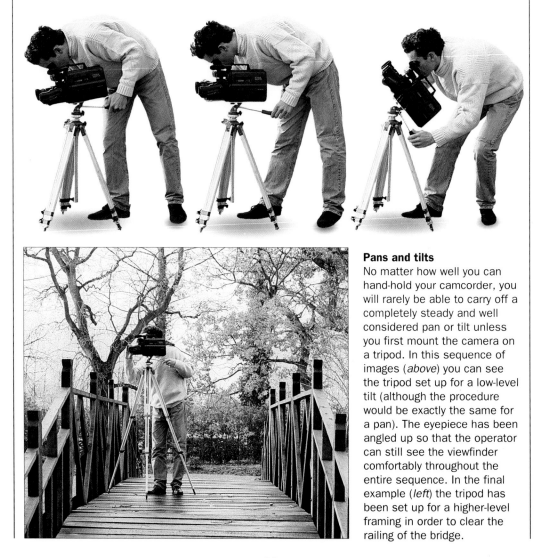

Pans and tilts
No matter how well you can hand-hold your camcorder, you will rarely be able to carry off a completely steady and well considered pan or tilt unless you first mount the camera on a tripod. In this sequence of images (*above*) you can see the tripod set up for a low-level tilt (although the procedure would be exactly the same for a pan). The eyepiece has been angled up so that the operator can still see the viewfinder comfortably throughout the entire sequence. In the final example (*left*) the tripod has been set up for a higher-level framing in order to clear the railing of the bridge.

High vantage point

One of the most dramatic camera angles is a high position shooting down on your subjects (*right*). Most portable tripods will not bring the camera up higher than about average head height. One way to solve this problem is illustrated here – using the roof of a car. First, attach a good-quality roofrack. Then lay down some type of flooring – preferably solid wood – both to spread your weight evenly and also to give you a good surface to clamp the tripod in place.

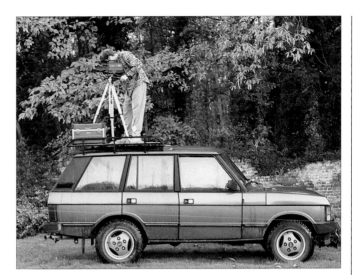

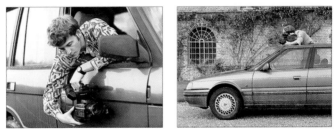

Improvized supports

If you want to shoot from a moving vehicle, then using a tripod is obviously not a practicable proposition. If road conditions are bumpy, some degree of camera shake is inevitable, but you may be able to minimize it by cushioning the camera to your body as you lean out of the window (*above left*). If the road is well made and smooth, you can try bracing the camera against the side of the car (*above centre*) – although some vibration will be transmitted to the camera . Another technique is to stand on the front passenger seat and shoot out of the open sunroof (*above right*). But do take care. Leaning out of a moving vehicle like this is potentially dangerous and in some countries may be illegal on a public road.

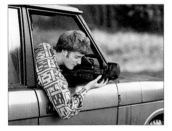

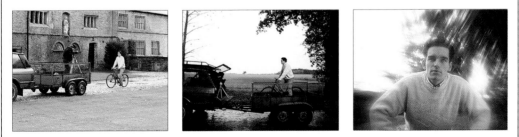

Tracking shots

One method of producing a very professional type of tracking shot is to mount the camcorder on a tripod clamped to the floor of a trailer, which is being gently towed behind a car travelling at the same speed as the cyclist (*above left*). In this way you can keep the focus and framing tight on the cyclist while having the scenery on both sides appear to be streaking by. This technique allows you to use the full range of shots (see pp. 64-5) from close-ups to full length. For a more controlled and completely convincing 'tracking' shot (*above centre*), the cyclist is in the trailer while the camera operator is shooting from the open tailgate of the car. The advantage of this technique is that you don't have to worry about matching the speed of the car and cyclist, which makes filming far easier. The principal disadvantage is that your range of shots will be limited to close-ups and mid-shots (*above right*). Anything fuller than this and the cheat will become apparent. Needless to say, you would not be able to do this on a public road.

Microphones

IT HAS ALWAYS BEEN SOMETHING of a tradition that while amateur film-makers take great care with their moving images, they tend to leave the quality of the recorded sound to pot luck. Camcorder users are no different.

Of course, all camcorders have a built-in microphone, but their quality varies. Some models at the top end of the range have detachable stereo mics, but many of the mono mics found on family budget models are often mediocre.

Another problem with the camcorder mic is its very proximity to the camcorder. Usually positioned just above the camera's zoom lens, it often picks up so-called service noise – the grind and rumble of the camera's zoom and autofocus motors.

To get round this intrusive noise and to record a better quality soundtrack, an external microphone must be fitted. Sockets for this secondary microphone are found on most camcorders. Only budget models or palmcorders may not have it. An external mic can fit onto the camcorder's accessory shoe, but for more professional results, it should be taken off the camera via an extension lead and placed close to the sound source.

External mics can be omnidirectional, cardioid or supercardioid. These terms refer to the direction from which they pick up sound.

An omnidirectional mic, such as are built into most camcorders, picks up sound equally from all directions, even from behind. Cardioid microphones eliminate sound from the rear of the mic, while supercardioids (also called shotgun mics) cut out sound from the sides as well. Supercardioid microphones are

the audio equivalent of the telephoto lens, used to record distant sound. However, the range of a domestic supercardioid is not much more than 16 metres (50 feet). Hyper-cardioid microphones are an even longer version of the supercardioid (a sort of super-supercardioid). They pick up and amplify sounds within an angle of 60° around the subject.

While the cardioid family of microphones seems an attractive choice of accessory, remember that you cannot 'zoom' with them as you can with an optical lens. In fact, your first choice for an external mic should be an omnidirectional of the same type that is fitted to your camcorder.

A good external omnidirectional microphone is ideal for recording the general hum of a party or gathering and is also useful for recording a group conversation. But most importantly, provided you choose one made by a reliable high-quality manufacturer, an external omni will give far better sound reproduction than a camcorder's own mic and can be used in many more situations than the cardioid.

Some manufacturers produce switchable sensitivity mics which combine all three pick-up patterns in one housing.

External mics
Most camcorders come with a built-in omni-directional mic, but the benefit of buying an external omnidirectional (*below*) is that it is often of better quality and you can take it off-camera via an extension lead to get closer to the subject, so avoiding extraneous noise.

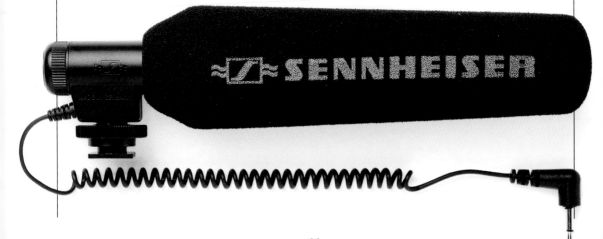

The type of mic you choose also depends on your camcorder's recording system. Stereo sound obviously requires a stereo microphone which captures a two-way soundstage by placing two 'capsules' at right angles to each other. These capsules pick up sound from opposite hemispheres of the pick-up pattern for recording onto the left and right channels.

Positioning the mic

If you are shooting and sound-recording on your own, without the help of an assistant, you will need both hands free to operate the camcorder controls. The most convenient method of positioning the mic is to mount it on the camera.

Alternatively, you could use a small microphone stand (this is similar to a tripod, and has an adjustable central column so that you can alter the height), or even a table stand. The disadvantage of this is that the mic position is fixed – you cannot follow a moving sound source. Mounting the mic on a lightweight boom or pole allows you to get the mic above the sound source.

Radio mics

The best way to ensure accurate sound recording is to place the microphone as close to the subject as possible – either by trailing an extension lead or by using a radio mic.

Many amateur tie clip (lavalier) microphones are of this type, with the tiny omnidirectional mic wired to a radio transmitter which clips to the speaker's belt or slips unobtrusively into a pocket. A receiver slotted onto the camcorder connects to the microphone socket to record the sound onto tape. Radio mics are an effective method of recording talking heads and interviews. However their dynamic (frequency) range is not as wide as that of wired microphones.

When using a radio mic, ensure that the microphone and the receiver on the camcorder have a clear line of sight. Listen to the signal coming through before you record and try not to position the transmitter mic more than (13 metres) 40 feet from the camcorder, as the signal weakens over long distances.

Headphones

When recording with a high-quality stereo mic in a complicated audio environment, you must monitor the sound as it is recorded, to ensure that there is no radio interference or loose connection affecting the sound and that what is being recorded is what is required.

Any set of headphones will do the job. However, serious video-makers should choose a closed-back pair which will effectively cut out extraneous noise. Some headphones have a volume control and this is ideal. Mono users (and some stereo-sound-tracked camcorders have mono headphone sockets) will have to buy mono headphones. Stereo headphones will have to be converted for mono use.

Radio mics (*below*) are ideal for 'talking head' shots. They clip onto a tie or lapel and transmit a signal to a receiver mounted on a camcorder. The cameraman can then stand on the other side of a main road without fear of the rumble of passing traffic intruding on the video.

Headphones
Your best buy is a closed-back pair of headphones (*below*), which will effectively cut out extraneous noise.

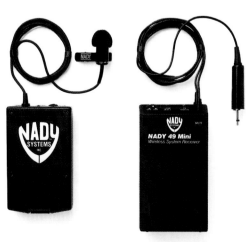

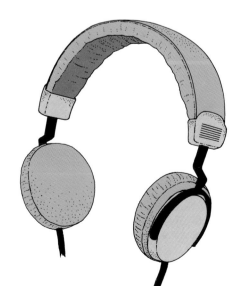

Editing Equipment

Video-making consists of two parts. The first is camerawork – using the video camera to collect enough good raw material with which to assemble the finished production. The second is post-production – mainly editing.

Editing covers everything from making a very rough second-generation copy with the camera shake cut out, to an accomplished production in which the scenes are re-arranged and reassembled. Editing equipment ranges from units that simply minimize quality loss while copying to sophisticated controllers which reorder the recorded footage.

Video enhancers/processors

When tape is copied from one tape to another, there is a loss of definition and over-all image quality (although the effect is far less noticeable when Hi8 or S-VHS is the master format). Simple video enhancers help to minimize this quality loss.

Connected between the camcorder and VCR, basic enhancers usually feature controls to enhance detail and sharpness. As their name suggests, they enhance the video image. However, they have their limitations. They cannot add anything to the video image that wasn't there to begin with. Poorly focused video will remain poorly focused.

More advanced processors can also control picture brightness and contrast and are also able to correct for colour anomalies and imablances – for instance, matching video shot at different times of the day in different colour light. In short, they process the image as well as enhance the video signal.

The most advanced processors have a split-screen facility to show the picture before and after enhancing. But if the images are over-enhanced they look very unnatural, with a 'ringing' effect along high-contrast borders. Reducing grain makes the picture look flat and colour correction can lead to uneven colour distribution.

Many models feature other embellishments. The most useful is a fader. While most cam-corders feature an in-camera fade, it is not always possible to know when to fade, even with the best shooting script (see pp.110-11). A fader can be used to give a more profes-sional scene transition.

Most of the more advanced processors (usually called AV enhancers) feature a built-in sound mixer (see pp.32 and 224). These often have four channels, which means that external sound from a commentary micro-phone and two music sources can be added to the original soundtrack.

However, you should beware of any pieces of equipment calling themselves video mixers or video editors, which are usually just enhancers. Two video sources cannot be mixed like audio signals can. For that, a gen-lock or mixer with a digital frame store is needed; to edit properly (to rearrange the raw footage into its running order), an edit con-troller is needed (although rough edits can be made with just a camcorder and VCR).

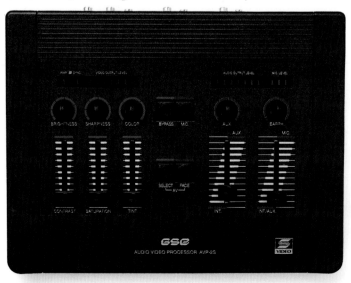

Edit controllers

Whereas enhancers play with the image by making it sharper or brighter, edit controllers are used to rearrange recorded video into a new running order. An edit controller is connected between a camcorder or VCR (player or master unit), which plays the original material, and a second VCR (recorder or slave unit) onto which a copy is made.

The edit controller has a memory which can store up to 99 scenes (sometimes more), and works either by using a timecode (see Box) or the less accurate linear tape counter laid down on the tape's control track (see p.221). Units which use a professional standard timecode are considerably more accurate than other types, although they are also much more expensive.

The timecode and linear tape counter are laid down on the tape as the camcorder records. They can then be read by the edit controller. This feature enables the unit to locate scenes in the master tape and fine-tune the cutting points.

Tape transport controls are exactly the same as on an edit VCR, with play, slow motion, frame advance, fast forward and rewind. The very best units also have a jog-shuttle dial (see p.33) which makes it possible to locate edit points with unparalleled accuracy. Some edit controllers have two sets of tape transport controls: one is used for the master (player) and one for the slave (recorder) units.

As the user shuttles through the master tape using the controls on the edit controller, the in- and out-points of each edit can be programmed into the controller. Each scene is then assigned a number. Once all the scenes

TIMECODES

Until recently, edit controllers relied on the pulses laid down on the tape's control track to locate specific shots. The control track is accurate to within +/- 6 frames.

However, frame accuracy is available with VITC and RCTC timecodes. VITC, which stands for vertical interval timecode, is the professional standard used in the broadcasting industry and is incorporated into some S-VHS and S-VHS-C camcorders. RCTC (rewriteable consumer timecode) is a Hi8 system.

Both timecodes assign an eight-digit number, indicating hours, minutes, seonds and frames, to each recorded frame. With edit controllers which read these timecodes, it is possible to edit with unparalleled precision. However, there are only a few edit controllers which can read timecodes and camcorders which lay down a timecode while recording.

have been stored in the unit's memory, the user then programmes a new running order into the controller. At the press of a button, the edit controller records the scenes on the slave machine in the desired running order, automatically fast-forwarding or rewinding between scenes. Edit controllers really do take the stress out of editing.

One drawback is that machines made by the big-name companies only work with compatible equipment – and this usually means equipment from the same manufacturer. But some independent manufactureres are now producing edit controllers that will

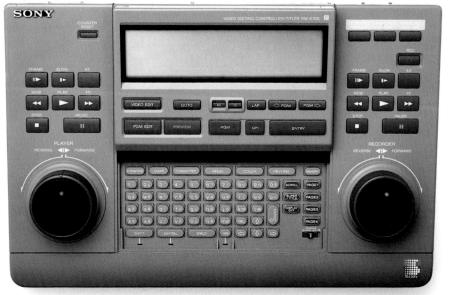

work with different makes of equipment, either via the right socketry or by learning the commands of an infrared remote control. These can read both VITC and RCTC time-codes (see pp.31 and 222). Most of the newer pieces of 8mm equipment can be made compatible by means of a socket called control L. Computers are also being constructed to work as edit controllers.

Family edit studio

While editing is undeniably a vital part of video-making, the cost of post-production equipment – even a basic edit controller – is often prohibitively expensive. The casual domestic user is often unable to do much more than merely tidy up the raw footage. However, some companies are beginning to provide editing equipment at a reasonable price.

Sony's Family Edit Studio (*below*) consists of a cut-price edit controller with a basic four-scene memory, a stereo audio mixer for adding music and soundtracks, and a title generator which works by drawing on a special 'graphics tablet'. Titles can be scrolled up and wiped across the screen.

OTHER POST-PRODUCTION EQUIPMENT

Sound mixers These are some of the most popular accessories. They allow music, a commentary and sound effects to be mixed and added to the original video. The most basic types are very cheap but not always of good quality. Many of the more expensive video enhancers feature a built-in sound mixer. The best mixers have four channels with inputs for a microphone, the original sound from the camcorder, and two music sources (see page 224).

Digital mixers All sorts of special effects can be added with a digital mixer and you can even dissolve two video images together.

Title generators An efficient way of adding titles, most title or character generators consist of a normal typewriter-style keyboard which is connected between the master and slave VCRs. They usually allow the title to be scrolled or wiped and give a variety of colours and type styles and sizes.

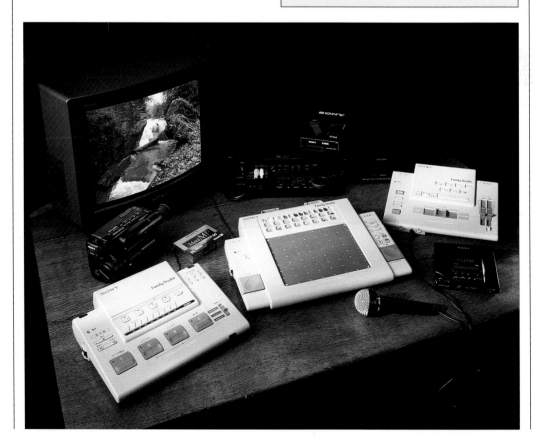

Edit VCRs

While an edit controller will control the functions of a compatible video recorder, it will only be as accurate as that VCR is. If, for instance, a VCR has no still-frame advance or slow-motion replay, then an edit controller cannot add this function to the deck. Without still-frame advance, edit points will obviously be less precise.

Many video recorders are made specifically for editing – hence their name, 'edit VCRs'. The tell-tale sign of an edit VCR is the jog/shuttle dial – a large circular control on the front bodywork. This allows the precise tape transportation essential for accurate editing. The jog/shuttle dial consists of two parts. The outer shuttle ring, which advances or rewinds the tape, allows a rough area of tape to be located. The recessed inner jog dial allows you to then move the tape one frame at a time to pinpoint an in- or out-point.

Most edit VCRs also have insert edit and audio dub functions, and special sockets that allow them to sychronize with other video equipment (see pp.244-5).

BACKSPACING AND SYNCHRONIZATION

Unfortunately, the video industry has never agreed upon a standard for the connecting socketry in VCRs. This presents a problem because all video recorders and camcorders backspace (also called pre-roll) before they commence recording.

To ensure that VCRs backspace (pre-roll) together while editing – otherwise your edits will not occur where you want them to – the equipment must be synchro-linked. To do this, the master (player) VCR is connected via the 'pause' socket to the slave (recorder) VCR by means of a special cable. Pressing 'play' on the master (player) VCR activates 'record' in the slave (recorder) VCR. However, VCRs of different manufacturers will not sync together. You cannot, for instance, sychronize a JVC camcorder with a Panasonic edit deck. It's a nuisance, but a fact of life. (For more information on backspacing, see pp. 61.)

FIRST
ENCOUNTERS

This chapter represents the first step towards creativity in video-making. It explores the subtleties of composition and explains how to exercize creative control over the image by manipulating such things as exposure and depth of field.

The White Balance Control

EVERY TYPE OF LIGHT SOURCE – sunlight, light from a deep blue sky, domestic tungsten, fluorescent tubes, purpose-designed video lighting and so on – has a different 'colour temperature', which is measured in units known as kelvin units. The more blue-white the illumination (daylight, for example) the higher its colour temperature; the more orange-red (tungsten), the lower.

The eye vs the video tape

To the human eye, these differences in colour temperature don't matter a great deal. If, for example, you were to look at an object known to be white – say, a handkerchief – under a variety of different light sources, the handkerchief would still appear white. This is because the brain compensates for the colour of the light so that we perceive colours the way we know they are supposed to look. This is not the case with video tape, which records colours more closely to the way they actually are. This means that, depending on the light source illuminating it, an object may have a colour cast that looks unnatural.

Making corrections

To ensure 'correct' colour rendition with video, you need to use the white balance control, which is part of all modern camcorders. For details on the white balance control on your particular camcorder you should consult your user's manual, but they all work in much the same way.

All current camcorders have a fully automatic white balance system, which recalibrates itself for changing light sources. In most circumstances, this system is very reliable and requires no intervention. As well, most camcorders now have manual presets for indoor (tungsten) and outdoor (daylight) illumination – and some for fluorescent lighting, too. Using the presets usually gives a more vivid colour reproduction than relying on the automatic white balance.

As good as the automatic white balance is, it can be fooled by objects in close-up of a single colour (monochromatic). To counter this, camcorders are fitted with either a hold or lock function. 'Hold' simply freezes the automatically set white balance before you zoom in to your monochromatic subject.

Colours correct

For this shot of windmills set against an overcast sky (*right*), colours are correct as the white balance has been properly set.

In the version below left there is a distinct overall bluish tinge to the light, indicating that the white balance is not completely correct.

Below right, you can see the result of shooting outdoors when the white balance control has been calibrated for an indoor, tungsten light source. The colours are far too warm.

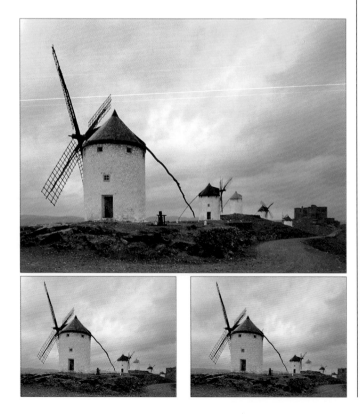

'Lock' is a little more fiddly. First, point the camcorder at a piece of white cardboard, or at a white lens cap, under the correct light source and then press the lock button to fix the setting.

Mixed lighting

The only time you are likely to run into a problem with white balance is when shooting in an environment lit by several different types of light – for example, when taping indoors in a room lit partially by daylight coming in through the windows and partially by tungsten light bulbs. If you imagine a person in such a room and you were to set the white balance for tungsten, the person (if illuminated by daylight) would look blue. If, on the other hand, you were to calibrate the white balance for daylight, then all tungsten-lit areas would appear red. In such a situation, you must decide which is the dominant light source, set the white balance accordingly, and then avoid the other light source as much as possible.

Strong colour cast
A large expanse of a single colour, represented here by woodwork (*right*), can fool the automatic facility causing inaccurate colour rendition. Use a manual preset to lock the white balance.

Mixed lighting
In this interior shot (*below*), the dominant light source is tungsten from the ornate chandeliers, although some window light (out of shot) is also present. The white balance was therefore set for tungsten.

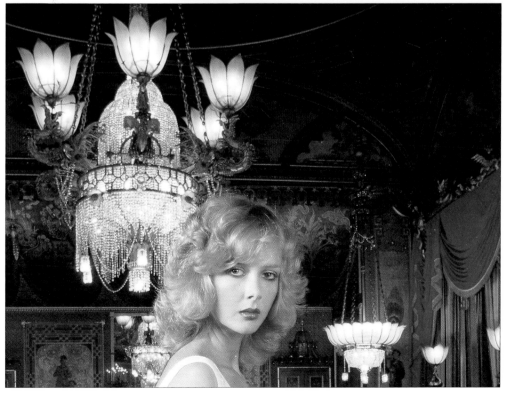

Exposure and Depth of Field

APART OF THE AIM of every photographic endeavour, stills or video, is to achieve correct exposure. But what exactly is 'correct' exposure? The usual answer is: an image that is fully readable throughout, with discernible subject detail in all but the very deepest shadows and very brightest highlights. This is fair enough as far as it goes, but exposure is more than simply a measure of the quantity of light illuminating the subject; it also has to do with the quality of that light, as well as what different intensities of light imply to the audience. So in view of this, perhaps a more fitting concern than 'correct' exposure should be 'appropriate' exposure.

Determining exposure

All modern camcorders are equipped with an autoexposure facility as standard. This system reads the intensity of the light coming in through the lens and striking the charge-coupled device, or CCD, inside the camera (see pp. 18-19), which then modifies the amount of electrical signal passed on to the magnetic recording medium – the video tape. If light levels fall below a certain pre-set level and the camera interprets a likely underexposure will occur, then an automatic gain control, or AGC (see pp. 16), feature cuts in to boost the signal strength emanating from the CCD, giving a better low-light capability.

1

2

3

Using exposure for effect

Normally the aim of exposure is to create a balanced image with subject detail visible in both shadows and highlights (unless these are extreme). In the examples *above*, this type of exposure is represented best by image 4. This is not meant to imply, however, that image 4 is the type of image you should necessarily aim to achieve.

Looked at here, static and unmoving, image 1, for example, appears bleached out, thin, lacking in detail and basically unusable. Seen as part of a moving sequence of images, though, and in the context of what comes both before and after, it might be a perfectly appropriate exposure to aim for. Imagine for a moment a scene opening with the blazing orb of the sun dominating the screen. After two or three seconds this image is replaced by a massively overexposed face apparently bleached of all colour and detail by the

intensity of the sun implied in the last shot. Slowly, taking perhaps five, six, or even seven seconds, the manual iris control is adjusted so that at the end of the sequence the audience can see a normally exposed face beaded with sweat.

So exposure as you can see has a great effect on mood and atmosphere. The lightness of overexposure can imply, as well as heat, openness, lightness, candour; the darkness of underexposure can imply mystery, suspense, confinement and sinister intent. And both extremes of exposure, as well as the steps in between, can all, if appropriate, be 'correct'.

CAMERA METERING SYSTEMS

In order for any camcorder to be able to determine 'correct' exposure, it is programmed to look at different parts of the image that is presented to its circuitry by the lens. Most exposure-measuring systems assume that the main subject is likely to be centre-framed. Thus, most metering systems emphasize the central area of the frame and pay less attention to exposure information coming from the periphery of the frame. More sophisticated systems might also cope with the potential exposure-distorting influence of a bright sky by taking less account of information coming to it from the top of the frame. The best systems take samples from all areas of the viewfinder (the more samples the better), and then produce a composite reading that should smooth out the worst effects of excessive contrast (the difference between the brightest and darkest parts of the image) to give a well-exposed image overall.

Exposure overrides

From the foregoing you might think that all control over exposure has been relinquished to a microprocessor. Well, this really isn't true.

The vast majority of camcorders, even budget models, have a backlight-compensation button. Simply pressing this button opens the lens iris up by a single, set amount to allow more light through the lens. This control is used in situations where you have the main subject between the camera and the sun or other principal light source, so that the side of the subject facing the lens is in shadow. If the scene were to be shot normally, the subject would appear in silhouette. This might be the effect you want to create, but if not, use the backlight-compensation button.

The other major exposure override found on camcorders is the 'manual iris control'. This is something of a misnomer, since it does not give full manual control of the iris. Instead, it opens or closes it by a fixed amount but without deactivating the auto-exposure. This has the effect of changing the parameters of the camera's autoexposure system, allowing a gradual and varying over- or under-exposure of the image, depending on which way you turn the wheel or dial (according to model). Once the control is adjusted, however, it will then over- or under-expose by that set amount until you once again change the setting. Like the backlight-compensation button, you can use the manual iris to prevent silhouetting but with more control, or you can use it to produce generally darker or lighter images at all times in accord with your personal preferences, or it can be used to produce vision-only fades to black (iris closed) or white (iris open).

4

5

6

7

The shutter/aperture relationship

For those making the transition to video from stills photography, it is important to understand the differences in the way a video camera's exposure system works. You may already be aware, for example, of the reciprocal relationship that exists between the lens aperture and the camera shutter. Lens apertures are traditionally calibrated in a series of f stops, also often called f numbers. Turning the aperture control ring from one number to the next changes the size of the aperture and either halves or doubles the amount of light passing through the lens. In order to obtain correct exposure, a variable-speed shutter comes into play. If, for example, you were to let twice as much light into the camera via the aperture and set the shutter so that the light acted on the film for only half as long as previously, then the overall level of illumination reaching the film would be the same and exposure would be constant.

Why, then, have a variable aperture and shutter? Well, there are other, aesthetic, considerations to take into account. Choice of shutter speed affects the way a subject is recorded. A fast shutter speed will freeze movement, while a slow shutter speed will cause the appearance of a moving subject to blur. Important considerations undoubtedly for stills images, but of no relevance at all to the moving image.

Because of this, the majority of camcorders have a single fixed shutter speed of $\frac{1}{50}$ sec,

Manipulating depth of field

In the first shot (*right*), the camcorder is positioned and focused close to the subject (the window latch) and depth of field is shallow. The greater subject-to-camera distance in the second shot (*below*) would normally produce a wider depth of field. To avoid this, I zoomed in and locked focus on the window latch, and then zoomed out again to recompose the shot. In the third shot (*opposite*), I moved back from the window for a greater depth of field and focused manually to get acceptable definition of both the latch and the actress.

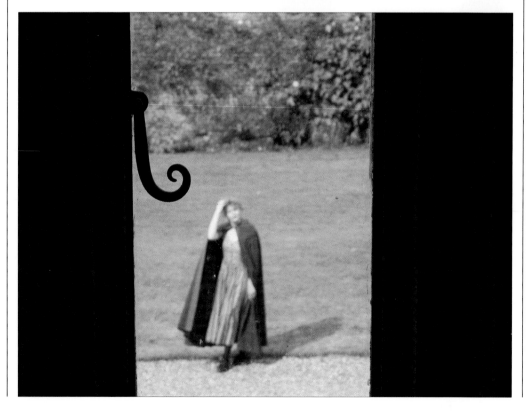

which corresponds to the video-output signal of the CCD. Some specialist camcorders do have much faster shutter speeds than this, but the CCD still outputs its signal at $\frac{1}{50}$ sec. What this means, in fact, is that a 'frame' will be recorded at, say, $\frac{1}{10,000}$ sec (the shutter speed used) and then be held by the CCD for $\frac{1}{50}$ sec before being output to the video tape. On playback, such a recording can be freeze-framed to study in sharp, blur-free detail such things as a golfer's swing, an athlete's hurdling technique and so on. Watched at normal speed, however, the images seem unnaturally jerky, almost stroboscopic – like watching an old-fashioned flick-book of still images pass before your eyes.

So, if the overwhelming majority of camcorders have fixed shutters, then the reciprocal exposure relationship between the shutter and aperture does not apply, and thus most camcorders do not have a variable aperture control ring on the lens. And even if one did exist, turning the ring from one aperture to the next while the tape was rolling would produce a jarringly obvious series of stepped exposure differences.

Depth of field

Although we talk about the point of focus as if it were some very precise distance from the camera, in fact there is a zone surrounding this point where the image is considered to be 'acceptably sharp' – in other words, viewed at normal size from a normal distance, the eye cannot discern what is in focus and what is not. This zone is known as the depth of field.

The extent of depth of field, both in front of and behind the subject, is dependent on three things. First, the focal length of the lens or, more relevant to camcorder users, the focal setting of the zoom. Second, the focus distance – the distance of the subject being focused on from the lens. And, finally, the aperture of the lens.

The rule works as follows: the longer the focal length (or focal length setting), the closer the focus setting, and the wider the aperture, the shallower the depth of field. On most camcorders, the user has no control over the aperture and so has to concentrate on focal length and focus distance to exercise this type of visual control over the image. And the combination of a fully extended zoom and the closest-possible focus setting would produce the shallowest depth of field.

A shallow depth of field, which knocks both the foreground and background out of focus, is ideal for isolating a figure. Conversely, an extensive depth of field is desirable for an establishing shot, when you want the audience to be able to see in detail the setting in which the action is to take place.

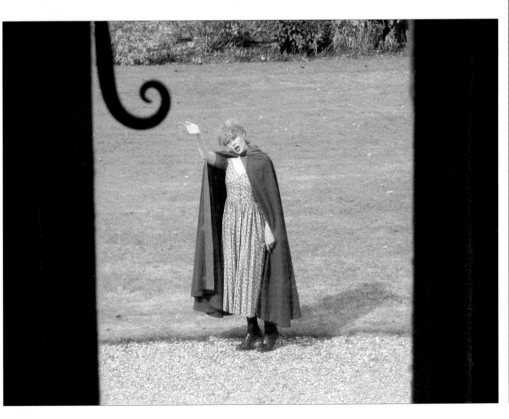

Focus Control

ALL CAMCORDERS FEATURE an autofocus facility. At present there are three main types of autofocus available: infrared, piezo and contrast.

Infrared (IR)

This is the most common autofocus system found on most cheaper model camcorders. Here, a beam of infrared light, transmitted from the camera, strikes the subject and is then reflected back to a rather bulky IR sensor on the front of the camcorder. The length of time it takes for the beam to reflect back to the camera depends on how far away the subject is, which, in turn, determines the focus setting of the lens.

IR is, in general, an underrated type of autofocus. Certainly it can be slow in operation – 1.5 to 2 seconds is the average time it takes to determine correct focus, and 3 seconds is not uncommon. But, very importantly, because it doesn't require ambient light in order to function, it is excellent in the sort of low-light situations that might cause other systems to shut down completely.

However, it is limited in range, and the subject being focused on must be in line with the IR beam, always dead centre of the frame. Also, if you are using a conversion lens (see pp. 18-19), you must ensure it does not obscure the IR sensor. Another problem with IR systems is that the beam of invisible light being transmitted may reflect back from, say, a pane of glass, thus making it impossible for you to focus through a closed window.

Piezo

This is a more sophisticated autofocus system than IR, and it utilizes a special vibrating element situated immediately in front of the CCD image chip (see pp. 18-19). A motor in the lens vibrates the element at a constant rate. As the subject moves in and out of focus, the video signal is measured to determine the point of sharpest subject contrast and, thus, the point of sharpest focus. A microprocessor

inside the camera constantly monitors this point of sharpest focus (see Contrast systems below). Inside the viewfinder there is a series of rectangles, which the user can select from to determine the parts of the frame the system will use to determine correct focus.

Piezo is an extremely quick focusing system and of all the autofocus systems is the one least confused by 'difficult' types of subject (see Problem subjects, p.45). It also allows you to focus on subjects a mere 4mm away from the lens, which is invaluable for macro work.

A variation on the piezo system is digital AI (artificial intelligence), a system in which the vibrating element is situated inside the lens rather than in front of the CCD. Correct focus is achieved by minute shifts of the vibrating focus lens; the front element remains still. Yet another type of piezo focus is the very advanced autotracking system, which locks on to a subject and follows it as it moves about the frame.

Contrast systems

In contrast systems, a microprocessor analyses the image falling on the CCD, examining the video signal to determine the point of sharpest focus, represented by the point of greatest image contrast. When this point is reached, it halts the adjustment of the lens. From your own experience with perhaps a stills camera, or even by looking at, say, a dark car against a white wall and taking your eyes out of focus, you can see that as a subject goes out of focus its image appears progressively softer, less contrasty. In this respect, it is similar to the piezo system, but it is less sophisticated. With piezo autofocus, the system is constantly checking its focus through the vibrating element. When focus is lost with the contrast system, however, the camcorder has to hunt from scratch in order to find the new focus position.

Pulling focus

This sequence of two shots provides a classic example of how you can manipulate audience attention by using the focus control. Focal length and focus settings were arranged to produce a shallow depth of field, which has firmly suppressed the background (*left*). Then, by changing focus alone, attention shifts away from the woman as the background jumps into sharp relief (*below*). This technique would be perfect to show another character entering the scene from the garden behind.

An upgraded contrast system goes by the odd name of 'fuzzy logic', and the claim is that it works in much the same way as the human eye. This autofocus system looks for contrast and brightness information in a smoothly expanding central zone until it has enough data to make a focus decision. Piezo and other contrast-based systems show the area on which the camera is focusing by means of a manually adjustable focus frame shown in the viewfinder – although, of course, this isn't recorded on the videotape. As well as the standard frame, the user can select a large frame for fast-moving subjects or a smaller rectangle to concentrate on small subjects or isolate one subject or detail.

It differs from ordinary contrast focusing in that it does not draw data from fixed zone sizes; it can also make 'intelligent' decisions about focusing. Thus it may, for instance, decide on an intermediate, less-than-perfect setting that still produces 'acceptable' focus, and so avoids going through the entire refocusing regime.

Manual override

Because of the problems with certain types of subject inherent in all autofocusing systems (see Problem subjects opposite), most camcorders allow you to focus manually, using the focusing screen in the viewfinder as a guide as you turn the focus control on the lens or, increasingly common, using a push-button manual focusing system. Whenever you are manually focusing, however, you should always rehearse your shot first so that you know precisely what the correct point of focus is for your subject. Only when you are sure that you have sorted this out should you run the tape.

Pulling focus

On the creative side, focusing the camera manually gives you the option of what is known as 'pulling focus'. For every focal length setting on the zoom range and at every subject focusing distance, there is a variable

Focus to control a dissolve

Here, as in the previous example, a shallow depth of field has been selected so that either the reflection of the building in the window (*below*) or the woman (*opposite*) is in focus at the same time. Then, depending on the action, you can pull focus between the two in order to cut or dissolve between the different scenes.

zone both in front of and behind the point of true focus that is also acceptably sharp. This zone is called the 'depth of field' (see pp. 40-41). If, the depth of field extends for, say, 1.5 metres (about 5 feet) at a particular focal length and focus setting, you could position two people 3 metres (10 feet) apart and then adjust the focus control so that as one blurs out of focus the other becomes sharp. This technique is often used in movies or television dramas to indicate that one character has suddenly noticed the presence of another; as a way of introducing a new character or object to the scene; or of a character making its exit.

The other common use of pulling focus is when a person or an object such as a car is moving towards or away from the camera, and you have to adjust the focus setting of the lens continuously to compensate. If, however, the subject remains constantly in centre frame, your camera's autofocus will probably be able to cope. But if the subject moves across the position of a stationary camera (with non-autotracking focus systems), or it moves diagonally through the lens's field of view, you may find that problems with auto-focus will occur.

PROBLEM SUBJECTS

Despite the claims made by the manufacturers, every type of autofocus system is prone to making errors in certain circumstances. The most common of these situations are:
• Shiny objects or objects that reflect a lot of light.
• Strongly striped horizontal objects.
• Rapidly moving subjects.
• More than one subject at different distances from the camera occupying the same zone in the viewfinder.
• Diagonally slanted objects.
• Subjects with little or no contrast, such as a white wall.
• Subjects positioned behind glass or behind metal railings or bars.
• Dark subjects.
• Night scenes.
• When using a special effects filter.

If by trial and error you find any of these give your camcorder's autofocus system a problem, switch to manual before shooting. This will give you control over the results.

Exiting the Frame

WHEN MAKING A VIDEO – be it an informal collection of family scenes shot on vacation or in and about the home, a more structured production involving an element of preplanning and story development (see pp. 106-17), or perhaps even a simple documentary (see pp. 190-91) – the more tricks of the trade you can introduce into the shooting technique, then ultimately the more watchable and enjoyable your tape will become.

Controlling your instincts
Almost without exception, the first time anybody picks up a camcorder and starts to experiment, their basic instinct is to follow the action – either by panning and tilting the camera or by walking along adjacent to the action in what could be described as a tracking shot.

Panning and tilting (see pp. 50-51) and tracking (see pp. 48-9) are difficult techniques, requiring a strong element of

Depth of field
With relatively low light, the camcorder's autoexposure system has selected a moderately large aperture, though depth of field (see pp. 40-41) is still adequate. The system easily copes with the changing light levels on the subject's face as she moves past the window. As she moves closer still, the focus changes in order to keep the image sharp. The aperture has automatically opened up to compensate for the large area of shadow (the girl's face) now dominating the frame, thus dramatically reducing the depth of field.

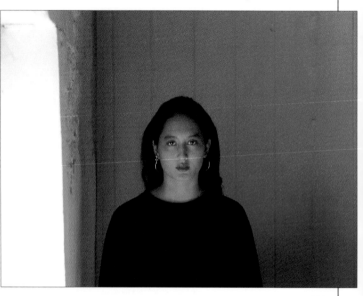

1

3

4

5

rehearsal to maintain focus and framing, as well as a steady hand and practised gait, if the results are not to appear jerky and uncomfortable on screen. Moreover, panning and tilting and tracking are often simply not necessary. The camera is the means by which you capture movement and it will do this even if you remain stationary and let the action flow past the lens – and often the results will be far more aesthetically pleasing, too.

One of the classic examples to illustrate this point is extremely common in every type of video production – having your subject exit the frame. In many amateur videos the camera pans across the field of view until the subject is lost from sight to the right or left of the screen. But as you can see from the sequence of frames on these pages, an equally effective technique, and often far more powerful in terms of its visual impact, is to have your subject exit the frame by walking up to and then beyond the camera.

MANUAL VS AUTOFOCUS

Although this shot represents just a few seconds' viewing time, having this character exit the frame by walking up to and then past the camera adds an important dash of professionalism and dramatic content. During the shot the camera was tripod mounted, which allowed me to pay more attention to altering, or 'pulling', focus as the actress approached in order to keep her sharply imaged throughout the scene. It is worth experimenting with your camera's autofocus (see pp. 42-5) in situations such as this. Depending on your camera's system, you may find that as the figure approaches, the autofocus hunts for the optimal focusing position, and this may show up on screen. When results are critical (a judgement you need to make for yourself), you may find that turning off the autofocus and focusing manually is the better option.

Focus

In a situation such as this, the only decision you then need to make is whether to pull focus to keep the image sharp as the person draws closer, or simply allow the figure to blur by keeping the focus set at some more distant point within the scene.

2

6

7

8

Tracking Shots

TRACKING IS A TYPE of shot in which the camera itself moves, and there are two types of situation in which it can be applied. First, it can be used to keep up with or follow a moving subject – for example a sports event, where the camera tracks alongside a runner in a race.

The second type of tracking shot involves the camera moving around a stationary subject – a person, perhaps, or even a structure or an inanimate object, as on these pages. The point of the exercise here is to introduce the audience in detail to whatever it is you have chosen to be the subject.

Problems with tracking shots

The biggest problem with tracking shots is keeping the camera steady. In a studio environment this is no problem – the floors are level and you can mount the camera on a dolly. Out on location, though, a dolly is often not practical.

So what can you do? Well, quite a bit. First, hand-held tracking shots, especially short ones, are quite practical if the ground is not too uneven and you have the camera firmly and comfortably into your shoulder. Some camcorders can be mounted in a shoulder harness, which is even better. Second, again if the ground is not too rough, you can have an assistant push you along in a wheelchair as you film. Third, you could film from a moving car (see pp. 26-7), an ideal solution for the sports event example above. With all of these solutions, a little camera shake should not necessarily be regarded as a drawback. After all, it could be construed by the audience as realism.

You also need to bear in mind that, generally speaking, a shot tracking left to right is interpreted as being perfectly natural, since it mimics the way most people are accustomed to absorbing visual information – when reading, for example. A shot tracking right to left, however, can create tension and disquiet and imply something is about to happen on screen – useful when used intentionally to produce this reaction.

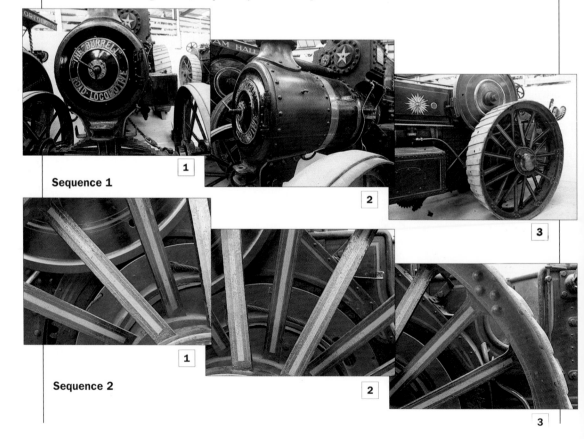

Sequence 1

1

2

3

Sequence 2

1

2

3

Tracking sequences

As you can see from the diagram (*right*), this series of pictures illustrates three different tracking shots using a magnificent old traction engine at an industrial museum as the subject. The whole sequence is only meant to last about 45 seconds of screen time, and I had it in mind to use it as the opening sequence for a documentary. Sequence 1 is a simple one, taking in the front-to-side aspects of the engine, while sequence 2 takes you in close for a detailed inspection of one of the large drive wheels. The third sequence, how-ever, is far more elaborate. Here we can see every detail and appreciate the quality and strength of the engine's construction.

Sequence 1

Sequence 2

Sequence 3

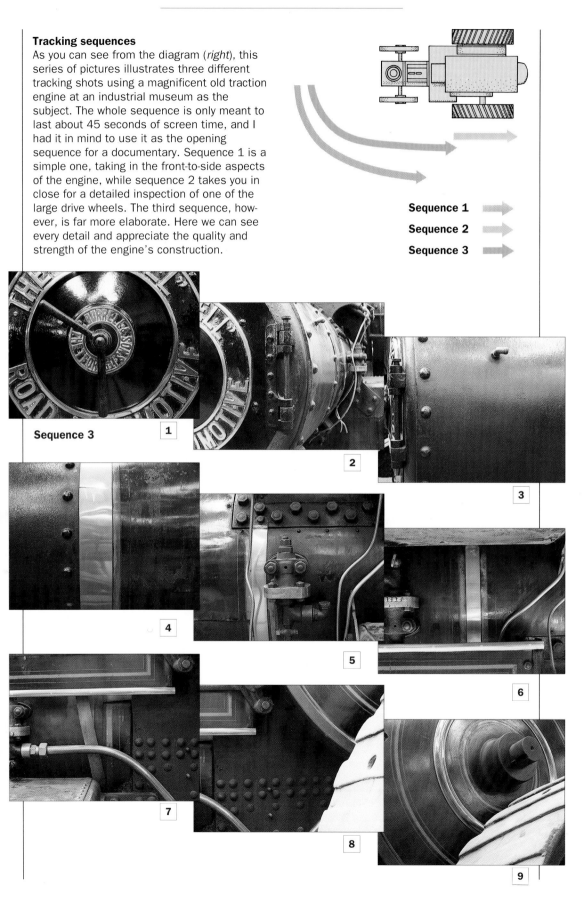

Sequence 3

1

2

3

4

5

6

7

8

9

Pans and Tilts

TWO OF THE MOST COMMON video camera movement techniques are pans and tilts. Almost as soon as anybody picks up a camcorder for the very first time and brings the viewfinder up to their eye, their instinct is to sweep the camera left or right (a pan), or up and down (a tilt).

Using pans

Pans are most often used when a single, static shot is insufficient to include all of a particular scene or subject, or when you want the audience to discover the scene progressively as the camera moves around. You might, for example, find yourself high on a cliff with a majestic coastline stretching from horizon to horizon. In such a case, you might instinctively pan the camera to include it all, quite indiscriminately.

It is far better, however, to evaluate the scene and decide where the pan should start and finish *before* you start to shoot. If you begin the pan too far to the left, there might be an edge of tarmac visible in the shot; whereas if you were to start just a degree or two to the right, the pan could open with the dramatic shape of a wind-shaped tree or craggy outcrop of rock. Likewise, if the pan ends too far to the right, the shot might encompass a pile of litter carelessly left behind by an earlier visitor.

The best way to judge the merits of a pan is to rehearse the shot first without the tape running. In this way you will be able to see in the viewfinder if there are any visual elements best omitted and also if there are any the camera should linger on for a second or two before continuing.

Using tilts

In the same way that panning is used to encompass a strongly horizontal subject, tilting can be used to capture on tape all of a strongly vertical subject that could not easily be taken in with a static camera. An obvious example of where a tilt would be invaluable is when you want to show the whole of a tall building or towering tree from a point quite close to its base.

On the more creative side, you can use tilts to add a little mystery or suspense to your work. In a fictional drama, for example, the camera could start off focused on the floor of a barn watching a smouldering cigarette just beginning to catch light to the surrounding hay. The tilt could then move up slowly to reveal a pile of hay bales with somebody working on top of them totally unaware of the danger developing below.

But no matter what the motivation for the tilt, you need to rehearse the shot before committing it to tape, just as with panning, to ensure that it starts and ends on an appropriate visual note.

Simple pan
Pans are ideal for integrating a character into a setting, as in this sequence of images (*above*). Note that the pan starts with a strong visual element, the bridge, on the extreme left, pans to the right past the figure, and then carries on to show you the complete setting. It finishes on an equally strong image of the river meandering into the distance.

Combining pans and tilts

If, when panning, you also move the camera up or down at the beginning or the end so that a particular feature is more interestingly framed in the viewfinder, then what you have achieved is a combined pan and tilt. Although not uncommon, it is difficult to carry it off smoothly without having to adjust the framing to ensure the final image is precisely how you want it to appear. The trick is, once again, rehearsal. Run through the shot two or three time before shooting; this will be especially beneficial if the final image is at a different distance from the camera than the rest of the scene. Panning, tilting and adjusting focus simultaneously is no easy matter.

Tilting down

Here (*left*) you can see the beginning and end of a tilt sequence. It started with the camera framed to show just the boy's feet and calves against the sky – quite a puzzling shot. Then the camera tilted down, not too slowly in case he fell, to reveal bit by bit the whole figure.

1

2

Pan and tilt

When trying pan-and-tilt techniques, start with a simple, uncluttered subject. This skater (*left*), shot against a plain background of ice, was moving relatively slowly, which made my task a bit easier. He also kept a consistent distance from my position, so changing focus wasn't a consideration. The sequence opened with the camera concentrating on his feet and then, while still panning, slowly tilted up until all of him was revealed. Trying to keep the figure in the same area of the frame is another problem you will have to contend with.

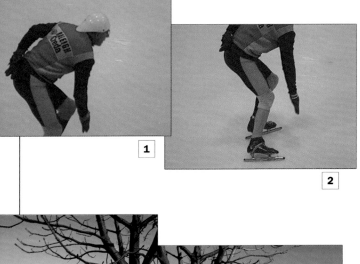

4

5

6

Using the Environment

MANY VIDEO CAMERA users have some sort of background in stills photography. This is no bad thing: indeed, many of the concepts underlying the visual organization and structure of the environment within which you place your subjects, and how your subjects relate to that environment – in other words, composition – apply to both. However, there are some unique characteristics of the moving image that are best to recognize from the start.

The environment includes sound

Like stills photography, the video image has to contain an element of impact in order to grab, and hopefully sustain, the audience's attention. The environment you choose to film in is a major factor in this. With video, though, you have the additional dimension of sound (see pp. 28-9 and 224-7); and the combination of sound and visuals can be a great determiner of the mood and atmosphere of your production.

Camera alignment

In this shot of a model at a fashion show in the grounds of a stately home (*left*), she is carefully framed against the central, clear arch in the wall behind. In this way, there is no conflict between the girl and the background. This was not just a matter of aligning the girl and arch; I also tightened the framing by zooming in slightly and dropped the camera position so that it was only a few feet from the ground in order to simplify the setting.

Contrast with the environment

In another frame from the same tape (*above*), the model is waiting her turn to parade her clothes. I had arranged the shot so that I was downhill from her. In this way, the framing would bring out the contrast between her exaggeratedly static pose and the sight and sound of the water spraying from the fountain out of shot.

Foreground frame

I found this scene of a horse stud (*above*) while driving through Austria. The horses in the paddock looked magnificent, but the surroundings consisted of a motley collection of outhouse fences, access roads, and so on. In the end, I climbed onto a gate shot down on the horse to show it against a simple backdrop of grass, clear of extraneous clutter.

On the minus side, discordant or irrelevant sounds from the environment in which you are taping distract and confuse the audience and can spoil their enjoyment of even the most beautifully shot production.

Simple is often best

Another important thing to bear in mind about video is that each aspect of your subjects and their surroundings is usually on screen only in passing. This means that the more simply you can present the environment to the audience, the more chance they will have of being able to absorb what it is you are trying to communicate. A cluttered environment can be very distracting.

Video is not like a stills photograph, where you can look back time and time again at the subtle play of light and shade, tone and texture created by the image. The impressions gained from images on screen are far more ephemeral and fleeting in nature. Short-lived as they are individually, it is the way they are put together that ultimately determines how the audience will judge the production as a whole. Making an effort to look out for the right sort of environment in which to record even a few minutes' worth of tape of something as mundane as your vacation destination or the children playing in the local park can make a huge difference to the tape's eventual appeal.

Balancing the environment
In this carefully framed shot (*above*), the actress and her environment balance perfectly. Also, the space left between her and the sculpture is designed to allow room for a second character to enter the shot. The simplicity of this image gives it sufficient screen impact for it to be held for quite some time while the tension gradually builds.

Merging with the environment
The actress (*above*) is dressed and lit so that at a casual glance she could almost merge with the John Bellamy picture behind. As she walks towards the camera, focus is pulled in order to keep her sharply in focus. The picture seems to recede into the background, almost giving the impression that the actress has just stepped out of its frame.

Repeating shapes
Because of the plot, the camera had to linger on the back of the actress (*above*) for about 10 seconds. The need here was to find a background that was sufficiently interesting to hold the audience's interest without taking attention away from the main subject. The massive doors of the house around which the action was set, with their repeating pattern, proved ideal.

Environment includes lighting
The type of lighting scheme you create has a tremendous effect on the way the audience responds to the environment in a scene. The overall tranquillity of the setting (*right*) – the soft curve of the bed reinforced by the gently muted, warm-coloured lighting – contrasts sharply with the strongly pyramidal shape of the actress with her arms outstretched. This creates a tremendous dynamic tension – something dramatic or revealing is about to happen or has just happened.

Placing the Figure in the Frame

How you use the area of the viewfinder to frame your subject has a great bearing on the way people will eventually view your work. Here you can fall back on the fact that your audience has long been attuned to the conventions of television. You can, for a start, forget the old, well-worn stills-photographer's adage that a centrally placed figure makes for a basically static composition (it was never necessarily true anyway). A central figure or object on the television screen is one that demands immediate audience attention – especially if it is shot in close-up or big close-up (see pp. 64-5). But when framing the face, don't let the person's chin rest on the bottom of the screen. This makes for a very uncomfortable-looking shot.

This does not mean, however, that you should avoid off-centre framing. Indeed, this type of framing is often essential – to imply, for example, that something else is happening out of shot; to justify a pan to where the person's eyes are looking (known as 'looking room'); as a compositional device to leave space within the frame for something else to enter the action; or to leave space for your subject to move into (known as 'lead space').

Maintaining the illusion of reality

Abrupt changes of light intensity can also bring your scene to grief when, for example, your subject moves out from the muted lighting provided by a canopy of trees in a park into the full glare of direct sunlight. The

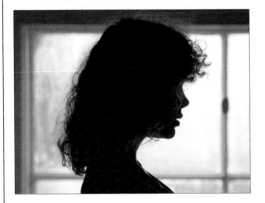

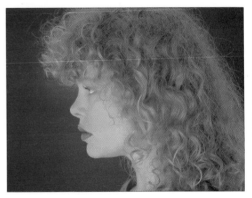

Lighting styles
In these two profile shots (*above* and *above right*), it is easy to see which one more immediately grabs your attention. However, you need to restrict the length of silhouette shots; as effective as they are, after a few seconds the audience longs to see the fully lit face.

Dynamic change
In these close-ups (*below left* and *below*) a simple movement of the head changes the intention of the shot. There is a strong sense of dynamism in the first produced largely by the diagonal composition of the head and eyeline. Her posture also suggests vulnerability. In the second, the actress appears more forceful, almost confrontational.

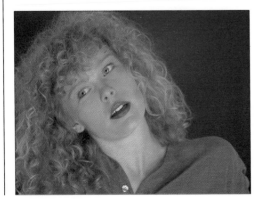

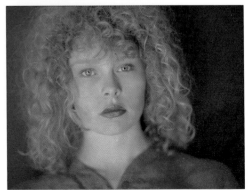

video camera's automatic exposure control (see pp. 38-9) won't be able to react instantly, and your audience will then be fully aware of the camera's intrusion. In other words, the impression of reality you have been trying so hard to produce will be revealed for what it actually is – merely an illusion.

To overcome, or at least minimize, these types of problem, keep shooting sequences quite short; there will be less time for anything to go wrong. Also, you should be able to plan short scenes with relative ease, thereby avoiding intrusive errors. The better this preplanning, the higher the ratio of successful sequences will be.

The moving camera

The actress is now looking up but the camera has moved around slightly to produce two different viewpoints. When the subject is in centre frame (*right*) you can hold the shot for far longer than you could with an off-centre composition (*below*). This latter position is used more as a lead-in to the next shot.

Action out of shot

These two examples of off-centre framing (*below left* and *right*) show how you can build dramatic tension in a scene. In the first of the two nothing seems amiss, but in the second her expression and eyeline leave the audience in no doubt that in the next shot the reason for her terror will be entering in the space provided.

Using Foregrounds and Backgrounds

MOST VIDEO PRODUCTIONS take place in a visually elaborate environment. Even a simple scene from your holiday video (see pp. 142-57) of people playing on a beach, could involve railings, parked cars, other people strolling by and hot-dog stands in the foreground. In the background you could have sunbathers, swimmers, the curve of foam and sand leading the eye on to hotels and the town centre beyond. All of these compositional elements help to place your action in some sort of context and provide depth and distance. So rather than think of them as extraneous 'clutter', try to use them selectively so that they support your story-line and add substance to your characters. Your main controls in manipulating the way the environment appears on screen are the viewpoint you choose to shoot from and the focal setting of your lens.

Viewpoint

The position from which you shoot is the basic determiner in what eventually appears

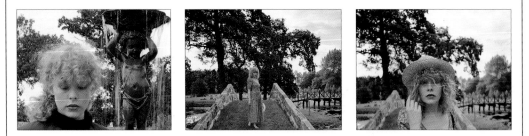

Relationship to setting

In the first of these three shots (*above left*) we see the actress thoughtful, relatively small in the frame, and balanced by the fountain in the background – important since this is the only element in the shot providing us with any movement. In the next scene (*above centre*), the actress is smaller still in the frame, but her central placement helps to give her added presence. The composition is also distinctly pyramidal, which gives dynamism to an otherwise static composition. In the final shot (*above right*), she has moved towards the camera. The camera is static and so framing of the scene has remained the same, but now the emphasis has altered and the setting, so important in the previous shot, seems to be of far less significance.

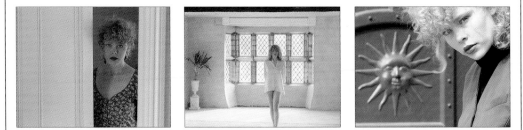

Settings for atmosphere

These three shots show how the setting determines the atmosphere you convey to your audience. None is elaborate but each adds important 'texture'. In the first image (*above left*) you know that she has just hesitantly opened the door. Before her appearance, the camera would have been trained for a few seconds on its solid blankness. But now, something formerly obscured has been revealed. In the next shot (*above centre*), the actress's general demeanour, her simple, revealing shift and the unnatural bareness of the room all combine to produce the feeling that she is not in control of the situation. Her fragility is echoed in the delicate panes of glass behind. In the final shot (*above right*), the actress is closer in shot and the emphasis has changed significantly. Even the fact that she is now fully clothed places her more in control.

or, often equally importantly, does not appear. Moving forwards or to the left or right slightly, for example, may exclude from shot a foreground element that detracts from the action. Alternatively, doing any of these things may include something that is of positive benefit. Bear in mind, however, that when you move the camera you also change the apparent relationship of objects within the frame.

Adopting either a high or a low shooting angle is a common camera technique for showing your subject against the relatively plain backcloth of the ground or sky. You have the camera and, unless you are working with a director or to a strict shooting script (see pp. 110-11), it is your decision.

Lens focal setting
Simply by zooming in or out you can change from a detailed close-up to a wide panorama – perhaps the best way of all of controlling the relative importance of the foreground and background elements of a scene. And, unlike moving your camera position (see above), zooming does not alter the apparent physical relationship of objects within the scene. A word of warning is called for here, however. You need to use this technique with extreme restraint, since it does not correspond with normal vision in any way. Nothing will put your audience off faster than being visually assaulted by constant zoom shots.

Zooming in – on the window of a building, for example – is often used to herald a change of scene – perhaps to the interior we believe lies behind that window. Zooming out, on the other hand, often signifies a withdrawal from one scene, to be followed by a change to another – perhaps even to a new location altogether.

Shape and colour
Filmed through the bars of the bed (*right*), with the lighting throwing her into relief against the dimly lit interior, her expression is thoughtful, even wistful. The strong vertical shapes created by the bars are in stark contrast to the softness of her mood. The next shot (*below*) creates a strong colour link between hair, lips and shawl. Her expression leads us to think of her as being isolated as she stares out of frame past the camera. In the last shot of this sequence (*below right*), by simply raising her arms the actress has divided the space in two, distancing herself from the rest of the room. But she now appears more active, more in control.

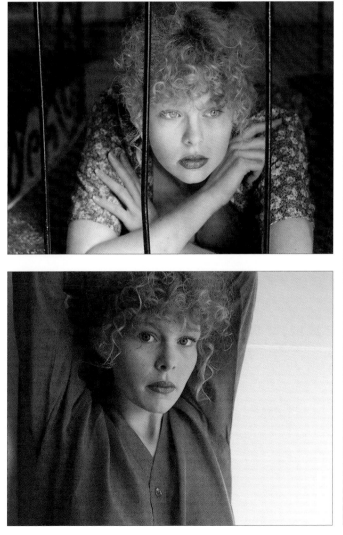

Quick Cuts

WHEN MAKING A VIDEO, especially a fictional drama, you are attempting to communicate a set of, often fanciful, ideas to the audience. To accomplish this, therefore, you need to establish a sense of reality within the structure of your production; or, to put it another way, you are asking your audience for their 'willing suspension of disbelief'. But in order for them to give this, you, as videomaker, must help and guide them through your choice and treatment of the visual content.

One of the most effective techniques for building suspense and dynamic action used in professional movie making is a series of quick cuts. The picture examples used here are not in any way central to the principle underlying the technique: the dinosaurs are nothing more than a convenient vehicle to carry the explanation.

In the fictional drama in which these dinosaurs appear (see pp. 206-15), two sisters have blundered into a forest caught in a type of time warp, where prehistoric animals and people still exist. On screen the audience sees the girls and dinosaurs interacting

After the shoot
To work properly, these shots need to be shown as a series of very quick cuts. Camera angles (see pp. 68-9) were chosen with care so that it appears that no matter which way the girls turn in their attempt to flee – left, right, backwards, forwards – there always seems to be another terrifying creature.

1

3

4

5

– or at least appearing to. In fact, all the scenes involving the girls were shot at one location and all scenes of dinosaurs in the 'Forbidden Forest' at another. But by cutting between the two, taking care to match eye-lines, and backgrounds, and to justify cuts with careful point of view (POV) shots (see pp. 66-7), as well as by easing the transition with sound effects added later in post-pro-duction (see pp. 224-7), an illusion of inter-action is created.

Preplanning

To cover myself during the shooting of this production, I taped much more footage than I thought I would want to use.

Draw some comfort from the thought that you really don't have to make any final deci-sions about how to organize the cutting be-tween scenes and within scenes at the time of shooting – there is always the editing stage to come. But with a production as complex as this, you would have certainly drawn up some sort of storyboard (see pp. 110-11) to ensure adequate coverage. Although not removing all your shooting options, the story-board will guide you in some important deci-sions, such as cutting points and so on.

At post-production, you can assemble your cuts on another tape just to see how the visual logic works. This initial assembly of material during editing is known as the 'rough cut'. And, if your preplanning has been adequate, you will have shot sufficient material to allow you to modify the storyline if necessary at this point in the process.

Arranging the cuts
How you arrange the cuts makes a big difference. If you intercut shots of the girls with those of the dinosaurs, you immediately and firmly make the connection between the two – they are reacting to each other. Omit the girls, however, and arrange the cuts appropriately, and it could also appear that the dinosaurs are squaring up to each other and are largely unaware of the girls' pres-ence in their domain.

2

6

7

8

In-camera Editing

NO ONE HAS EVER PRODUCED a prize-winning video film without editing; but then again, not everyone wants to shoot competition-standard movies with all the intricate post-production work that entails. However, you still want your home movies to look as good as possible: a poor holiday video is just as boring to your relatives and friends as one hundred awful snapshots. For this, you will have to edit in-camera.

A movie edited in-camera must flow just like one which has had all the advantages of post-production editing brought to bear. To do this, you must abide by certain rules.

First, have a rough idea in your head of what you want to shoot. This is not to say that a full shooting script (see page 111) is required. That would be too large an undertaking and would also remove the spontaneity from a day out. But you should have a rough idea of what you want to shoot and the sequence in which you want to shoot it, simply because, with no subsequent juggling of the scenes in the editing suite, you'll have to get it right first time.

Second, a working knowledge of movie-making techniques is a definite advantage. Alas, there is no substitute for experience here. Either you know how to match eyelines and reverse angles and how not to cross the line (see pages 249, 72-3 and 70-71) or you don't.

Third, keep it simple. Don't attempt ambitious combinations of shots that have a greater chance of error. Remember, just one basic mistake can ruin a whole sequence – and you don't get a second chance.

It's stating the obvious a bit, but be very conscious of the record/pause camera mode.

One of the easiest mistakes to make is to forget to stop recording at the end of a scene, or to get confused over how many times you have pressed the button, and find yourself in pause when you thought you were recording and vice versa.

When you are editing in-camera, you're stuck with whatever you take – unless, that is, your camcorder has a record/review function. This feature replays the last few seconds of a scene, so that you can check everything is OK, and returns the camera to the out-point ready to record again.

Of course, there is nothing to stop you entering playback mode to run through your footage. But the problem with this is that very few camcorders are equipped with a precise frame advance mechanism. Without this function, it is difficult to return exactly to the end of the last recorded scene. Using play or fast forward/rewind, it is easy to overshoot – leaving a second or two of white noise before the next shot – or run short, cutting off a couple of seconds of the last frame. Backspacing (see Box) is another problem.

However, difficult as in-camera editing can be, you can still adopt these principles without worrying about getting everything spot on. Providing everything has been shot chronologically and competently, you can perform the minimum of post-production editing just to tidy things up. All this involves is copying your tape onto a VCR (see pp.220-23).

In-camera editing is an attractive option to the thousands of casual movie-makers not interested in post-production. But remember, you need a sound understanding of basic movie grammar just as much as the videographer with banks of edit controllers.

JUMP CUTS

A jump cut occurs when the cameraman stops recording, then starts again from the same position. The result is that the subject appears to 'jump', either from one part of the frame to another, or with discontinuous movement. The soundtrack may also be affected.

To avoid a jump cut, change the camera position, camera angle or focal length – or any combination of the three – before starting to record again.

DO'S AND DON'TS

• Don't wave the camera around like a hose pipe.
• Don't zoom unless absolutely necessary. Even then, keep zooms to a minimum.
• Don't pan if a wide establishing shot can show the same scene in a better way.
• Do keep your shots to around 5-15 seconds in length, with a two-second runout at the end to compensate for possible backspacing (see Box).

BACKSPACING

Just like VCRs (see pages 33 and 58), camcorders backspace: before they commence recording, the tape rewinds for a couple of seconds, which means that anything up to the previous 50 frames will be recorded over. This applies only when the camcorder is turned to record/pause from the stop position, not when you merely pause the recording.

Camcorders vary in how much they backspace, so you will have to experiment. To determine exactly how much your camcorder backspaces, video a stopwatch for one minute. Then rewind to the 30-second mark of the sequence and pause. (Unless your camcorder has a frame advance facility, you may have trouble with precise location, so make a note of exactly where you pause.)

Turn the camera off. Turn it on again and record something totally different. When the tape is replayed, the new sequence will begin at something like 28 seconds, indicating that your camcorder backspaces by two seconds.

Armed with this knowledge, you should always make sure that you allow an extra two seconds at the end of a shot if you are going to turn the camera off or enter recorder mode (from camera mode) to view the recording. Otherwise, you will lose the end of your shot.

1

2

3

THE LANGUAGE OF MOVING PICTURES

This chapter demystifies the jargon of
video-making by explaining what
commonly used expressions
and abbreviations mean in practice.

Types and Functions of Shots

ET US FIRST START WITH a simple definition: a shot is a piece of continuous footage concerned with a single aspect of any event or action. However, there are many different types of shot and a whole movie and television language (simply adopted by video) has evolved to describe them.

Basic shots
The three most commonly used shots are the basic close-up (CU), the mid-shot (MS), and the long shot (LS). A CU is when a single head and shoulders view fills the frame; an MS occurs when the framing allows a view extending to about waist level (if two people

are in view, this would be an MS two-shot); and an LS is a framing that incorporates the entire figure (two people in view would be an LS two-shot). Although these shots are described in terms of the amount of a human figure that can be seen, the same definitions would apply no matter what the subject matter.

Variations on a theme
As well as having a basic CU of a head and shoulders, you could have a framing that contained just the face. This would be termed a big close-up (BCU). A framing that concentrated on just part of the face would be an

Putting the shots together
This illustration (*right*) indicates the framings of the most common shots.
 The sequence (*opposite* and *below*) represents the range of shots you would expect to see in a edited sequence. The order in which they are presented here is that most commonly used in drama and documentary work.

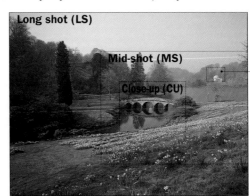

Long shot (LS)

Mid-shot (MS)

Close-up (CU)

Big close-up (BCU)

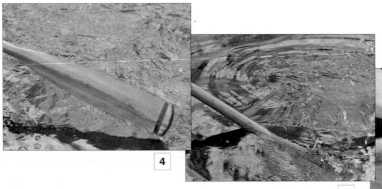

4

5

Medium close-up
The camera cuts to an MCU of the oar dipping into the water and lingers there long enough for the audience to see two or three full sweeps through the water. This shot was motivated by what was seen in the previous shot.

Big close-up
Now we are in a BCU showing just the hands on the oars – again a shot motivated by what the audience has previously seen.

extreme close-up (ECU), and, moving out a little, a framing that took in the head and chest area would be a medium close-up (MCU). Likewise, a framing that showed a full figure in its immediate surroundings would be a very long shot (VLS), while one that showed the figure as just a small part of a large landscape would be an extreme long shot (ELS).

Depending on the function you decide the shot is to have in the production, shots can be called by other names. For example, the ELS of a figure in a landscape could legitimately be termed an establishing shot if your intention is to use it to establish the location in which the action occurs.

Appropriate shots

When deciding what shots to use, you need to bear in mind that each framing can be read like a subtext by the audience. In an interview situation, for example (see pp. 188-9), you never see any participant framed closer than an ordinary CU. To move in tighter than this, say to a BCU, would imply an intimacy not appropriate to that situation. A BCU would be entirely appropriate in a dramatic production, however, where the audience is being asked to identify more intimately with the characters on the screen.

Generally speaking, an MS is used to imply social neutrality, or as the tightest framing it is comfortable to use when there are two people in shot, while an LS can be used to imply isolation, coldness or some similar emotion. It is, however, impossible to lay down hard-and-fast rules about the emotional impact of shots, since so much depends on other factors – dialogue, lighting, the preceding action and so on.

Very long shot 1
An establishing VLS used to show the setting (river, banks, and hint of country beyond) as well as the actor and boat.

Mid-shot 2
The camera moves into an MS of the front of the boat as it continues to move towards the camera position. This immediately tells the audience that they are about to be 'introduced' to the character.

Mid-shot 3
With approximately the same framing in MS, the camera now shows the actor rowing away from the camera position – a reverse action of the previous shot.

Mid-shot 7
The camera pans back from the CU to show the actor once more in MS.

Long shot 8
This LS shows that the boat is again moving towards the camera and signals that this piece of action is coming to an end.

Long shot 9
This reverse action LS has been used to conclude the sequence.

Introducing Drama through POV

THE TWO SEQUENCES of shots you can see here come from additional footage taken during the making of a fictional drama production (see pp. 206-15). In the story, two sisters have ignored the warning of their mother and entered a forested area behind their home. Once inside, they endure a series of terrifying experiences as they blunder around inside a world populated with prehistoric creatures. Finally, they stumble on to the path out of the forest and reach home and safety.

The edited version on pages 206-11 is intended to run for only four minutes of screen time. However, you run a grave risk when it comes to the post-production editing stage (see pp. 220-23) if you don't shoot sufficient tape to cover such eventualities as continuity errors, focus and exposure problems, and incorrect eyelines, as well as additional scenes to allow you the flexibility to develop the dramatic content of the storyline during editing.

What is POV?

Like many other fields of creative endeavour, video-making suffers from its fair share of jargon and abbreviated terms meant to convey quickly a very precise concept. To the uninitiated, however, these can be confusing. A POV shot is simply an abbreviation of 'point of view'. It is used to describe a scene shot from the point of view of the subject.

Sequence 1
. . . peering through a gap in an old wall, she becomes transfixed by the sight . . .

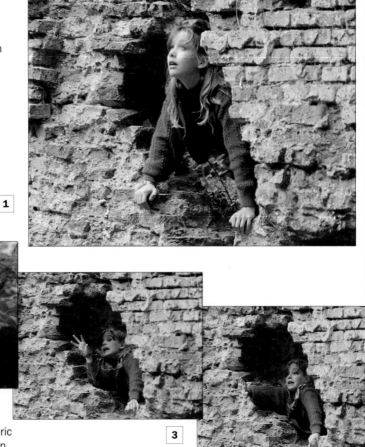

1

2

. . . cut to a POV of prehistoric man on hill opposite. Start in long shot and zoom in to close-up . . .

3

. . . reaction shot to POV. Girl raises hand in disbelief . . .

4

. . . as full horror sinks in, she gathers herself and prepares to flee. . .

Sequence 1

In the first sequence (*left*), for example, the camera starts in a mid-shot of one of the sisters peering through a broken wall somewhere in the forest. From the expression on her face the audience is alerted to the fact that she has seen something she cannot quite believe. To help build dramatic tension, the camera lingers on this shot for quite a time. Next we cut to a POV, so that the audience can see what has frightened the girl from that character's viewpoint – a prehistoric man half hidden by foliage on a hill opposite.

In fact, what is portrayed here is just the final frame of that shot as the camera rapidly zooms in from a long shot to a close-up, again adding to the tension. Next we cut to a reaction shot as the girl, now truly terrified, raises her hand as if to ward off what she has seen. Finally, the camera remains on her as she prepares to flee.

Sequence 2

Another way of using a POV can be seen in the second sequence (*below*). The girls have obviously become separated for a time and now the other sister, apprehensive because, being the elder of the two, she feels responsible for the situation, looks carefully out from behind the shelter of a large tree trunk. Then, hearing a noise (added later at post-production), her eyes swivel in its general direction. On hearing it again, she suddenly looks up in disbelief. Now we cut to a POV of the source of her understandable alarm – a prehistoric bird perched high above her in the tree.

For the POV to be believable, it is vital that the eyelines match the camera angles. If, for example, she had been looking into the middle distance, then the audience would not believe that the shot of the monstrous bird had been taken from the girl's viewpoint.

Sequence 2

. . . frightened and now alone, she looks out desperately from her hiding place . . .

. . . cue sound fx noise as girl's eyes swivel . . .

. . . cue same noise as she looks up to where bird should be. . .

. . . cut to POV of bird.

Camera Angles

THE CONVENTION that has grown up with the movie industry, and then later with television, is that the majority of images are shot at the normal eye-level of an adult person – in other words, with the camera about 1.5 metres (5 feet) from the ground. This, in most situations, presents the audience with a perspective to which they can easily relate.

Problems can crop up, however, when you are taping subjects with an eyeline different to this 'normal' height – the most obvious example being that of children. If you hold the camera at an adult's eye-level, then you will be shooting down on them, apparently diminishing their size even further. Not only will they appear smaller on the screen, but you also will miss many facial expressions, since the top of their heads and foreheads will dominate.

Striking a balance

In stills photography, the camera angle is often the substance of the shot, the justification for the image: a single, static snapshot. The moving image, however, more closely relates to reality, and in reality we are used to seeing views, people, scenes and so on as a constantly shifting collection of viewpoints. But a constantly shifting series of camera angles will appear strange and even disturbing when viewed by an audience – even if you take care to ensure that the transitions are fluid and professionally executed.

High camera angle
This high camera position (*left*), looking steeply down at the actress, is extreme and implies a strongly dramatic situation. It is an obvious lead-in to the next shot of the person she is responding to.

Profiles
Profile shots (*right*) can be difficult. They tend to appear unnatural if held for more than a few seconds. Here the shot is used to justify a change of scene to the view outside the window.

An extreme example of this type of effect is the little-used 'subjective camera' technique. In this, the camera becomes an active character on screen and the audience sees all the action, as it were, through this character's eyes – sweeping up from a seated position to focus on a standing figure, or panning left in response to a knock on the door.

So, in general, you will produce a far more entertaining and watchable tape if you use a limited selection of well-justified camera angles. This will give not only visual variety to your production but will also leave your audience with a more rounded impression of what is going on.

Camera angles for effect

As has already been mentioned, a high camera angle looking down on somebody diminishes that person's physical presence on screen. Used intentionally, however, you can imply through this technique that the person has less authority. Conversely, a low camera angle looking up at somebody implies that that person carries more weight and is more important – somebody you should look up to. Your audience will recognize the implications of these camera angles and store the information away as part of their overall impression of the event. But don't over-egg the cake! Exaggerate these angles and the effect could well turn out to be comic rather than dramatic (unless that is the effect you want to achieve).

You can also use camera angles to open out or close down the screen space. For example, a character taken square-on to the camera in medium close-up or close-up (see pp. 64-5) can make the screen space appear flat, perhaps even two-dimensional. Angle the camera, though, so that the face is seen more in profile, and the audience is more likely to look into the shot and see the space beyond the character.

An angled face
This type of shot (*left*) appears more natural than a full profile and it can remain on screen far longer as a result. It is the usual type of head-height shot used when taping a character in conversation with somebody else. The space allowed screen-right would be filled when the camera pans back to include the other character.

Low camera angle
This shot (*right*) is partway through a tilt sequence (see pp. 50-51), which started on her feet when she noticed a puddle of water on the floor, worked its way up her body to her face, and then carried on up to the ceiling where the source of the problem could be seen.

Crossing the Line

A VITAL ASPECT OF video-making is establishing the *geography* of the shot – in other words, where people are in relation to each other and to features of and objects in the setting, the direction the action is moving in, and so on. This is something you need to be particularly aware of when shooting, but also when editing your work (see pp. 220-23), since it is all too easy to put together sequences that leave the audience confused as to the precise geography of a scene.

The line

The simplest example to illustrate the importance of maintaining a coherent geography within a scene is that of a football match, where the direction of play is vitally important to the audience's understanding of what is going on. If, in this situation, you were to have two cameras recording the match from different sides of the field and you were to cut between them, all the action from one camera would appear to be moving left to right, while all the action from the second camera would appear to be moving right to left. This is a type of continuity error known as a 'reverse cut' and it occurs because the camera is said to have 'crossed the line'.

The 'line' is an imaginary line along which the action moves or an imaginary line established by a subject's eyeline. As long as the camera cuts from shot to shot taken on only one side of this line, there is no continuity problem.

Crossing the line safely

It would be an unwarranted restriction on the freedom of movement of the camera if, having started to shoot on one side of the action, all camera positions on the other side were regarded as being off limits. But this is not the case, since there are ways you can safely cross the line without destroying the geography of the shot.

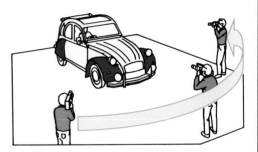

Crabbing

This is when the camera, in a continuous take, arcs across the line so that the audience can see that the direction of the line itself has changed. Although this causes no confusion, it is a long, drawn-out affair to watch on screen and thus not always appropriate. Crabbing is also, like tracking (see pp. 48-9), a difficult technique for the amateur to carry off smoothly without specialized equipment.

1

2

3

The basic error

Here you can see a car travelling towards the camera, initially filmed head-on. The first cut shows the same car being filmed from the right of the road travelling diagonally through the frame right to left. Then we see the car being filmed from the left of the road and the car is travelling diagonally left to right.

Another point to bear in mind is that the car must be further along the road in each shot – otherwise it will appear to be travelling backwards.

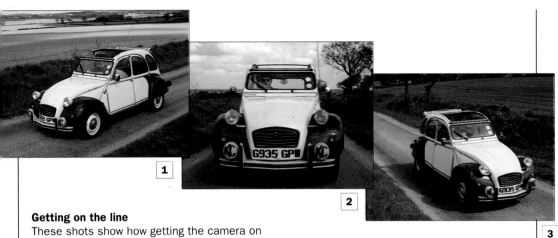

1

2

3

Getting on the line
These shots show how getting the camera on the line works. By inserting an intermediate, head-on shot taken directly on the line (*shot 2*), the apparent change of direction of the car is immediately acceptable.

1

2

3

Using cutaways
In this example you can see how a cutaway has been used to disguise the reverse cut. In the first shot, the man approaches the car while the camera films from the 'near' side of the vehicle. Next, we cut to a close-up of him inserting the key into the car door, and in the third shot we see him climbing in – although the camera is now on the 'far' side of the vehicle in relation to the first shot. Without the intermediate cutaway, the change in perspective would have been jarring.

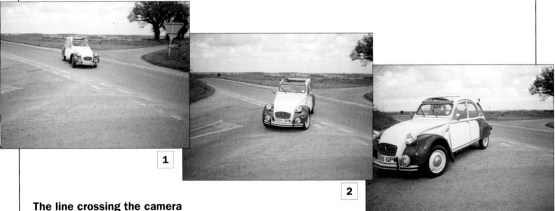

1

2

3

The line crossing the camera
One way to cross the line safely is, in fact, to allow the line to cross the camera instead. In this sequence of pictures, the camera was static as it filmed the car approaching left to right, slowing down, and then turning a corner before moving off again right to left. But because the audience can see the change of direction, and line, occurring on screen, the geography of the shot is not confused.

Reverse Shots

ONE OF THE ADVANTAGES you have when you start using a camcorder is that your audience already has in place a whole visual grammar of the moving image. But like all good grammars, this is not necessarily something you are consciously aware of – it simply sounds right or, in this case, looks right when you see it on screen.

Borrowing from the professionals
Your objective should be to give the audience an all-encompassing, more rounded perspective of a view or scene, be it a landscape, wedding, fictional drama, or whatever. You can reveal as much or as little as the production demands, but the audience needs to see it from more than a single angle. Otherwise you run the risk of producing what initially sounds like a contradiction – 'moving stills'.

In other words, video images taken from the single, static viewpoint, the same as those produced by an ordinary stills camera.

A simple professional technique used in practically every television or cinema production is the 'reverse shot'. In the first shot you see the actor, square-on to the camera, staring into the distance. In the second shot, you cut to the reverse – the camera looking past the actor taking in what the actor was looking at in the previous shot.

Because the audience assumes that a series of shots is connected in both time and space (unless there is evidence to the contrary), they will assume that shots 1 and 2 are taken in the same place and at the same time. In fact, shot 1 could be at one location and shot 2 at another two weeks later. This technique is similar to a POV (point of view) shot (see

1

Changing viewpoint
Although not strictly speaking a reverse shot, as the camera has not moved completely through 180°, this sequence (*above* and *right*) illustrates how easy it is to add visual variety and pace to your work simply by changing the camera position.

2

pp. 66-7), except that in a POV the audience assumes that it is seeing through the eyes of the character. Here the audience knows they are just alongside the character.

Although the technique sounds obvious, it is an excellent way of injecting some visual stimulation and variety into your work. You can also exploit it as a way of motivating a change of scene, cutting from one piece of action to another. For example: shot 1 head-on view of a woman on top of grassy hill staring down; shot 2 reverse shot looking past the woman down into the valley. Camera zooms in to pick out a cottage; shot 3 cut to interior shot. The audience will automatically assume that the interior belongs to the house they saw in the previous shot, whether or not it does.

Variation on a theme
For this sequence (*above*), the camera was safely mounted on a tripod and so I let the group walk past, swivelled the camera round, and continued taping them as they moved off into the distance. This type of reverse shot often makes for a better cutting point than cutting from a frontal view of people – the transition to another scene seems more logical.

The classic reverse shot
In the first shot (*above*), we see the actress square-on to the camera, staring through the bars of the gate. In the second shot (*right*), the camera is looking past her; the audience shares her viewpoint.

Directing the Action

ONCE YOUR CONFIDENCE in using the camcorder grows, you may want to adopt a more high-profile role than simply capturing moving candid sequences from the sidelines of the action. Unfortunately you may find that as soon as you point a camcorder towards somebody, they turn to wood. With children as subjects this is usually not too much of a problem (see pp. 128-35), since they will soon become absorbed in their own activities. With many adults, however, you may find that you have have to work just a little harder to get them to unfreeze for the camera.

Constant chatter
One of the tricks I have picked up and used time and time again during many years as a

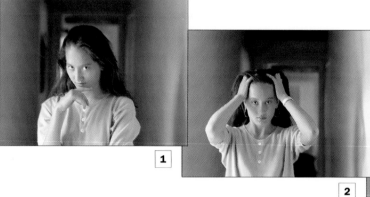

1

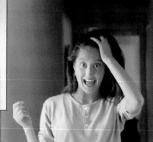

2

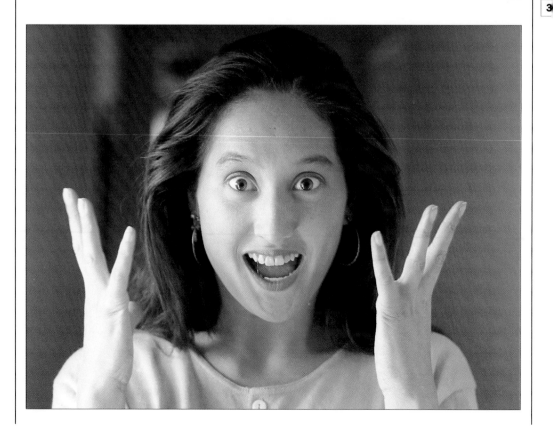

stills photographer and, more recently, as a video photographer, is the value of talking constantly to the subjects while shooting to put them at their ease. Obviously with the innovation of live sound, you don't want to end up with a soundtrack consisting entirely of you making encouraging noises. But half the battle is won as soon as you have your subjects relaxed and used to the presence of the camera. So, the time for talking is during a rehearsal of the scene you want to shoot.

A rehearsal doesn't have to be a formal, scheduled event. If you are just after good, fun pictures of family and friends, you can go through the unwinding process while pretending to tape them. Then, once they are performing happily in front of the camera, grab your footage. One thing in

your favour with video is that you can always promise to let your subjects view the tape immediately after shooting and censor any bits they really can't bear to let other people see.

If it helps, place the camera on a tripod (see pp. 26-7). This way you will have both hands free to gesture with and generally carry on your task of directing the action while the tape rolls.

In essence, the process described here is much the same as that carried out by a director. Artistically, this person's role is to draw out from the actors the range of emotional content appropriate to the script and to ensure that what ends up on tape captures the spirit of what the scriptwriter intended. The same techniques work just as well for unscripted family videos.

4

5

6

The moment is right
If a shoot is going well, capture on tape as much, and as varied an amount, as you can. Afterwards, you might want to edit the tape down (see pp. 220-23) if you are working within the confines of a script. Any of these frames here, for example, would make ideal reaction cutaway shots if you didn't want to use them as part of main action sequences. Alternatively, shots like these make ideal family video album pictures. They are great fun to record and will bring you immense pleasure through the years.

Continuity

CONTINUITY HAS TO DO with maintaining the illusion of reality: the audience should not be forced to question the feasibility or logic of what they are watching. Paying close attention to continuity is thus an important aspect of manipulating audience reaction.

Types of continuity error

The first type of continuity error to bear in mind is continuity of action. If, for example, you were taping a sporting event such as a motor bike race and you made the mistake of crossing the line (see pp. 70-71), in order grab some additional footage from the other side of the track, then the result could be disastrous.

Another common continuity error has to do with the mood of the scene. If you were taping a group of people having a meal at a restaurant where the general atmosphere was obviously convivial and relaxed, but you used a cutaway of one of the characters looking despondent, then this would be a mismatched cutaway, and a definite continuity error as well, unless something within the previous shot justified that character's expression.

You are probably more aware of the other types of continuity error because they sometimes occur even in professional productions on television or at the movies. This type of error concerns props, such as ornaments in a room, or actors' clothing or articles of personal property – a pen or cigarette lighter. Continuity problems can occur when these seem to change from one scene to another. For example, in scene 1 the audience can see a vase of blue flowers slightly out of focus in the background behind one of the characters. After a few minutes of parallel screen action we cut back to that character framed in the same way only to find that the blue flowers are now lilac or, worse still,

Time shown on clock

Hair parting

Make-up – colour of eye shadow and lipstick

Scarf — colour and how tied

Door closed

Bracelet on wrist

Number and position of cups, etc on tray

Position of telephone and cord

Closed book

completely missing. This usually occurs because some time – prehaps days or even weeks – may have elapsed between the shooting of the two scenes.

Avoiding errors

Unless you pay scrupulous attention to details such as the ones mentioned above, continuity errors are bound to occur. Since most errors occur because of the time delay between shots, it is important that you make a careful list of exactly what props are visible, and where, on the set, or what personal possessions are visible about the characters themselves, before finishing a taping session. You can then use this list when taking up that piece of action on another day. Better still, take a Polaroid picture of the set and the characters in situ and use that as your reference.

If shooting is breaking for, say, just an hour for lunch, then make sure nobody is allowed to touch the set unless they are conscious of the need not to disturb anything. But you will still need to ensure that one of your characters has not rolled his sleeves up or removed his watch during the lunch break, or you will have yet another type of continuity error on your hands.

Is it an error?

You do not need to show the audience every transition, no matter how slight, of every character in order to avoid making a continuity error. This could become extremely tedious viewing, since much depends on the action and what we know of the characters themselves.

Take a video of a car accident as an example. Two cars have collided and a woman scrambles out of the back seat of one of them wearing a coat and clutching a briefcase. The next scene is parallel action of passers-by running towards the scene of the accident, cut-ins of people hurt inside the wrecks or being helped away because of the danger of fire. It would not be unreasonable if, when we next saw the first woman, now standing on the side of the road watching anxiously, she had put the briefcase down and was holding her coat over her arm. Sufficient time has passed and the circumstances justify her changed attire. This is not regarded as a continuity error.

Possible continuity errors
This picture is full of details that could become continuity errors if shooting took place over an extended period. In a set such as this, you must make a careful note of the exact position and condition of every item every time shooting is interrupted, or, take a Polaroid picture.

Cupboard doors and drawers closed

Position and type of props on counter tops, tops of cupboards, etc

Flowers - type, colour, condition

Type and position of fruit in bowl

Blue pen on paper

Chairs pushed close to table

LIGHTING STYLES AND TECHNIQUES

Lighting, and the ability to manipulate it to good effect, is one of the keys to successful video-making. This chapter looks at a range of lighting effects and at the moods that different types of lighting evoke.

Silhouettes and Backlighting

MANY CAMCORDER USERS assume that the function of light (natural or artificial) is to reveal the subject with as much clarity and detail as possible. This is not always the case. In fact, once most subject detail – texture, tone, pattern and colour – is stripped away, what you are left with is shape; and shape can be a very powerful visual device indeed. In its most extreme form, when literally all subject surface detail is omitted, what you have left is a silhouette. Perhaps the easiest way to concentrate on the shape of the subject is through a technique known as backlighting, or *contre-jour*.

Exposure

All modern camcorders have automatic exposure, a system that measures the light coming in through the lens and falling on the charge-coupled device (CCD), which then alters the amount of video signal passing to the tape to produce a 'well-exposed' image (see pp. 38-9). Also, somewhere on the camera you will probably have a back-light-compensation button, which is designed to open the iris in the lens a little wider (and hence allow more light to enter) when subjects are positioned with the sun behind them. This is because if the sun is behind the subject, then the side facing the lens will be

Sunset
The setting sun, here in the outback of Australia, often throws up a striking backcloth of colours (*above*). Once below the horizon it will silhouette anything positioned between the sky and the lens.

Dusk
There is a short period following sunset when there is still sufficient light to capture this type of shape-dominated imagery (*above*). It doesn't last long, however, so you need to react quickly.

Simple background
The figure of Christ overlooking Rio (*above*) is unmistakable, even though no detail can be seen. Shape, as this image demonstrates, can be a very powerful communicator.

Silhouette and form
Looking like a set from Death on the Nile, these ancient ruins at Karnak, Egypt (*above*), form a fascinating montage of light and shade. This is from the end of a very slow tilt, where the camera starts off focused on a solitary figure standing amongst the columns.

Perspective
There is no detail at all in the silhouettes of these two young boys in Thailand (*above*). And by anchoring the foreground so firmly, they help to emphasize the strong linear perspective and three-dimensionality of the composition.

in shadow. But if you don't use the back-light-compensation button, then everything in shadow will be underexposed.

If, however, the subject is large in relation to the rest of the frame, your camera's automatic-exposure system will probably take the shadow area of the subject into account and allow more light in to produce a well-detailed image. On the few camcorders with full f-stop control (see pp. 40-41), you can overcome this by first pointing the camera at a bright area of the scene for a few seconds (the sky, for example) so that the aperture stops down, and then turning the automatic-exposure system to manual. This should freeze the aperture that the system last selected. Next, recompose the scene and shoot.

On most camcorders, however, the method described above will not work because you cannot disable the auto-exposure facility. Instead, you will need to arrange the scene so that the subject you

want silhouetted is not too large in the frame, either by zooming back or adopting a more distant camera position. Alternatively, if your camcorder's autoexposure system favours anything positioned centre frame (as most do), then make sure your subject is well off to one side. All camcorders vary, however, and if your user's manual does not give you sufficient information on the subject, you will have to do some experimenting.

One word of warning is called for here. If the light is behind the subject, then you need to ensure that its source – the sun or an artificial light – is not shining directly into the camera lens. This will cause a large amount of image-degrading flare. If you position yourself correctly, often you can use the subject itself to shield the lens. If this is not possible, lens hood attachments are available and have some limited application, or you may even be able just to hold up your free hand to cast a little shade over the lens.

Studio set-up
To light a set for a silhouette (*right*) you need a plain, probably neutral-coloured backdrop evenly lit close in but taking care there are no 'hot spots' – bright reflections. Next position your subject between the backdrop and the camera, far enough away from the lights so that no illumination reflects back and thus spoils the high-contrast set-up you have created.

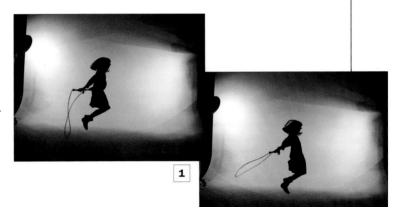

1

2

Optical illusion
Although this is obviously not a silhouette, at least not in the traditional sense of the word, the starkness of the clown's costume against the drabness of the canvas back-ground (*above*) lulls the eye into failing to notice what detail is present in the scene.

Domestic lighting
Even a single domestic light strategically placed can produce a striking silhouette (*above*). The characters in this scene are in fact a pearly king and queen, who are normally lit to show to full advantage their overdecorated and very elaborate costumes.

Morning mist
The light mist common to early mornings, before the warmth of the day has had a chance to burn it off, is a great subduer of subject detail (*above*). Often scenes shot at this time of day take on a soft, muted quality, ideal for imagery with a roman-tic or delicate subject.

Using Existing Light

Most video users rely solely on available, or existing, light. Indeed, modern lenses and video cameras are so sensitive that you can often successfully tape in rooms brightly lit with normal domestic bulbs.

Grain and smearing
In rooms illuminated by central ceiling lights, however, you need to be careful of heavy toplighting, which will throw dense shadows on to the faces of your subjects, as well as giving the image a grainy, broken appearance. This results from the high level of video gain needed when light levels are low. When the CCD (charge-coupled device – see pp. 18-19) determines that underexposure is likely, the camera's automatic gain control cuts in to boost the video signal being output to the tape. Gain is basically the electrical amplification of the signal. As well as boosting the image-forming information, however, any imperfections and general electrical 'noise' are also amplified. Hence the distinctive grainy appearance of the image.

Ceiling lights combined with side lights usually produce a more pleasing effect, but you need to make sure then that you do not include any bare bulbs in shot. To a lesser or greater degree, all camcorders suffer from 'smearing' when bright light sources are visible in generally low-light situations. This is the vertical blurring of highlights, both above and below the light source. You sometimes see this even on professional video productions on television when the headlights of a car sweep across the screen catching the lens full on, or there is a bright explosion at night. Modern camcorders using CCDs have completely eliminated the visual defect known as 'comet tails', caused by the persistence of the signal on old-fashioned video tubes, but vertical smearing remains a problem at present on many models.

Existing light for effect
You should continually be looking to pick up on existing lighting effects all around you, using them to brighten and heighten the visual impact of your production. Dappled sun-light filtering through overhanging trees, the graphic play of light and shade of daylight through railings, the delicate tracery of light streaming into a room through lace curtains, shafts of daylight thrusting through a partially open door: the possibilities are endless.

On these two pages I have included a selection of these types of chance situations. To have set up the same lighting effects using artificial illumination would have required tremendous amounts of equipment and personnel and have been prohibitively expensive as a result.

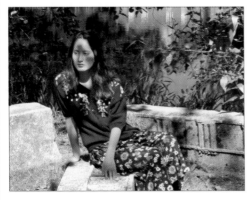

Dappled sunlight
This effect (*above*) was created by sunlight filtering through the leaves of an overhanging tree. As the wind gently stirred the leaves, there was a continuous dappling of the shadows on the actress's face, alternately revealing and obscuring her features.

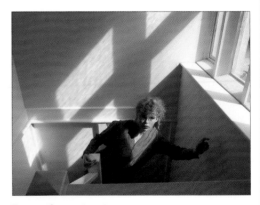

Dramatic contrast
With the camera set up at the top of the stairs (*above*), the steepened perspective immediately adds a little drama. Link this with the high-contrast lighting and starkly defined areas of light and shade and you have the perfect lighting scheme for the action about to unfold.

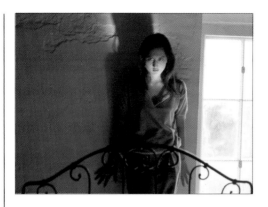
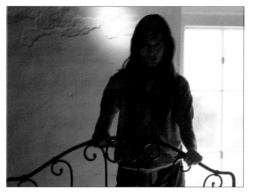

Artistic licence

When needs must, you might have to help a natural effect along just a bit. In the first shot (*above*) with the actress directly adjacent to the only light source in this bedroom scene – the window – her face was entirely in deep shadow. To overcome this problem, I used a mirror to reflect some of the available daylight on to her face, almost like a spotlight. In this next shot from the same sequence (*above*) the actress has moved forwards out of the beam of light. Her face is now lost in shadow, a fact that aids the dramatic content of the scene. She is now moving forwards to confront the situation as yet unrevealed by the camera.

Manipulating mood

Both of these examples were taken in the same location and at the same time, but it is interesting how subtle differences in light quality trigger different reactions in the audience.

In the first shot (*top left*), the actress is evenly and softly lit by light diffused through the tree canopy above. The lighting is almost intimate and certainly romantic. The slight green cast is not a problem as it would be with stills photography, since the audience is well used to this type of effect in the moving image from their experience of film and television productions.

In the next shot (*bottom left*), simply positioning her so that a shadow crosses her face, causes the mood to take on a slight edge.

Lighting Effects

Lighting is much more than simply recording a fully detailed, descriptive image. It is, above all, the great determiner of mood and atmosphere. Appropriate lighting – artificial or natural – can be used to indicate heat or cold, openness or secretiveness, happiness or sadness, furtiveness or candour, and many other shades of emotion.

In order to obtain the best possible images, you need to be familiar with all the techniques of placing lights, or working with daylight.

Lighting contrast

This commonly used term describes the difference in lighting levels, or lighting ratio, between the brightest highlight and the

MANIPULATING THE RULES

One often-exploited lighting cliché is that high contrast equates to high drama; flat, low-contrast lighting, on the other hand, is subconsciously recognized by the audience as representing a truthful or factual (i.e. non-dramatic) approach to a subject, such as you would expect in an interview or documentary piece (see pp.188-9). With this in mind, you could decide to light a piece of pure fiction using this flat-lighting technique to imply that what you are portraying contains an element of truth. Manipulating audience reactions is all part of the craft of video-making.

High-key lighting

This lighting style (*right*) aims to produce an image where there are virtually no dark tones at all. To achieve this effect you need to flood your subject with light (or use an exposure lock facility, if available, taking a shadow reading from your subject). Note how the intensity of the light behind the actress seems almost to eat into her form, making her appear somehow less solid.

Low-key lighting

As its name implies, low-key lighting (*left*) is the opposite of high-key lighting (see *above*). The aim here is to produce an image where dark tones dominate. To do this, light must be restricted or, if possible, you need to take a highlight reading and lock this setting into the camera. This lighting scheme appears sombre, thoughtful, or brooding.

deepest shadow in the same shot. If the difference between highlight and shadow is too great, and even if the video tape is able to record detail in both, your camcorder's auto-exposure system will make a decision to expose either for detail in the shadow areas of the scene, at the expense of the highlight detail, or to expose for the highlights at the expense of the shadow detail.

But how can you know what 'decision' your camcorder will make? The way your particular camcorder will react in such a high-contrast lighting situation is a design feature of the system determined by the manufacturer. Almost certainly, this type of information will be considered 'not relevant' or 'too technical' for the user and so will not be included in your camera's manual. This leaves you with no choice other than to experiment by trial and error. First, set up or seek out a scene containing both dense shadows and bright highlights adjacent to each other. Next, shoot that scene and, finally, study the results carefully.

Simple backlighting
In this shot (right) the strongest lighting is coming from behind the actress and her face has been left largely unlit. This lighting style gives her a distinctly sultry, 'come-hither' appearance.

Backlighting and fill-in
In this version (below) white cardboard reflectors were placed just out of shot on either side of the actress's face in order to bounce some illumination into the shadows. The impression is now more innocent, more romantic.

Overlighting
In an attempt to bring out full detail in the set as well as on the actress (*above*), large mirrors were used as reflectors instead of the cardboard types in the previous example. You can see that although the scene is now a little overlit, the overall impression is one of very strong sunlight and heat.

Cross lighting
With a single light source placed to one side, you achieve an effect known as cross lighting (*above*). If the shadow side of the face is then too heavy, you can use a reflector or a second, low-power light to reduce contrast slightly. This style of lighting is often employed to imply an air of menace or furtiveness.

Soft uplighting
Here (*right*) the floodlight used to light the face has been heavily diffused to produce a soft effect. But the light is also slightly below the actress's eyeline. With the light positioned like this you need to be careful you don't accidentally create a 'shock-horror' impression. If the audience has previously seen some reason for the light to be coming from this direction –a fire burning in the grate, for example – then it will be accepted as natural.

A minority of camcorders have an exposure-lock facility. This allows you to fill the frame with the part of the subject in which you want detail accurately recorded and lock that exposure value into the system. You can then recompose your shot, bringing in new highlights or shadows as you wish, knowing that your locked setting will still determine the overall exposure of the shot.

But even if your camcorder does not have an exposure lock, this will often not matter. If, for example, you know that your camera is likely to expose for the highlighted side of a room near the window, you can use the dense shadows farthest away from the window as the location for an unexplained noise or the area from which somebody creeps into the light.

Reducing lighting contrast
If high contrast is not the effect you want, however, then you must either make the highlights less bright or the shadows less dense. If your main light source is daylight through a window, for example, you could hang a piece of lightweight net curtaining over the glass. This will diffuse the light, making it less directional and thus less contrasty. To make shadows less dense, you can either introduce another light source or use reflectors to bounce some of the light coming in through the window into the shadows.

Reflectors can also be used when you are shooting outdoors. Often, one side of a face will be lost in shadow, which can look amateurish on screen. If you feel that using reflectors will spoil the spontaneity of an

Three-point lighting

Three-point lighting is a technique that evolved in Hollywood during the 1930s. 40s and 50s. To replicate it, first position a spotlight behind and above the subject's head. This separates the figure from the background and bathes the hair and shoulders in a halo of light. Next, place your main frontal lighting unit at about a 45° angle to the subject and about 2 metres (7 feet) above the ground. Finally, use a fill-in flood (or diffuser) on the other side of the face, again at about 45°, to lighten any shadows created by the first frontal light.

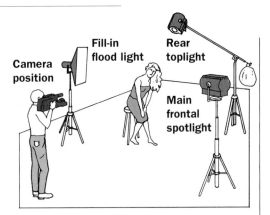

outdoor scene, try to position the action near a light-coloured wall. Then light reflecting back from the wall should be sufficient to take the edge off the contrast.

Reflectors don't need to be complicated pieces of equipment. One of the most usual devices is simply a large piece of white cardboard. This produces a good, soft, bounced illumination. If you want a more hard-edged reflected light, cover the cardboard with kitchen foil.

Lighting the subject

In terms of lighting, your chief concern is usually the overall illumination levels of the area within which you are shooting. Working indoors, for example, you will need to ensure that ambient light levels are not so low that there are unwanted pockets of deep shadow visible in shot, or that sunlight from a window (or illumination from a lighting unit) is not reflecting back from, say, a mirror or glass door and causing unwanted and distracting highlights.

Once you have adjusted lighting levels so that you have achieved the general effect you want, characters can move about freely without you being overly concerned that at any particular point, if the action were to be frozen, they might not be perfectly lit themselves. Unless the character is in critical close-up or mid-shot, the audience will not notice. It is, however, in close-up and mid-shot that you will need to pay very careful attention to the finer points of lighting style and technique.

Light and Shade

THERE IS A TENDENCY among many amateur video photographers to arrange their subjects so that they are lit frontally. Perhaps this is a carry-over from stills photography, where many books recommend, quite falsely, that you should *always* stand with the sun at your back to take a photograph. The idea behind this advice is that the sun will then not cast unwanted shadows on your subject.

Such sweeping generalizations are, by their very nature, wrong as often as they are right. Rather than something to be avoided, shadows (in other words, the play of light and shade) are great providers of depth and distance, of texture, of form and shape. They are, in fact, often central to the mood and atmosphere of the shot. In contrast, frontally lit subjects can appear extremely flat and two-dimensional, and often lacking in interest as a result.

Artificial light

This tendency to frontally light subjects carries over into video photography with artificial light, too. This is photographic tungsten light provided specifically for the camera – not existing, domestic indoor lighting.

The compactness and ease of use of modern camcorders has much to do with their mushrooming popularity. And rather than diminish their portability, many photographers use a single, high-powered tungsten light mounted directly above the camera

Changeable light

Don't fall into the trap of thinking that rapidly changing lighting conditions are something to be avoided. Certainly, solid overcast produces a constant light, but one of such low contrast that often you need to supplement it artificially using a video light to introduce a little sparkle (*left*). Bear in mind, however, that the average lighting unit is not particularly powerful, and so can be used to good effect only on relatively near subjects.

Dappled light

Often the most interesting natural lighting effects come from a bright, blue sky with fast-moving clouds travelling across the sun. The alternating light and shade can be fascinating. A similar lighting effect can be achieved by positioning your subject under overhanging leaves (*right*) and allowing the wind to blow the foliage through the sun's rays.

when working outdoors at night or indoors in low-light situations. This lighting arrangement does give the camcorder its neatest physical profile, but it also carries with it all the problems associated with using frontal daylight as the sole source of illumination.

To counter the flatness of a single light source, if possible try to enlist the help of an assistant to hold a secondary video light off to one side of the subject. The light on the camera can then act as the principal illumination, while the other can be of lower output. This will lighten the shadows cast by the main light and also produce more form-revealing graduation of light through to shade.

Directionless light

In the first shot (*top*), taken indoors on a dull day, it is not just the low light levels that are causing a problem – the light is also so diffused as to be directionless. This is much the same problem you will encounter outdoors in dull, overcast conditions.

As you can see in the second shot (*above*), the problems were relatively easy to solve. To add the sparkle, I simply moved the subject a few feet to one side to bring the faint highlight from the window into shot. This introduced

that all-important lighting contrast. And then to bring the girl's face out of the gloom and inject some more life into the scene, I used a heavily diffused photoflood positioned to the left of the camcorder.

Trial and error is about the only way to discover the best type of light to use for fill-in work, especially if you want to use a camera-mounted unit. It will, however, have to be at least 100 watts and, if mains power is not available, you will need a 12v shoulder-slung battery pack.

Lighting and Lighting Accessories

MODERN CAMCORDERS are capable of producing an image under the most unfavourable of lighting conditions – some even by the light of a single candle. However, the correctness of colour and image definition will be degraded in comparison with the normal, well-lit presentation. Although good for atmosphere, some added lighting will invariably produce a better tape.

Shooting outdoors

In many scenes shot outdoors, lighting levels should not represent a problem, especially if the scene is being illuminated by daylight from an open sky with the sun itself nowhere in shot. This type of lighting is reasonably non-directional and soft, which means that contrast levels, the difference between the brightest highlights and deepest shadows, are not too great for the camcorder to deal with at a single exposure setting. If, however, contrast is too great, the autoexposure system may set itself for either the shadows or the highlights, with the result being that detail in the other area is lost.

If you are aware of this potential problem, one of the most useful lighting accessories you can carry with you is a reflector. This can be as basic as a piece of white cardboard or reflective material that you unfold and position (out of shot) on the shadow side of the subject. Light then strikes it and reflects into the shadow, thus reducing contrast levels.

Nearly all camcorders have an accessory shoe positioned on top, in which you can mount a portable, battery-powered light. This is particularly useful when working reasonably close to a subject on a dull, overcast day or towards dusk, since both conditions produce very flat, uninteresting contrast. There are problems with this type of lighting arrangement, however. First, it produces an intense, but generally short-range, beam of light, making it unsuitable for more distant subjects. The working distance of these lights depends on their wattage and this should be stated in the manufacturer's literature accompanying them.

Second, frontal lighting coming directly from the camera position is nearly always harsh and unflattering to the subject. And, third, the camcorder's autoexposure system may give undue emphasis to the artificially lit area and close the iris down to such a degree

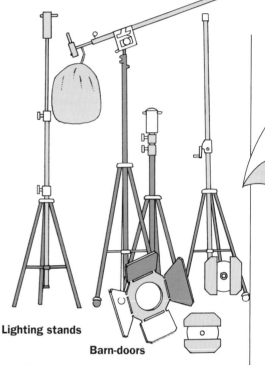

Lighting stands

Barn-doors

that the rest of the scene is massively underexposed.

You cannot do much about the working distance of your light, but you can moderate the other two problems by diffusing the light slightly – perhaps by placing one or two folds of a handkerchief over the light. Make sure though that the light does not produce so much heat that fire becomes a risk.

Shooting indoors

Apart from light levels being generally low indoors, the same problems of contrast also exist. If your predominant light source is, say, window light, then anything placed near the window will be brightly lit, while objects away from the window, towards the rear or sides of the room, could be in deep shadow.

To help alleviate this problem, again reflectors could be a partial solution, especially if your subject is quite small and takes up a large part of the frame. However, in most cases, light levels indoors will need boosting artificially.

For candid work, informal impromptu shots when you could be walking from room to room, you could rely on normal room lighting, which will probably be either tungsten or fluorescent. If, as in many rooms, the main light is ceiling-hung, then you will find that unattractive top shadows are evident in all

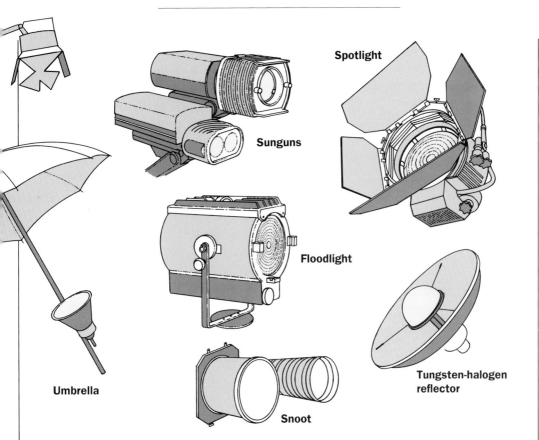

Spotlight

Sunguns

Floodlight

Tungsten-halogen
reflector

Umbrella

Snoot

your footage, and this is a particular problem when shooting faces. If possible, turn on any sidelights that may be there as well – but you will need to take care not to include the light bulbs themselves in shot.

In rooms where there is a mixture of tungsten and fluorescent (and perhaps daylight as well from windows), the white-balance control on your camcorder may have trouble coping with the different colour temperatures present, and colour casts are likely as a result. In such circumstances, you may be better off to rely on a camera-mounted 'sungun' type light and simply put up with the unattractive frontal lighting produced.

Fixed lighting

For more structured video productions – interviews, dramas, plays – you have the op-portunity of using high-output, mains-powered, fixed lighting units, such as spotlights and floodlights. If hiring or buying these units, read the literature or talk to the sales assistant to ensure that all the lights are operating at the same colour temperature. Other-wise, the colour casts that were evident when using mixed domestic lighting will occur once more.

A floodlight, as its name implies, literally floods a large area with a reasonably soft illumination. This is achieved by mounting the bulb in a large, polished-metal reflector. Reflectors of different dimensions are available to alter the spread of light. A spotlight, on the other hand, comes in a sealed unit with a lens in front, and is generally used to highlight a very defined area, such as the side of a face. The lens should be adjustable to allow beam width and intensity to be varied.

These two basic lighting units are capable, however, of producing a wide range of lighting effects when used with various accessories. The one you may be most familiar with is a brolly reflector – an umbrella made of highly reflective material that can be mounted so that a light shines directly into it before reaching the subject. This produces a very even, soft, romantic type of lighting.

Other light-modifying accessories include snoots and barn doors. A snoot is a hollow conical attachment that fits over the front of the light to produce an extremely narrow beam. Barn doors are simply hinged flaps, four in number, that fit around the outside of a light. Each flap can be independently brought into the light beam to effect very subtle graduations of light and shade. They are also invaluable when, for example, you have a floodlight positioned adjacent to the camera. Without the barn doors, light may spill out directly into the lens, causing image-degrading flaring.

SPECIAL EFFECTS

Special effects have many applications in video-making: they can be used to add realism to your production, by simulating weather conditions such as rain or snow or creating believable backdrops, or to conjure up fantasy worlds and allow you to give full rein to your imagination. This chapter looks at some of the most common special effects and shows how to achieve them.

Fire, Heat and Explosions

UNLESS MONEY IS NO OBJECT – an unlikely state of affairs even for professional film makers – then you should limit the type of special effects you attempt to those that have the greatest likelihood of being believable. An all-action chase scene, such as the classic car chase from *The French Connection*, relies on a team of highly professional stunt drivers, stunt co-ordinators, special camera teams and lighting crews, plus a fleet of cars to be demolished, all for the sake of a few minutes' screen time.

But special effects do not necessarily have to be dramatic to have impact. Attention to detail,

Explosions

As dangerous as this shot (*above*) looks, at no time was the rider within many yards of the actual flames. The trick here is to film the rider coming head-on to the camera with the lens extended to its maximum zoom setting. With the lens at telephoto, the planes of perspective are steeply compressed, which means that objects in the background (the fire) appear to be larger in relation to foreground objects (the rider) than is normally the case. Timing was critical, however. The fire was courtesy of a couple of hay bales soaked in paraffin and then torched. As they exploded into flame I captured the rider coming into shot off the end of a low ramp that he used to get the bike into the air. Just out of shot were fire hoses and fire extinguishers ready to douse the flames if they appeared to be getting out of control.

while not perhaps even being consciously picked up on by the audience, helps to build the illusion that the action filmed has an element of reality to it. For the experimental videomaker, this is the undeniable challenge of the medium, as well as being a large part of the enjoyment of embarking on the work in the first place.

In this chapter you will be introduced to a wide range of special effects that, if carried off with care, can make a very positive contribution to your work. None of them will involve you in tremendous expense, except perhaps in terms of your time in either setting the equipment properly or in finding the best location (see pp. 112-15) to stage the action.

These two pages look at using fire, heat and explosions. Whenever you are using inflammable material, or asking other people to work in close proximity to it, you need to exercise extreme caution to ensure that nothing can go wrong. Although you are working as an amateur, your attitude to personal safety should always be at the highest professional level.

Heat haze

This type of special effect falls very much into the category of reality-building. If you are taping a scene that is supposedly taking place somewhere hot, then you can signal this to your audience by including a few seconds' worth of heat haze as, in the example here. In the first shot (*right*) you can see how the scene would look if taped straight. There is nothing wrong with it, and the fact that the woman is wearing only light underwear and a flimsy wrap should by itself say something about the weather.

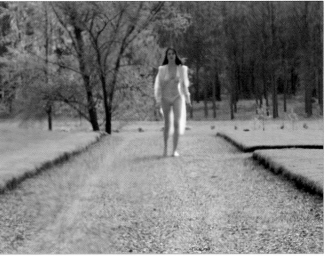

However, you can see in the 'after' shot (*right*) that the shimmering of the air in front of the lens adds dramatically to the impact of the shot. Unfortunately, to obtain the best from this effect you need to see the air actually shimmer, something that is impossible to impart in a book.

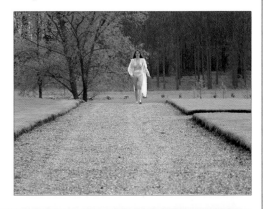

And finally, in the third image (*right*) you can see the simple set-up that was used to create the heat haze – an ordinary portable camping stove. By taping through the heat rising from the flame you can create a whole range of different strengths of shimmer either by regulating the strength of the flame itself or by adjusting the wind shields at the sides – the more upright the shields, the more they concentrate the heat and, thus, the greater the effect.

Manipulating the Weather

WHEN IT COMES to shooting a video, your main concern is usually the weather and whether or not the sun will be shining tomorrow. Having gathered together helpers, actors, actresses, equipment and so on, the last thing you want is to spend a miserable day huddled in the back of a van waiting for the rain to stop falling, the mist to clear or the wind to die down sufficiently so that you can make yourselves heard. If, however, the storyline you have developed (see pp. 110-11) actually calls for snow, mist,

smoke or rain, there is every reason to believe that the sun will shine all day long and visibility will be perfect all the way to the horizon.

Having gone to all the bother and expense of organizing a day's shoot, you cannot afford to be totally at the mercy of the elements. But you do need to know what you can and what you cannot achieve in terms of manipulating the weather.

Certainly, if you need sunshine and blue skies and on the day of filming the worst

Snow and mist

With some special effects, such as fake snow, the trick is not to be too ambitious. Try to arrange your camera angles so that the lens takes in only a restricted area of terrain. Slightly high camera angles, with the lens looking down, will help to concentrate audience attention on a small area only. Low camera angles can also be useful if, for example, they take in only the ridge line of a hill in the immediate foreground. Fake snow, usually ground-up polystyrene, is available by the bag and, at a distance, looks extremely convincing when scattered lightly over the ground. You can also use ground-up polystyrene to simulate falling snow, but this looks best when blown slightly in a breeze or by a fan machine (see p. 99).

Snow effects are often coupled with mist. Apart from adding atmosphere, a good mist will also obscure a too-obviously summer's sky or a deciduous tree in full leaf when it should be bare – two factors that are potential spoilers of your carefully worked illusion. Mist is not difficult to make to order – solid carbon dioxide (commonly known as 'dry ice') is simply mixed with water. You can do this yourself in a large plastic bowl or hire a special mist generator, which uses the same principle but in a more controlled way.

A winter's day

In these three shots you can see how a pleasant summer's day was transformed, for an hour or two, into winter. The first image (*top right*) shows an area of grass partially covered with fake snow. The giveaways here, however, are the tree in full leaf and the sunny scenes that can just be glimpsed beyond the tree. As you can see in the second and third shots (*centre* and *bottom right*), the introduction of a heavy mist has helped immeasurably in disguising the cheat.

storm in five years hits your location, then either you pack your bags and go home or else you indulge in some last-minute creative script rewriting. But a light covering of snow, or any of the other adverse conditions already mentioned here, can be conjured up with relative ease.

Some weather conditions can be mocked up with relatively simple equipment that you might have around the home. Others are more tricky. The movie business, including television, relies heavily on being able to produce 'weather' to order, and so an entire industry of special effects gadgetry has come into being. By looking through the telephone book or reading the small advertisements found in the back of many film and video magazines, you should be able to organize the rental of everything you need at quite reasonable cost.

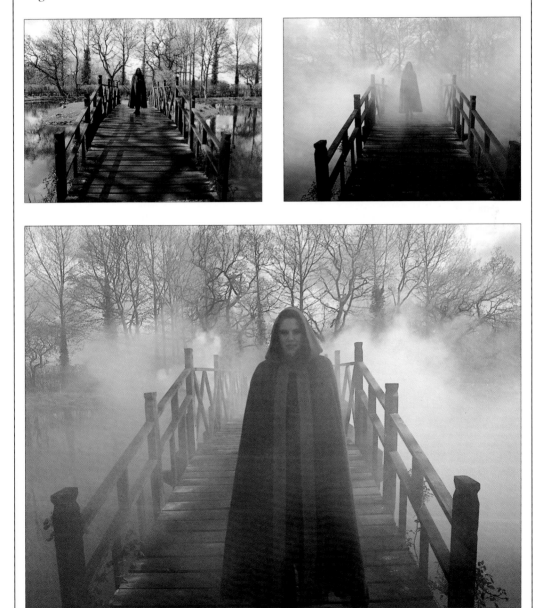

The importance of shape
These three frames are from a different scene in the same production. Here you see the caped actress walking towards the camera across a wooden foot bridge. The first shot (*top left*) has been included as the 'before' image, so that you can see the level of transformation possible. Note, however, that as the mist starts to obscure general detail in the scene (*top right* and *above*), those shapes that are apparent become far more powerful visual elements.

Smoke

If the area you need to show on screen is large, or the density of mist very high, then you may have to use smoke-producing special effects rather than simply dry ice. Smoke machines, like the one shown right, are readily available for hire. They come with full written instructions, which you must read and follow carefully. Consult the store about the quantities of both cylinders of chemical you will require for the amount of smoke you need to produce. If in doubt, buy extra.

Smoke bombs are also a useful idea. These look a little like large fireworks, which you push firmly into the ground and then light. Different types burn for different lengths of time, but five minutes is about average. Of course, if you are filming outdoors, and you take all necessary safety precautions, then you can always make smoke from a real fire. Once the blaze is well alight, the more green material you add, the more smoke you will produce.

Smoke machine

Finally, there is what is known as a fog generator. This device uses an electric element to heat a small amount of oil. The smoke given out is very authentic, but the smell is none too pleasant.

When using a smoke machine, smoke bombs or fog generator bear in mind that too much wind will disperse the smoke too rapidly and that too little wind will cause the smoke to hang unnaturally in the air.

Keep an eye on the wind
In the first shot (*top left*), the scene with the actress in front of the ruined, arched cellar support of an old house is not particularly atmospheric. In the bright sunshine we can all clearly see that nothing is amiss. However, with the inclusion of smoke, produced by three smoke bombs, (*top right*), there is now a distinct feeling that she is right to be frightened.

The genuine article
There is nothing mysterious at all going on in this scene. If you look closely at the right-hand side of the first frame (*bottom left*), however, you can see part of a house beyond the wall. To obscure it, I built a small bonfire to the left of and behind the camera. As the smoke blew across the frame, the house simply disappeared (*bottom right*).

Wind effects

Another aspect of the weather you can create to good video effect if the genuine article fails to materialize on cue is the wind. As with many of the special effects discussed so far in this chapter, wind effects can be very convincing if you are not too ambitious in what you are trying to achieve. For example, a relatively small fan placed close to an actor will noticeably ruffle his or her clothes and hair. But the type of clothing worn by the actor is important here – lightweight garments will react more readily to the slightest breeze, accentuating the effect from even a very small fan unit.

When deciding on shot types (see pp. 64-5), my advice is to stay in close-ups and mid-shots and to avoid long shots. In this way the camera will ensure that the effect is easily visible to the audience and there is less chance of the lens picking up some other aspect of the environment that should, theoretically, also be being blown about by the wind. The classic error I have seen numerous times when watching B-movies on television is a shot of the 'victim' running down a forest path with her clothes being blown against her body by what appears to be a strong head wind. All around her, however, the trees are at rest and the autumnal fall of leaves on either side of the path are perfectly still.

Wind machines

In this image (*above*) you can see a small portable wind machine attached firmly to a supporting ladder. This size of machine is readily available for hire but you will need a mains power supply. It is also quite noisy in operation, which makes the recording of live sound difficult, even when using a directional microphone (see pp. 28-9).

In practice

When the shot is set up correctly (*below*), you can see just how believable small-scale wind effects can be. Note that this shot is framed in mid-shot and that there is nothing moveable in the background or on the periphery of the frame that gives the cheat away.

Rain effects

Creating rain is probably one of the most convincing of all the special effects the amateur can try. If you are taping indoors and want the impression of rain falling outside, then all you need do is direct water from a hose on to the glass window panes. Make sure, of course, that the hose itself is not visible at any time through the glass. To simulate the effect of real rain, the source of the water should be above the window area. If the window is wide then you will need to ensure that the water coverage is even right across the glass.

Working outdoors is really not very much more difficult, except that you will have to choose your camera angles carefully so that at no time does the effect become transparently a cheat. On big-production movies, widescale rain effects are sometimes created using high-pressure fire hoses. When a series of these are all turned to fine spray and pointed upwards, it can appear to be 'raining' over quite a sizeable area. This gives the camera far more flexibility in terms of movement and angle. Scaled down somewhat, you should still be able to achieve excellent results with the minimum of equipment such as an ordinary garden hose.

The first step

The first thing you need to do is thoroughly wet all the area of ground that will be visible when you start taping. On this uneven, roughly made road (*above*), the potholes have filled up nicely with water to make puddles. But even the grassy areas had to be watered because grass, and all foliage, tends to look darker, more saturated in colour, when wet. Another point is that the strong backlighting is likely to catch the water droplets lying on the grass, creating highlights corresponding to those that will be seen when the 'rain' starts to fall.

Drizzle

For these two shots (*left* and *below*) you can see the rain, first, just starting – big drops and irregular coverage – and then, second, settling down into a light rain, or drizzle. For both of these, an ordinary garden hose was used. The adjustable jet control was removed because it didn't produce the right coverage of spray. A better option turned out to be simply holding a finger over the top of the hose and then shaking the hose up and down to give a slight drifting effect.

Bringing pressure to bear

For this series of images of heavy rain I used a car pressure washer, similar to those used in garages. For the first image (*top left*) I set the washer up at full pressure and adjusted the nozzle to produce a fine spray of water. The effect is that of a sudden downpour. To avoid the potential problem of the spread of water being inadequate, I zoomed in on the cyclist, as you can see in the second image (*top right*). For the third (*above*), the wind-blown effect was achieved by rapidly turning the water on and off producing pulses of water. An assistant, just out of shot of the camera (*right*), kept pace with the cyclist. If taping goes on for any length of time, don't forget to keep the ground good and wet. How quickly the water evaporates depends on how hot a day it is.

Fantasy Effects

THUS FAR IN THIS chapter we have been attempting to create special effects that appear to be as natural as possible – wind, rain, snow, smoke, fog, and mist, and so on. On the next four pages, however, the emphasis is on fantasy effects.

Trick lighting

One of the easiest special effects to achieve is fantasy-style lighting. From our viewing of television and movies, we are all used to seeing characters seemingly lit by neon advertising signs, shop window illumination, or nightclub or disco lighting. Film and television directors often signal the location of the action to the audience by using these types of lighting effect.

What is assumed to be an error in stills photography – colour casts or intrusive shadows, for example – is often quite acceptable in the moving image. The moving image gives its audience more of a context in which to view and understand the action.

Linked to the visual side of the production is the soundtrack. Imagine that a character's face is being filmed in tight close-up at night, and no setting is discernible. Suddenly half the character's face is illuminated by a red, or green, or blue light. Accompanying the visuals is a soundtrack of traffic noise and the call of a paper seller. Together these tell the audience that the source of the coloured illumination is probably the flashing neon of an advertising display, or something similar. The same type of scenario indoors, this time accompanied by a soundtrack of dance music, glasses being clinked and people laughing, will indicate a setting such as a disco or nightclub.

Projected backgrounds

Projected backgrounds are used to make the audience believe that the characters really are standing in front of an exotic location such as the Taj Mahal or the canals of Venice. Often small segments of a scene are faked by using a projected background, possibly to save the expense of sending actors and a production crew out on location or because at the post-production editing stage some problem has occurred that was not foreseen when the live location footage was taken.

Another situation in which projected backgrounds are often used is a shot of somebody driving taken from in front of the steering wheel so that the audience can see the scenery changing through the back window of the car. If done well, it can be extremely difficult to know whether you are watching the real thing or a cheat.

Painted backgrounds

The movie industry has a long tradition of using painted backgrounds, either setting a whole scene or as 'matted-in' parts of a scene. The very best matt painters are highly valued and their work is perfect as long as you ensure that the lighting effects on the 'real' part of the set correspond to those used in the painted part.

If you want to try this yourself, however, there are two things to bear in mind: first, unless you want to paint a large area of background, you will need to keep framing pretty tight on your subjects and also restrict their movements so that the edges of the painted area are not apparent in the viewfinder as you change camera angles.

Second, if you position your characters well in front of the painted backdrop and use the lens set to the telephoto end of its zoom range, you can use the resulting limited depth of field (see pp. 40-41) to your advantage. If, for example, you focus the lens carefully on the characters, then the background should be sufficiently indistinct for you not to have to worry too much about the finer details of your handiwork.

Model work

If you would like to try your hand at model making, then the easiest option is to use commercially available constructor kits for the main pieces. You can then construct a setting to the scale of your model out of things you might have around the home – cardboard, coloured paper, string, sticky tape and so on. For 'props', you can utilize toy cars and animals or even pieces of scenery from an electric train set or pieces of furniture from a doll's house. This would be an ideal holiday project to involve young children in, giving them endless hours of fun building and decorating the set, selecting the props and then seeing the results played back via the television.

Coloured lighting effects

For the first pair of images (*top left* and *right*) I used two quartz–iodide photographic lamps, but any high-powered, point-source lighting would do. I positioned one light well to one side to project the distorted shadow of the bicycle on to the wall. For one image, this light was covered with a sheet of green gelatine filter material, and for the other, pink gelatine. I then aimed the other light, covered with blue gelatine, at the side of the subject's face.

For the third image (*above*) I used a deep orange-coloured gelatine filter, but this time I positioned the subject much closer to the background so that her shadow is clearly visible. This effect looks at its best when you see the character animated with the light following her and her shadow distorting as she moves.

Sheets and strips of gelatine filter material are available at most large photographic stores.

Projection techniques

There are two types of projection technique: front projection and back projection. With back projection a still or moving image is projected on to a special translucent screen that does not produce a 'hot spot', an area of bright intensity, corresponding to the projector lens. You then position your subject on the other side of the screen and light him or her separately. You must ensure, however, that no subject lighting spills over on to the back-projected image on the screen, otherwise it will tend to look flat and lifeless. One way to minimize this is to position your subject well forward of the screen.

The other projection technique is front projection – the one I used to produce the image below. The only piece of specialized equipment you will need is a small, semi-silvered mirror positioned in front of the camera lens at a 45° angle. The projected image is beamed upwards where it strikes the mirror and is reflected on to the screen. The camera lens, however, looks directly through the semi-silvered mirror. For this to work properly, the axis of the camera lens and that of the projector lens must be very nearly the same, otherwise the subject will cast a shadow on to the screen.

As with back projection, you need to light the subject separately, making sure no light spills over on to the screen.

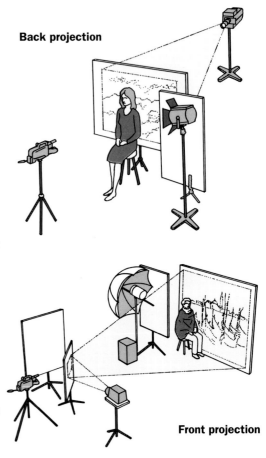

Back projection

Front projection

Model sets

These two model sets are both part of a short tape I made a few years ago with a science fiction, futuristic theme.

As you can see, many of the props consisted of ordinary, plastic construction kits, such as the *USS Enterprise*, carefully painted, and cast-metal models, all readily available from model-making and general hobby stores. The *Enterprise* was suspended above the set by pieces of cotton (as was the ringed planet in the other set) and the lighting carefully arranged so that the cotton would show as little as possible.

Other parts of the set were decorated with model cars and futuristic buildings made up for me in metal and then spray-painted. In the set with the bridge, the supporting round 'boulders' are in fact made of pâpier maché, painted, and then varnished to give them a sheen as well as to protect them from the water. To achieve the 'star' effect, I pierced a large piece of cardboard all over with small, neat holes. After positioning the cardboard over the set, I rigged an ordinary domestic light bulb above it and switched on. The only light escaping from behind the cardboard is through the holes.

THE PRE-PRODUCTION PROCESS

A little forward planning can make a world of difference to your finished video – and help you make the best use of your resources. The topics covered in this chapter lie at the very heart of successful video-making.

.

Creating and Adapting a Script

THE IDEAS BEHIND PRODUCING a script are many and varied. First, working to a script makes you plan, in advance of shooting, your requirements in terms of personnel (technical as well as actors), equipment and locations.

Second, a script imposes structure and logic, allowing you to produce a video in the most efficient and cost-effective manner (see pp. 116-17) by, for example, shooting all scenes involving the same locations, actors and equipment at the same time, irrespective of where those scenes will eventually be edited (see pp. 220-23) into the final tape.

Third, a script provides the words the actors will speak and indicates how they should be spoken. Of course, a video production does not have to have words at all. It might be all mime with a music track or voiceover added later (see pp. 182-7 and 224-7). Even so, a script, in this case in the form of a storyboard (see pp. 110-11), is still necessary to help the actors know the approach they should be adopting to their movements or how they should be relating and reacting to other members of the cast.

Evolving a basic script

As a starting point, you might want to think about taking a classic and adapting it, first by shortening it, and then by bringing it into a contemporary setting and imposing modern dialogue on it. This will involve you in quite a bit of creative writing as well as some logistical problem solving, such as set building or location research (see pp. 112-15), or just how the actors move about the setting you have selected for them to perform in.

However, you will probably be more interested in scripting your own short video production – a fictional drama, perhaps (see pp. 200-209) – rather than in staging and shooting an already published piece of work. Your first problem could well be finding the initial inspiration for a storyline. Your favourite pastimes or some aspect of your daily routine at home or at work might suggest something to you, or you might get together with friends and have a brainstorming session, bouncing ideas off each other until a structure starts to emerge. A few sessions such as this should provide a basic storyline, perhaps a subplot or two, a suggested number of actors, ideas for locations, the type of equipment neces-

sary, and some idea of final screen time. If you seem to be overstretching your resources (physical, financial or creative) in any of these areas, then you should scale down your approach. It is always better to produce a well-conceived and well-executed simple tape than one that tries to do too much and fails.

The next stage is to start working up the first draft of the script (this is often termed the treatment). This contains notes on the setting, the relationship of the characters to each other and to the setting, dialogue, directions of movement of characters as well as any other aspects particular to your story that need to be spelled out – day or night, for example, progression of time, type of lighting, weather conditions, states of mind of the characters and so on.

Depending on how things are progressing, you might need to reconvene the brainstorming sessions to test your progress so far and gauge reactions or to help you solve a technical difficulty or a complication in the plot that you can't seem to get around. Equally, you might prefer to work entirely on your own, not consulting with others until you have solved all the problems.

From first draft to first rehearsal

Once you have your first draft, or treatment, it is a good idea to give it to somebody whose opinions you trust, to read and react to. It might be best if this person has not been involved in any of the initial meetings, since a fresh eye can often point out a weakness of plot or characterization, or an impossibility in the logic, that those more familiar with the work might fail to notice.

After this, you should try the first full-blown reading of the script. Don't be despondent if the dialogue sounds stilted or unnatural in places. This phase of the process is designed to find out problems and then iron them out. The actors will know if what they are being asked to say feels right. If they say that something would sound more natural if expressed some other way, then take note and be prepared to let the script become a synthesis of all these different inputs. After this first rehearsal you should take some time to marshall your thoughts before moving on to what should, by and large, be pretty close to the final script.

Modifying a script

It is not unusual for a script to be modified even during the shooting stages of a production. You may, for example, have scripted a character to make a particular type of entrance down a staircase. In your mind's eye when writing the script, you could see clearly how this would work. In reality, however, the staircase you are confronted with is utterly inappropriate and so the script will need adapting to take account of this. This goes back to the point made above that a script is only a skeleton of the action and dialogue – you should never view it as the blueprint, something sacrosanct and unalterable.

Other common problems that necessitate script changes have to do with the weather (see pp. 96-101). If the script calls for blue skies and sunshine but it happens to be pouring with rain then, to salvage the day's shooting, a script change may be essential. Likewise, a piece of equipment, such as an extreme-angle camera lens, might be unavailable or too expensive to hire, making it impossible to shoot the scene you had originally planned. Script changes for this type of reason, however, often have more to do with the shooting script and storyboard aspects of a production, which are the subjects of a separate discussion (see pp. 110-11).

SCRIPTING NONFICTION

It is just as important to script a piece of nonfiction as it is to script a fictional drama. The major differences between the two types of production are that for a documentary or an interview you will not be able to write or control the dialogue or the flow of action to any fine degree. In other respects, though, the process is not dissimilar.

For an interview (see pp. 188-9), part of the initial scripting procedure will be to research the subject of the interview and to make contact with the interviewee to put forward your ideas. You might, for example, be asked to submit in advance the list of questions you want to ask, and you might also have to agree to certain parameters within which the discussion will take place (the treatment stage). On the day of the interview, you might do a few dry runs of asking and answering the questions to overcome any nerves the person might have in front of the camera, and also to discover if the questions submitted need modifying at all to draw out from the interviewee some other points of interest you might otherwise have been unaware of (drafting and rehearsal stages).

A documentary (see pp. 190-91) can be a mixture of images and interviews, with a voiceover (see pp. 227) linking the two together. Interviews for a documentary might progress as above through the treatment, drafting and rehearsal stages, or they might be more spontaneous affairs resulting from chance meeting during the filming of the piece. The voiceover, however, can be created following precisely the same stages as those used in the fictional piece of work, except that it will have to use the visuals as the springboard instead of the visuals growing out of the written word. Nonfiction videos, of course, also include such things as vacation or sporting tapes – just two examples of subjects that would benefit immeasurably from some degree of preplanning and scripting. For a vacation tape, for example of a town or village you have come across on your travels, you should start by looking around some of the points of interest it has to offer – parks, stores selling unusual products or handicrafts, interesting public buildings, and so on. Do this before committing anything to tape and then spend a little time creating a sketchy storyboard of subject material and how best each feature could be shot. Next, you could visit the public library to research the location a bit more thoroughly. Here you could well discover aspects of the town's history that you might also want to tape. You might even want to tape some printed photographs found in the books there showing what the area looked like 50 or 60 years ago. Another excellent source of research material could be the local tourist information office. Here you might find maps of public footpaths and rights of way giving access to attractive scenery that you might otherwise overlook as a stranger to the region. Once you've gathered together all this material, refine your initial storyboard to produce a coherent, well-rounded treatment of the subject. It's also a good idea to take notes from the material you have read so that you could produce a voiceover at a later stage.

If your video is of a sporting event then you will produce a more watchable tape if first you familiarize yourself with the rules of the game being played. Not only will your anticipation of what is likely to happen next be sharper but, as a result, your coverage will be more interesting.

Creating a Storyboard

OMPARED WITH CINE FILM, video tape is incredibly cheap and, instead of just two or three minutes of, for example, Super 8 per reel, a video cassette offers you hours of recording time. This can create as many problems as it solves.

With so much potential recording time at your disposal, unless you have a fair idea of the structure of your production – be it a once-in-a-lifetime family wedding (see pp. 120-27), highlights from your last vacation (see pp. 142-57), or (as here) a behind-the-scenes glimpse of circus life – what you are likely to end up with is a series of haphazard shots and an incoherent storyline. This is not the type of combination likely to hold the attention of a sophisticated audience weaned on a diet of cinema and television dramas.

What is a storyboard?

The basic idea behind a storyboard is that you plan, *before* shooting, the basic direction your video production will take, as well as at least some of the most important detail you will want to cover and the approximate running time of each sequence.

A storyboard of some description is particularly important if you don't intend to edit your work afterwards. In-camera editing (see pp. 60-61) means that you need to have a very clear notion of the sequence, action and pace, and how they all intermesh, before squeezing the trigger. Post-production editing, on the other hand, allows you the freedom to shoot scenes in the most convenient fashion, irrespective of where they will eventually fall in the finished production. For example, you might want to shoot the opening and closing scenes consecutively simply because they both take place at the same location and involve the same personnel.

For a full-blown fictional drama (see pp. 206-15), such a storyboard might take the form of drawn cells, each detailing the personnel involved in every shot, camera angles (see pp. 68-9), and even framings and lens settings. This is along the lines of how professionals might tackle the job.

Alternatively, if all you want are a few minutes of coverage of a little village in, say, France you happened to have driven through on your vacation, then all you need do is take a quick look around, sit down at a café somewhere with a cup of coffee and spend a few moments scribbling down on the back of a paper napkin the sequence of shots you want to include, their order and approximate timings. It's a little investment of time, but it could well make a world of difference to the final product.

Circus storyboard

Putting down in sketch form what you want to achieve (*see below*) is the best way to realize the potential of the video medium and to develop your skills as a video photographer. But unless you are producing a fully scripted drama, always allow the opportunity for the action to grow spontaneously. Use the storyboard as a guide, not a straitjacket.

Opening credits shot. Superimpose titles

Long sho Introduc characte

Cutaway "audience" reaction

Cutaway
Mock astonishment

All too m Weight lif on to gr

Alternative approaches

Don't think that you have to be able to draw well in order to make an effective storyboard. In the top example here, stick figures have been used to indicate an establishing long shot from the major storyboard below, as well as the weightlifter in silhouette and in close-up.

In the next version the storyboard has been even further simplified, and geometric shapes have been substituted to represent the same scenes. All the storyboard is supposed to do is set out the point of each shot in the context of the overall production.

Shooting script

Yet another alternative to the storyboard is a shooting script – in other words, a written version detailing exactly the same information contained in the sketches. Although it may take a little longer to produce for a complicated production, a shooting script is just as effective for planning shots.

1 Low-angle shot of high-wire artist against plain canvas background. Frame figure to the right to allow for rolling credits on the left.

2 Establishing long shot of weightlifter and clowns. Need to see all characters in frame here, and in costume to introduce humour.

3 Keep in long shot. Shoot comic weightlifter from low angle. Set exposure for sky to throw figure into silhouette.

Storyboard · Circus sequence

Cut to weight lifter, low angle against sky

Dissolve to close-up

Zoom in. Tension, strain, bulging veins

Cut to weight lifter and clowns talking outside caravan

Cut to clowns rehearsing ju

Move in to close-up to show clowns make-up

Research and Recce

GOOD, INTERESTING VIDEO TAPES don't just happen, or at least not very often. More usually, they are the result of careful consideration of all the aspects that go to make up the shot, such as lighting (see pp. 78-91), camera angles (see pp. 68-9), types of framing (see pp. 64-5), post-production editing (see pp. 220-23) and so on. Researching the location for your video in advance of shooting is another vital element in a successful production.

Bringing back the goods

Often all you need do is keep alert to the possibilities inherent in the area around your home or workplace. A series of still photographs might help you to decide whether or not it would make a suitable location for a video. You can consider them at your leisure and discuss them with other interested parties, and then go back later with your camcorder when you have planned your video.

Another source of good locations can come from your normal family vacations (see pp. 142-57), when you are likely to be visiting new places, either in your own country or abroad, that you might want to incorporate into a video storyline. In this type of location, which you might not easily be able to return to, you should shoot as much tape as you can. If you already have some basic story ideas in mind, then try to tailor your coverage accordingly. If this is not the case, then just think of the camcorder as a collecting device for raw material. Shoot the location from all different angles – inside and out, if relevant – and at all times of day, from dawn to dusk. Then, during the post-production stage, you should have enough material to weave into the final edit with interior shots taken at another location or even in a studio set.

Stratford-upon-Avon, England
Take locations from as many angles as possible so that you can evaluate their potential at a later date. Here (*right* and *below*) are three views of one of the most famous cottages in England, the home of Anne Hathaway (wife of William Shakespeare) at Shottery, near Stratford-upon-Avon. With sites such as this, tourists are always a problem, so you need to visit either during the winter when there are less visitors about or early in the morning before the crowds arrive.

Brighton, England
These shots (*above* and *right*) were all taken either outside the nineteenth-century Royal Pavilion at Brighton or along that town's famous promenade. By matching styles of architecture, it is possible to cut from one location to another without the audience being aware of the change.

Taj Mahal Hotel, India
This ornate hotel interior in India (*below*) could easily be used with the outdoor material taken at Brighton (*above*).

Romany caravan
It is a good idea to stay alert to the type of exterior location that you could easily mock up an interior to match. Here (*right* and *below*), for example, is a charming little Romany-style caravan. It would take relatively few carpentry skills to create a curved wooden set in which to stage the interior action, using cut-in exterior sequences wherever necessary. For the sake of authenticity, take notes (or still pictures) of interior decoration and equipment so that you can replicate them later when you come to build your set.

Funfairs
A funfair (*above*) is international in flavour, making it an ideal video location.

Rail head, Canada
Sometimes you come across a setting so powerful, with such a presence when you see it through the camera's viewfinder, that you feel as if you want to create a story to match the location. For me, such a location was this grain storage silo (*right*) adjacent to the lonely railroad lines in the Canadian interior, spotlighted here by the raking, late-afternoon sun.

Tokyo, Japan
What constitutes a good and unusual location can depend to a large extent on the cultural background of your audience.

For Westerners, a view of a traditional Japanese stone garden (*above*) makes a fascinating location simply because it looks so alien to their eyes.

The genuine article?
These buildings (*above left* and *right*) are genuine only in the best traditions of the Hollywood Western. They are, however, not even in Hollywood, but in the desert region of Spain. It is not at all unusual for locations to be chosen for logistical and financial reasons, although superficially it does not seem to make much sense to go to Spain to shoot Western scenes. In fact, the Spanish government offers quite generous financial incentives to attract overseas film crews to their country. Added to this is the relatively inexpensive labour costs involved in hiring local extras and technical personnel. When shot from the correct angles these buildings look real enough, but look closely and you can see that they are nothing more than 'flats' – façades. If you could peek around the corner you would find huge wooden props supporting the walls.

Budgetary Control

THE IDEA BEHIND budgetary control is that you get the best possible value, and the best possible production, for your money. And budgeting for your time is as important as budgeting for money. This means that you need to plan every aspect of the production thoroughly in advance in order to ensure that your resources are used to maximum effect.

Personnel

Many videomakers band together with other enthusiasts when undertaking a project of any size or of a complicated nature. This pooling of resources means that the technical expertise and equipment available will be far greater than that which could be mustered by any individual. Many experienced amateur videomakers have a good basic grounding in the varied disciplines demanded by their craft – camera operation, sound recording, directing, lighting, editing, set building, electrical work, script writing and so on. This is useful since it may therefore be possible to cut down on the numbers of people involved, and thus the expense, by some doubling-up on functions.

For this co-operative effort to work, however, everybody involved must be pre pared to look critically at their own technical strengths and weaknesses and to set aside their personal preferences for the common good. It is impossible, for example, for all the crew members to be camera operators; and you may turn out to be more useful monitoring the sound or lighting, or managing the logistics of moving the crew and equipment from location to location.

The other aspect of controlling personnel expenses concerns the cast. Not all video productions will involve actors, of course, but where they are called for don't be over-ambitious in what you try to achieve. Right back at the scripting stage (see pp. 108-9), try to prune numbers down as far as possible. The fewer people involved, the more chance you will have of everybody being available, and on time, for a shoot. Members of the crew may be able to take small parts in front of the camera as well, but only if this does not compromise their technical duties.

Locations

To add realism to your production you may need to film in real locations, such as a warehouse or a store. If you are fortunate, a local trader may be willing to allow you to use their premises without charge in return for some free advertising. If, for example, you will be hoping to show your finished video production at local video clubs, you could offer to include on the printed programmes or flyers the names and addresses of those people who helped in the production in return for permission to film. The end credits of the video (see pp. 228-9) could also include a list of 'We would like to thank the following . . .' While filming, too, you could ensure that the name of the store or warehouse featured prominently in the establishing shot for the interior action.

The more thoroughly you research locations prior to shooting, the more chance there will be of you finding something suitable close to home. The less you have to travel the better, and the cheaper, the whole undertaking becomes. And always be prepared to compromise. If a convenient location is right for the action in most respects, then why not do a little rewriting of the script to make it ideal? In video production, as in most other things, there has to be a balance between what you would ideally like and what you can afford.

Budget sheets

The example (*right*) could act as a master budget sheet for the personnel costs of a video production. First, you will need to produce a storyboard or shooting script (see pp. 110-11) for each scene so that you know precisely who is involved at each stage of production. Once each scene has been budgeted, the information can be summarized on the master sheet. Keeping this type of information on a personal computer means that new sheets can be generated whenever needed. Once you have worked out all known costs, it is always advisable to add in a contingency against the inevitable extras you have not accounted for. You will need a similar type of budget sheet for all other aspects of the production, such as equipment, locations and transport.

BUDGET SHEET

Production name: · · · · · · · · · · · · · · · Date: · · · · · · · ·

1 Scheduled shooting time: ⎯⎯ days

2 Personnel:

Technical	Cast
1	1
2	2
3	3
4	4
5	5

3 Agreed rate: £ ⎯⎯/day

Projected personnel costs (1 + 2 + 3): £ ⎯⎯

Contingency @ 25% of above: £ ⎯⎯

SUBJECTS

This chapter looks at all the classic
video subjects and shows how the
technical and aesthetic considerations
covered in the previous chapters can
be applied to them.

Weddings

OR THE BRIDE AND GROOM in particular, but also for their families and their friends, the wedding is one of the most important days in their lives, so it is important that you get the photography right.

The time leading up to the departure to the ceremony is usually frenetic: flowers to arrange, transport to marshall, bride to dress, catering disasters to overcome, children to feed and keep clean, last-minute advise to proffer. The last thing anybody involved in the preparations has time or inclination for in the midst of this seeming chaos is to brief the photographer. This means that to do your job thoroughly and professionally, you need to have one or two meetings with the parties involved well before the big day.

Weddings are series of set pieces, and not to miss any of them requires a high degree of preplanning. As a help to you, look at the suggested shot list form on page 122. When you meet with the leading players, probably ten days to two weeks before the wedding day, take this form, or one you have devised yourself, along and go through all of the categories of information you need from them in great detail.

If everybody involved cannot be there, leave the form and arrange to call back and collect it and to answer any questions that may have arisen. Once you are certain that you have everything you need, still exercise caution. As a safeguard, the night before call them on the telephone and check that no details have altered.

Also, unless you know the venue of the ceremony well, you should visit the site before the wedding day so that you can scout out the

Hats off
Don't lose sight of the fact that weddings are fun occasions. After the nervousness of the bride and groom emerging from the church (*above*), a rousing cheer, hats in the air, and the throwing of confetti (*right*) make a good contrast to the more formal pieces to come.

Panning
When in close, panning is the best way to ensure you include all important participants. This pan (*left* and *below*) starts with the bride and groom and bridesmaid and then sweeps round to encompass other family members.

best locations for shots, work out some shooting angles, and to see if there are any features of the location that you need to avoid.

Coverage
At the very least, your video coverage should include the bride and groom emerging after the ceremony. To get the timing right you will need to be inside during the ceremony, and then quietly excuse yourself a minute before its conclusion. So as to cause as little disturbance as possible, make certain that you find a seat at the end of a row adjacent to an aisle.

Other of the set pieces that are absolutely essential will be the bride and groom together; the couple with the bride's family; another with the groom's family; and another with both families. And don't forget the best man, bridesmaids, the more distant family members and friends, and of course the confetti and rice-throwing ritual. You can cut down your work a little by taking advantage of the organization being put in by the stills photographer who will no doubt be there as well. If that person is doing the work of organizing the standard set pieces, then just tag along and try not to get in each other's way. An air of friendly co-operation should prevail.

Weddings often bring together many different generations of people, so stay alert to any very elderly members who might not be able to move into position for the set pieces,

and ensure you shoot some tape of them, too. You will be at an advantage here if you can arrange to have somebody who knows the families well on call to point out these people to you.

Bear in mind here that video photography differs very considerably from stills photography at this type of occasion. With stills you, by and large, just want that collection of frozen moments when everybody is perfectly arranged and hopefully not blinking or yawning when the shutter clicks. But with video coverage you also want to record, both in vision and with sound, the activity and confusion, and the fun, as people are called for their turn in front of the lens. Make sure you get the mistakes people make – the trips, the stumbles, the yells when it's realized that the bride's uncle has accidentally included himself in the groom's family shot, and so on. At the end of the day, it will all add up to a more rounded, more atmospheric, and, most importantly, a more enjoyable tape to watch.

After you are satisfied you have all of the set pieces, detach yourself from the fray to take some general wide shots of the overall activity. If the building is attractive in its own right, some of your coverage should concentrate on its façade. But keep alert to the action and make sure you are in the right position to cover the bride and groom leaving to enter the transport taking them to the reception. If the information on your shot list form is correct, you should have a little prior warning of when this will be.

SHOOTING LIST FORM

Bride's name: **Tele no.** **Or contact**
Home Name
Work At (tele no.)

Groom's name: **Tele no.** **Or contact**
Home Name
Work At (tele no.)

Date and time of wedding:
Address of venue:
Contact name and no. to arrange prior access:

Type of coverage required at church, registry office, etc (please give as much detailed information as possible):

1 6
2 7
3 8
4 9
5 10

Please nominate family member or friend who can assist on day:
Name
Tele no.

Estimate departure time to reception:
Address of reception:
Contact name and no. to arrange prior access:

Type of coverage required at reception (please give as much detailed information as possible):

1 6
2 7
3 8
4 9
5 10

Coverage to continue to what time?

Equipment checklist:

- Camcorder
- Spare tapes
- Spare batteries
- Lights
- Tripod or Steadicam
- Filters

Zoom

These two frames (*right*) are from a slow zoom that starts in mid-shot and comes in closer as the bridesmaid moves out of the way, and ends in a close-up framed tightly on their faces as they turn to kiss.

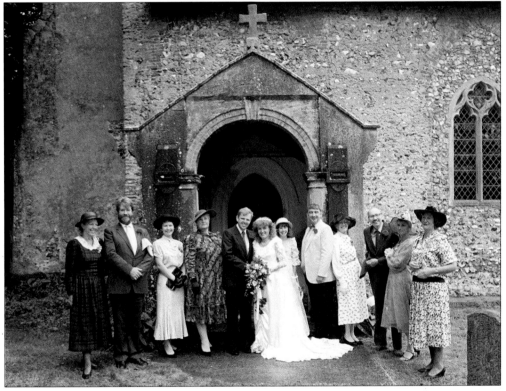

Formal is appropriate

Shot in wide-angle, this type of arrangement is more or less how a stills photographer would have arranged the personnel – it is formal and completely appropriate to the occasion. From this basic shot, you could next zoom in to linger for three or four seconds on the reactions of individuals in the group.

Cutting points

Now with the camera on a tripod to leave yourself freer to offer some direction, you can record the couple moving away from the church and heading for the wedding car. An ideal cutting point is reached as they draw close to the camera. The next shot could pick up on them entering the car and driving off with the crowd waving after them.

The reception

Having covered the departure of the bride and groom after the ceremony, ideally you should aim to be at the reception ahead of them in order to get some footage of their arrival at the festivities. If the reception is being held, as this one was, in the grounds of a large house, perhaps with a marquee as the base of operations, you will almost certainly want a good mixture of indoor and outdoor footage. The variety of these two fundamentally different settings will certainly help to make a better tape. But there is no right or wrong way in which to order the shots. A factor beyond your control is the weather. As a general rule, if the sun is shining at the start of the reception, then try to shoot as much outdoor material as possible. At any moment the clouds may roll in and the rain start to fall.

Using the setting

Here, again, you will be better prepared if you have taken the opportunity to visit the site of the reception before the wedding day. You will be looking to see if there are any natural features of the setting that you particularly want to include in the coverage, or particularly want to avoid. If this has not been possible, then try as soon as you can to slip away for a few minutes and have a quick scout around to find the lie of the land.

Always bear in mind that weddings are about romance, so the more romantic you can make the shots appear the better – especially for the inevitable set pieces. Helpful features you should keep an eye out for could include a small glade of trees with a strategically positioned bench, a rose arch, a plant-covered arbour, garden summer house,

Cutaways

Shots that will make good cutaways are invaluable when it comes to editing your footage together to make a coherent story without too much repetition. This one (*above*) is particularly valuable from an editing point of view because it shows the guests looking out of shot to the left and right. This thus gives you the flexibility you need to introduce the next scene with the action moving in either direction.

Using perspective

While the weather was on my side I was determined to use as much of the grounds at this reception as possible for a variety of coverage. For this pose, I took advantage of strong linear perspective to help make the bride and groom most definitely the centre of attention. But I also arranged the others so that the eye naturally follows the line of figures, echoing the lines of the bridge.

Using the environment

This lakeside setting (*right*) is simply ideal for wedding coverage. I started the shot with the zoom back at wide-angle to give near full-length framing, but also to ensure that the surroundings were visible. This scene was shot against the light, so as I moved into close-up I had to adjust the exposure manually.

an attractively planted flower border, and so on. At the wedding illustrated on these pages, I was very fortunate that the grounds contained a small stream feeding into quite a reasonable-sized lake, complete with an arched stone bridge. Water always seems to conjure the right atmosphere for wedding images, so use it to best advantage.

Care and attention

As with all photography, however, remember that you need to take the time to compose your shots with considerable care. Use the zoom facility, universal now on all camcorders, so that you can preview shots before committing them to tape. Look out for the right balance of form and shape, how perspective directs the eye to the most important element of the shot (or helps distract from some less-attractive feature you

want to suppress), and how surface texture can help produce a more pleasing and professional result.

Colour, too, should be of vital concern to you as photographer. This is especially true when arranging the more formal shots. There may not be a lot you can do if the outfit of the groom's mother clashes horrendously with the colour of the bridesmaid's gown, for example. But you should certainly be aware of the colour in the surroundings, and make sure that flower colour or a painted façade visible in shot is not distracting attention away from the main subjects. These are not things that might even be appreciated by your clients if you get them right. They are, however, likely to be very evident if you get them wrong. It is well worth taking a little extra time and trouble to look around before you start shooting.

Pulling focus

This sequence (*above*) was a long, continuous take, during which I pulled focus in order to keep the couple sharply focused throughout. It is a good, animated sequence, yet sufficiently anonymous to

allow it to be edited into the final wedding story just about anywhere. Pulling focus is a difficult technique to get right, so you should rehearse it beforehand. If you don't, then almost certainly you will lose focus somewhere during the take.

The kiss

It is hard to imagine a wedding tape without coverage of the bride and groom kissing at the ceremony. This is such an obvious set piece that there should not be too many problems in persuading the couple to do a few different takes if you need to reposition yourself in order to capture different aspects of the scene. It is at these moments that you can in fact direct the action quite strongly, since it is in everybody's best interest to get the material in the can. This scene starts with the bride and groom centre stage, posed in front of the main flower display in the marquee. Quite a lot of effort went into ensuring that the couple looked perfect for this shot, even making sure that the bridal gown draped properly to describe a perfect circle on the ground. Next, coming in close for the kiss itself and moving off to one side so that the young bridesmaid is in shot looking on. Having introduced her already, the next cut to a close-up of the bridesmaid is obvious. And to finish off the scene, cut to a close-up of the bride and groom's hands with the wedding ring prominently displayed.

1

2

3

4

Cutting the cake

This is another set piece for any wedding. The sequence starts with a mid–shot of the bride and groom, and moves out to show the guests toasting the happy couple.

The guests

It will be disappointing if, at the end of the day, certain of the guests have been accidentally omitted from the tape. If you can, obtain a guest list and tick off the names of people as you move around outside or in the marquee. You will probably need the help of somebody who is familiar with everybody present.

Grand finale

It is always best if your video coverage of any event can end with something memorable, a grand finale, rather than just drift to some inconclusive ending. For this exuberant scene, I had been given prior warning (by the bridesmaid) that a dunking in the swimming pool was a distinct possibility, so I kept a close eye on the pair of them to make sure they didn't drift away unobserved.

Children at Play

IT IS PROBABLY FAIR to assume that the majority of people buy a video camera so that they can have a permanent record of their family over the years, and especially of their children as they grow to adulthood. And one of the best things about taping children is that they are rarely intimidated by the camera. Certainly they are initially curious and some will undoubtedly try to hog the limelight (which can make for good video, too), but after a short period they soon become immersed in their own activities, allowing you to get on with the job in hand.

Providing filmic diversions

Your task will be easier if the location provides your subjects with some natural diversions – in other words, somewhere where they can let loose and have fun. Obvious locations include adventure playgrounds, school yards, local parks or a nearby wood, perhaps an empty lot, gardens, fun fairs, and of course beaches and swimming pools. But if none of these opportunities is open to you, then just some favourite toys or picture books scattered around your living room will help the children to relax and enjoy themselves.

Coverage

Unless you simply want a jumble of undirected, moving snatches of unstructured activities, with no plot or logical sequence (which might be sufficient for a doting parent, but is distinctly lacking in interest for a wider audience), then you will have to take a hand and organize your presentation.

In essence, this means putting together a varied series of differently paced scenes and shots, including close-ups of various types, to contrast with head-and-shoulders mid-shots and full-length long shots (see pp. 64-5), establishing shots, pans and tilts (see pp. 50-51), zooms, and so on. And to place these in the context of a video presentation, you might have to organize some of the children's activities, arranging games, for example, in order to establish a plot of sorts – a logical sequence of events. This will also give you a better chance of being in the right place at the right time with the camera.

Sequence 1

Even a simple sequence like this (*right*) needs an anchor point, some logical development. If you know children, then it is obvious that an inflatable bed in a swimming pool is going to generate some video-worthy action, and so you can be ready with the camera. The girl in possession of the inflatable is having a hard time repelling boarders. After a tussle, the boy is vanquished and she waves her victory towards the camera.

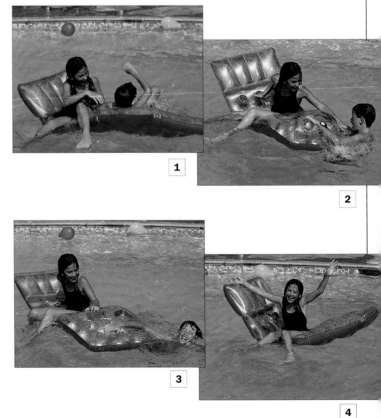

Establishing shot
It often helps the audience if first you shoot a few seconds of tape with the lens pulled back to show the location and context of what is to follow (*above*), before zooming in to show the detail of the action.

Sequence 2
Here is a closer view (*right*) of the location filmed in the establishing shot above. This type of action sequence can take up far more screen time than the first example. Although these shots show just a snatch from the middle of the scene, it would have started with boys ducking down under the water to let the girls climb on to their shoulders (and, of course, being bucked off a few times), then on to the waterbag fight itself, finishing with close-ups of the loser fighting to keep balance before finally hitting the water. Editing this scene (see pp. 220-23) with another of the other girl losing the next battle would be logical and provide you in total with a minute or so of fun screen time.

1

2

3

4

REMEMBER

•Children are best taped with the camera down at their own height – not with it held at the usual adult height 1.5 metres (5 feet) from the ground. Coverage of children with the camera looking down on them always draws the audience's attention to the presence of the camera. Apart from that, you will end up filming the tops of their heads and miss many of the facial expressions of your subjects.

•Keep alert to what is happening on the periphery of your vision. In this way you can capture a lot of lively and spontaneous video action in addition to your main subject – useful as cutaway shots.

•Children do get bored quite quickly, so don't tax their patience by insisting on a long shooting session.

Sequence 3

This sequence (*right* and *below*) of the kids diving into the pool was taken with the lens zoomed back to its widest angle. The action is good and the variety of shot framing helps to keep the audience's attention.

Cutaways and cut-ins

Keep alert to what is happening at the periphery of your vision. To help link sequences, to ease cuts and make them seem less abrupt, to give a fuller, more rounded impression of the activities, and also to show reactions to the action, shoot cutaways or cut-ins, such as the ones shown *right* and *below*. A cutaway shot is of, for example, a person who has not appeared in the establishing shot, while a cut-in shot includes a person who has already been seen.

Rollerskating

No matter what situation you are taping – children playing in a swimming pool, for example (see pp. 128-31), or, as here, kids having a great time at a rollerskating park by the coast – it is important to bear some basic rules in mind.

First, let your audience know where the action is taking place by introducing the sequence with an establishing shot. And if you intend to include a commentary of some description, then a few seconds' worth of images will be even more important to give you the time you need without rushing your speech.

Second, use well-motivated frame changes – for example, from long shots to close-ups – to add variety and interest to your coverage (see pp. 64-5). If you focus on some

interesting piece of action in mid- or long shot, then use that as the motivation to cut to a close-up of it.

Third, keep alert to unusual camera angles that might contribute, albeit in an oblique fashion, some extra information about the characters featured.

Fourth, keep your coverage short – usually two to three minutes is ample for an unstructured activity such as this.

And finally, learn to expect the unexpected when children are your subjects – because they are so unpredictable that is invariably what happens.

If you stick by these simple rules, then at the end of the day you should have a tape that is not only capable of holding your viewers' interest, but also one that is appealing to a more general audience.

Establishing long shot

Here (*right*) you can see the establishing long shot used to introduce this sequence of images. Although this scene is on screen for only a few seconds, both the content and the quality of the light change quite dramatically. Pop music can be heard faintly in the background, coming from a source somewhere out of shot.

Medium close-up

Immediately following on from the establishing shot, we can cut to this medium close-up of a disc jockey (*right*). The source of the music is now revealed and the cut has been motivated by the soundtrack of the previous establishing shot.

Reaction cutaways

Images that are shown together will be viewed by the audience as being part of the same sequence. In these two cutaways (*left*), the children appear to be reacting to the previous shot of the disc jockey.

Action-packed mid-shots

Just because you are holding a 'movie' video camera, you don't necessarily have to keep it moving all the time. In the example (*above*), the kids are really tearing about, and to move the camera as well could lead to images of utter confusion.

A change of view

Looking for a different camera angle just to give a little visual variety, I decided to drop down quite low and move into the skating arena itself (*above*). The children in the immediate foreground help establish the different planes of the shot, adding important perspective, depth, and dramatic effect.

A change of pace

Here we have what could be described as the 'human interest' angle. A few seconds' worth of the two younger children (*above*) are almost certain to bring a quiet smile to the faces of those watching.

Revealing details

Often, just by showing a detail of the action you can imply a lot of the excitement inherent in the occasion. I zoomed the lens in for a close-up of this boy's feet (*right*) as he flashed by my camera position, and panned slightly to keep him in frame for three or four seconds.

Unwanted backgrounds

Just as in stills photography, you need to ensure that the backgrounds to your shots act positively to create the right impression. In the first of these two examples (*above*), a medium long shot and a slightly low camera angle gave too much prominence to a cluttered and rather unattractive background. To overcome this, I zoomed into a mid-shot and raised the camera angle slightly so that I was shooting down on the figures, showing them against a completely plain background (*above*).

The School Play

IF YOU HAVE SCHOOL-AGE children, one of the events you are likely to want to cover with your camcorder is the school play. Apart from being a lot of fun, both for you and the children, it is also extremely good training for the skills you would need to develop if you ever intended to tape any type of amateur stage production.

Rehearsals

It is best to become involved with this type of project at the earliest possible stage. In this way you will be able to build up a good rapport with the children, teachers, director and so on and they will learn to accept your (and the camcorder's) presence at rehearsals without embarrassment or inhibition Always make sure, however, that you do not get in the way.

Try to ensure that you obtain coverage of all the players – don't concentrate on just the stars. And don't forget about the people backstage: a play is a co-operative endeavour and everybody is important.

You should also familiarize yourself with the piece being prepared for production. The better you know the storyline then the better your coverage is likely to be. As well as taping the children reading their lines, use your knowledge of the script to be ready to capture any moving parts the director might be wanting to practise. Look out for different combinations of children reacting to each other and make sure you record these, too. In this way at the end of the process you should have acquired footage of everybody involved. And don't worry if you cover the same scene more than once. When it comes to editing your tape (see pp. 220-23), you will probably be glad of the extra flexibility this doubling up of material allows you.

First encounters
The earlier you become involved the better. In these images (*left*) the children have come together for only their first rehearsal. The players are not yet relaxed with each other or at all confident in what they are doing.

The work progresses
This scene (*above*) comes from about the third rehearsal. Now you can see that the children are smiling more and the scripts are less in evidence, indicating that they are beginning to enjoy the process as their confidence grows.

Contrasts
Your coverage will be more generally entertaining if there is a good mix of contrasting material. Here I was concentrating on obtaining character shots of the different actors, but rather than just run these as a sequence, I decided to included a bit of footage of some of the younger boys (*above*) taken on a very early taping session, when the camera was still very much a novelty.

The final push

A play is about theatre, and theatre for children just isn't the same without costume: they love dressing up. So at least the last quarter of your video production should be taken from material shot during dress rehearsals.

The assumption here is that your recording will probably come to an end before the actual performance. Taping when the auditorium is full of expectant parents all wanting an uninterrupted view of their children might be too difficult a problem. Also, the stage lighting during the actual performance will probably be very subdued and this could cause a problem with gain (see pp. 82-3). However, this is something you need to decide for yourself.

First dress rehearsal

In these two images (*left*) I've tried to show both the spirit of co-operation among the children, as well as the work being put into the production by the parents who helped with applying the children's make-up.

Complete coverage

Coverage wouldn't be complete without some footage of the three-piece band (*left*) who had worked very hard on the musical side of the production. After all, so many of the rehearsal scenes had had music running through them, it would have been odd not to have shown its source at some stage.

Varying shots

Now with all the players in full costume and most of the compulsory footage in the bag, I was able to concentrate on capturing a varied selection of group and individual shots (*above*). You will appreciate this type of variety when you come to edit the material together. But one problem at this point I did encounter was a lack of light. To solve this, I bounced two high-output floods, positioned either side of the stage, off the ceiling to bring background lighting up to a reasonable level. I then allowed the on-camera light unit to act as a spotlight to introduce a bit a lighting contrast and sparkle. This would have been impossible with an audience in attendance.

Making a Pop Video

OVER THE LAST TWO decades or so, the mass production of electric and acoustic instruments has encouraged a boom in young hopefuls – soloists as well as musical groups – all trying for their 'lucky break'. Pop groups can rise relatively quickly from near obscurity to national prominence. But the only way to bring this about is to ensure that you receive the right type of exposure, and plenty of it. More than ever before, if you want to get yourself noticed by those in the business who matter, you will have to be that much more professional in your presentation of both yourself and your music.

One of the traditional methods of breaking into the big time is to make a demo audio tape, copy it as many times as you can afford, and then mail it to every relevant record company and radio station you can find in the phone book. But modern music is as much about image and personality as musical ability, and so an excellent method of letting those who matter see, as well as hear, what you can do is to put together your own pop video.

First steps

The first step towards creating a pop video, assuming of course you already have the music and lyrics recorded, is to scout out possible locations (see pp. 112-15). For this type of presentation, however, a normal domestic setting, such as a garden or local park, is probably not the most eyecatching of possibilities, unless you are deliberately using the mundaneness of the environment as a foil to the more outrageous nature of your music.

An example of this approach could be to utilize the anonymity of much of today's civic and amenity architecture. Once you have found somewhere suitable, you could

Opening titles

If you intend to send your video out as a promotional exercise then you could start of with a shot of the whole group, the rock band New England, used as a backdrop to the opening credits (*below*). These could list the names of the band members and any relevant information about them – years in the business, professional engagements, etc.

1

2

3

Shooting position

In these opening shots (*above*) I decided to tape the group in silhouette by shooting into the sun (see pp. 80-81). This is an easy technique for adding a little impact and drama. Throughout this sequence the camera was hand-held and I needed to shift my position only slightly to catch the best angles as they started down the log pile towards my position.

contrast a vigorous, vivacious sound and lyric against a very desolate and soulless environment.

It is not difficult to imagine any of the hundreds of near-identical shopping precincts in city suburbs or town centres being turned to your purposes on a Sunday when all the stores are closed. As long as you use only the public-access areas and don't cause a nuisance, it is unlikely you will need permission or attract other than curious passers-by, but it is always best to check with the relevant authorities first.

If, of course, you want to shoot on private property, then permission, preferably in writing, should always be sought. You may also be asked to take out an insurance policy to safeguard the owner against any injury or damage. This is perfectly reasonable and premiums for a day or two's shooting will not be prohibitively high.

Breaking the rules

Once you have found a location, use your camcorder to take a tour of the entire area. Cover all aspects of it from every conceivable angle. You will need to view this tape again and again as you plan the overall flow as well as the detail of coverage on the day(s) of the shoot. Unless you are very experienced at putting visuals to music, you should look at how the professionals do it. All good video rental stores stock a wide range of pop videos, some produced and directed by the greats of the movie industry. Look at these, noting in detail how they construct a three- or four-minute tape.

You may want to use more than one location, perhaps cutting between them during the editing process (see pp. 220-23). You may also want to mix indoor and outdoor locations.

Normally when cutting from scene to scene, the object is to motivate the transition and make it as natural and 'seamless' as possible. Extremely rapid cutting can be used to create an effective montage.

Incongruity, attention-grabbing, perhaps even mystery and surprise – these are some of the elements you may want to weave into your production. And to achieve them you can pretty well break all the rules you want. Zooming, for example, is usually recommended as a special effect only, since it does not correspond with normal vision. Likewise, panning and tilting can be pushed beyond their limits by carrying them off at a dizzying pace. Another technique you might want to try is shooting at an angle, known as a Dutch tilt (see p. 215).

Synchronizing with the soundtrack

By far the most difficult part of making a pop video is to provide interesting and varied coverage of the band, with cut-ins, close-ups and unusual camera angles, while maintaining synchronization with the soundtrack. Editing is vitally important and unless you have access to dedicated editing equipment such as a synchro-linked VCR with jog/shuttle controls and a timecode edit controller (see pp. 30-33 and 222) your production will almost certainly be doomed to failure.

Look for angles
When they were about halfway down, I saw an opportunity to use the legs of the two guitarists as a frame for the others. I had to drop down, though, to take advantage of the angles so that I was filming almost from ground level.

A shooting script is essential for a pop video. For each take that you plan to use as a cut-in, you should record action for the entire song. This way you will be able to cut between them relatively easily.

Matters are simplified enormously if the camcorder has an audio line in facility. This means that a recording of the song can be fed straight into the camcorder and is better than recording the sound 'live' through the camcorder's microphone.

When it comes to editing, choose one of the continuous sequences as your 'master' shot (not to be confused with master VCR), and copy this from the camcorder to the master VCR (see pp.220-21). Then transfer this tape to the slave VCR. The slave model must have an insert edit capability which lets you 'insert' new video on top of old while keeping the original soundtrack. Be careful, because some insert edit functions replace the sound as well as the pictures.

Cuts are made by inserting footage onto this master shot – be it of the lead singer or the whole group – so that you return to the master shot once the inserted scene is complete. Follow the instructions in the user manual.

If you are using either VITC or RCTC timecodes and an edit controller, you should have little trouble in pinpointing frames, and if the two VCRs are synchro-linked (see pp.244-5) you should get reasonable lip synching.

With the pre-roll and backspace on unsynchronized camcorders and VCRs, you could be out by a full second (25 frames) if you try to insert a cut-in, making your pop video look like a badly dubbed foreign movie. Lip synchronization will tolerate a margin of error of about five frames – that's just 0.2 of a second. You can work out the backspace yourself by counting beats. If the song is in four:four time, and the backspace time amounts to three beats, you'll have to manually set the slave VCR recording three beats before you take the master VCR out of pause. For a full run-down of backspace and editing procedure, see pages 220-23.

Special effects

Some special effects need to be choreographed into the filming process. These include smoke, fire and explosions, as well as weather tricks, such as wind, rain and snow (see pp. 92-105) and the use of special effects filters. Use these as appropriate but with discretion. Any type of effect quickly loses its impact if over-used and can become annoying.

Once you have the overall structure of the tape assembled – the rough cut (see pp. 220-23) – you can think about all the post-production special effects you might want to include (see pp. 232-3). These include fades, dissolves, wipes, poster-ization, solarization and so on, depending on the sophistication of your editing equipment (see pp. 30-33). Recording the soundtrack, too, is a vital post-production task (see pp. 224-7).

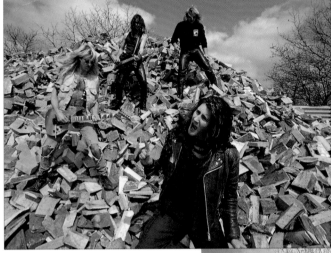

1

First cut
In this first cut, the change is heralded as much by the lighting as by location. I was shooting with the sun so that it was easier to see the singer miming the lyrics. You need to tie sound and visuals together intermittently throughout the tape.

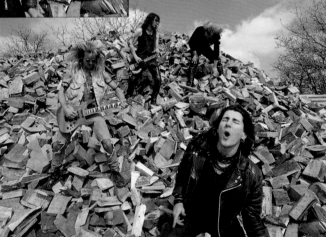

2

3

Rapid cutting

In this sequence we are now in a different part of the sawmill. The scene starts off in quite an orderly fashion, in keeping with the music, with the whole group on the back of the truck. Pretty rapidly, however, the music moves into another phase, and so do the visuals. In these images you can see the cutting process between the truck and other locations within the mill. These cuts act like reaction cutaways, but the truck scene is used as the anchor point for both the visuals and music. What you can't tell from these static images is the speed of the cutting, which at points is almost frenetic. If you make the cuts too brief, however, you run the risk of them becoming practically subliminal, and much of their impact will be lost.

Details and close-ups

As an additional part of your coverage, take a break from shooting sequences and concentrate instead on close-ups and details. As well as showing the audience more of the members of the group, they will also make a welcome visual break. Predominantly in the shots so far, we have seen the group in mid-shot and long shot, with only the occasional close-up. The balance between close-ups and long shots is something you have to work out when editing, but you will need the raw material to work with. Fail to shoot sufficient material in the first place, and your options are more restricted.

You should not stay in any one close-up for too long, however. For a start, they can be unflattering, especially if you hold a face in big close-up for seconds at a time. When filming very lively, energetic sequences such as the ones on these pages, it is also difficult to keep framing acceptable in close-up for very long, simply because the subjects move around so much. Certainly you could ask them 'to hold that pose', but that would rob the shot of some of its spontaneity.

On Vacation

VACATIONS ARE ONE OF the photographic highlights of most people's year. A lot of time and effort, not to mention money, goes into making the vacation a success, and we all want to look back on our video coverage with pleasure and pride. One of the best ways of ensuring this is by putting some effort into preplanning. If you are going somewhere completely new for your vacation, there will probably be more sights to see and activities to enjoy than you will have time for. So before you arrive, a little reading on the region you will be spending most time in will almost certainly be of benefit. Good, comprehensive tourist guides exist for most destinations, and the relatively low cost will be more than repaid.

Early morning

There are three good reasons for making an early start on vacation. First, the light often has a golden tinge before the sun is fully up, and morning mists, can produce a very soft, romantic type of imagery. Second, the earlier you arise and begin taping, the less likelihood there is of other tourists getting in the way. Third, in many resort destinations, the only opportunities the locals have of going about their normal business is first thing in the morning. This sequence of images (*above*) was taken in The Gambia, West Africa. Here it is still common to see Africans in traditional dress. When I started filming, this man was quite unaware of my presence, but as I moved in closer for a change of angle I could sense that my intrusion was not appreciated. If this occurs to you, don't insist on taping. Simply smile, thank the person involved, and leave. In some countries photography is still looked on with suspicion.

Tourist attractions

This scene (*below*) was also shot in The Gambia, but here the locals were putting on a dance specifically for the tourists. And there were busloads of them there all jostling with each other, and the dancers, for space. In these circumstances, you can forget about decorum and concentrate on getting the best footage possible for yourself. My plan of action basically consisted of getting in front of everybody else as close in to the action as possible, zooming the lens back to wide-angle, and trying to keep my mind on composition and framing while leaving the camera to take care of focus and exposure. To give some structure to the scene I decided to concentrate the camera on one individual – the young woman dancer. Towards the end she realized that I was taking an interest in her and started playing to the camera. This somehow made the scene more vital. Don't be embarrassed about getting people to react to the camera in this way.

A word of warning about exposure is needed here. The white balance control is calibrated to produce accurate skin tones under different lighting conditions. Unfortunately it is calibrated to Caucasian skin tones, so you may find some exposure problems when taping very dark-skinned people.

Basic precautions

Beach activities feature heavily on many people's vacation agendas, but sea and sand can be a dangerous combination for the delicate mechanisms inside your camcorder. Take sensible precautions, therefore, when taping at the beach. Don't, for example, use the camera if there is a very high wind blowing a lot of sand about. If the camera is splashed with sea water, carefully dry it off immediately.

A third precaution I put into effect for these shots. Seeing that I was actually going to be taping from a boat, I wrapped the entire camcorder in a tough plastic bag, making a hole in it just large enough for the lens, protected with a UV filter, to poke through. The bag was not so tough, however, that I could not still operate the camera controls. Scenes such as this often benefit from a good range of different shots (see pp. 64-5), and here I have covered this vacation activity from two very different perspectives, with shots ranging from close-ups to long shots.

1

2

3

Vacation montage sequences

A video camera is not designed just for moving subjects and broad panoramas; it is equally effective at recording, for example, small details of architectural interest, such as doorways, posters, fountains, graffiti, or shop signs – in fact anything that catches your eye and you find pleasing. This type of coverage is often associated in many people's minds with stills photography, but think how much more vibrant your images could appear when viewed via your own television set, perhaps with a voiceover commentary to go with them (see pp. 227) intermingled with live sound recorded at the time of filming. And a vacation, when you have plenty of time and your eye is still fresh to the new sights all around you, is a perfect opportunity to experiment with some more unusual types of video coverage.

Coverage

To start the sequence of images it is a good idea to let your audience see the overall location. So why not begin with some coverage of, for example, your car entering the town or village? Then a minute or two of general tourist images of some of the location's more picturesque aspects would give you plenty of time on the voiceover to describe its geographical position and any aspects of historical or contemporary interest. As the taping continues, you could subtly introduce the topic of whatever you have decided to feature as your video montage of images.

The success of this type of approach largely depends on the aesthetic appeal of your subjects and the degree to which you can bring your subject alive with your commentary. A visit to the local tourist office could be worthwhile for background information, as could half an hour spent in the library or museum. If your subject is a contemporary artefact, then you might be able to speak to a craftsperson still engaged in its production. Perhaps you might even want to record a brief interview (see pp. 188-9).

Showing just a small handful of images of diferent examples of a particular subject could be a worthwhile sequence in the middle of a more traditional type of coverage of a vacation destination, but if you can put together 20 or 30 good examples then you have a substantial piece of work that is more than capable of becoming the main focus of attention for a five- or six-minute mini-documentary (see pp. 190-91).

Shot timings

For the series of wall images (*below*), I mounted the camcorder on a tripod to ensure completely steady pictures. But for one or two of them I could not get the angles I was after, so for those I had to hand-hold the camera. For each individual image, I shot 20 seconds' worth of tape because I knew I would be editing them down at the post-production stage (see pp. 220-23) and wanted to cover myself. If you don't want to edit afterwards, however, then I would suggest varying the times for each image, concentrating longer on the ones you find most interesting, but not exceeding about 10 seconds at the outside. This will probably be ample time for you to record any highlights of information for a voiceover, and not so long that your audience starts to lose concentration.

Wall decorations

Wall decoration in the form of art, political comment, or simple graffiti is an ancient tradition, with a history stretching back thousands of years. While on vacation in Portugal, I found Lisbon a rich source of this type of imagery. Lisbon has been an important settlement ever since Roman times and now, as an industrial centre, as well as being Portugal's capital, it is a city with a politically aware and a politically expressive population.

Museums and other vacation attractions

Not all vacations are sun, sand and exotic locations. Many people are drawn to such venues as galleries, exhibitions and museums featuring aspects of local history or more contemporary interest.

As interesting and informative as these places may be, they do not necessarily lend themselves to the traditional type of video coverage – it is not a general overview of the interior you are after at such a place, it is a detailed look at whatever that interior contains that attracted you to it in the first place.

Vacation montages can be ideal subjects for those of you who don't intend to edit your material afterwards. With the minimum of pre-planning, just a few minutes jotting down a shot list (see pp. 110-11) as you first walk around, you will be able to produce a perfectly coherent, entertaining and informative tape that you can take out of the camera and play back via the television without any additional work whatsoever.

If you are interested in recording a commentary to accompany such a tape, then you will need to research some basic background information. For the sequence on these two pages, I found the museum bookshop contained ample material, most of which came free in pamphlet form.

In terms of audience concentration span, I would recommend that montage sequences such as these should not last more than five minutes of screen time at the outside. Using that as your basic starting point you can quickly work out how many images you can shoot and how long you should give each one. For example, five seconds of screen time per image means that you could easily accommodate 60 images within your five minutes.

2

3

8

9

Exploring the detail

The images you can see here carry on the theme of video montage introduced on the previous two pages. Here, however, I have taken as my vacation subject a small industrial museum in the north of England.

In fact, what inspired me to try this approach was a little scene I witnessed at the museum when I first arrived. A man walked in with his wife who was then posed against all of the exhibits in turn while he proceeded to squeeze off four or five seconds of tape of each. It struck me then just how badly the video medium is capable of being used. Not only would the eventual footage be an unending catalogue of tedious, static shots of his bored-looking companion, but the tape would not even begin to explore just how fascinating and often beautiful the museum exhibits were.

Family Vacations

YOU DON'T NEED exotic locations for enjoyable family videos. For many busy people, the only real time the whole family can spend together, without the intrusion of work and the numerous domestic activities that take up so much time and energy, is on their annual vacation. And whether at home or abroad, a favourite destination is the coast, especially for those who have young families.

Children do not often need a structured environment to be able to enjoy themselves. Sand, sunshine, and open space is usually sufficient. And while they are unwinding and letting off all that pent-up energy, you can grab some excellent material on tape. For at least part of the vacation, put aside the temptation to close your eyes and doze. Instead, record pictures of your children you will be able to look back on with pleasure for years to come.

1

2

Wheelbarrows
An age-old game for children is playing wheelbarrows, and these two (*right*) were having a raucous time. Their 15-month-old brother who, up to this point, had been quietly playing with a bucket and spade in the shelter of a plastic wind-break, was attracted by the noise they were making and raced over to join in.

1

6

7

A question of balance

There is undeniably a place for candid video coverage – people can be at their funniest when they think nobody is watching. Often, however, you will need to intrude into the scene you are taping, even if it is only because you want to record aspects of the same action from two different camera positions. Whenever possible, though, keep the mood light, the remarks funny, and try to make doing the take again as much fun as possible for all concerned. But you need to strike a balance between your desire for interesting shots and potentially destroying the spontaneity of the activity and the enjoyment of your subjects. Your family doesn't always want to be greeted by a call from the sidelines of: 'All right kids, that was great. But just one more time now!'

Leap frog

If your family is like most, with brothers and sisters squabbling most of the time, then shots like this are particularly rewarding. The children had started their game of leap frog (*below*) without any encouragement from me and were only too pleased when I asked if I could film them for a few minutes. I only needed two camera positions for cutting purposes later on, and so I didn't need to ask them to try it once more – they were going to do it again anyway. With an activity such as this, you never know when the fun is going to occur in the sequence – here, obviously, as they collapse in a heap at the end – so it's best to keep the camera running a bit longer than absolutely necessary, just in case, and be ready to zoom in to close-up.

149

Planning your video

Don't fall into the trap of thinking that you have to turn your holiday footage into an epic production the length of *War and Peace* – short snippets can be just as enjoyable. But even short snippets such as the ones shown on the following pages benefit from having some sort of structure. A coherent and interesting storyline is far more enjoyable to watch than a disjointed selection of images that dart around from one subject to another.

Start by thinking about the subjects you might want to tape and about the camera angles and types of shot you might use. Then jot down your ideas on paper.

This is particularly important if you are planning to 'edit' in camera (see pp. 60-61). With no access to a sophisticated editing suite, you must make sure you get it right first time. You don't have to draw up a detailed storyboard like the ones shown here. A scribbled note will suffice (see pp.110-11). But taking a little time to think things through before you start taping will make all the difference: you will be able to plan for camera angles and types of shot that you might otherwise overlook in the heat of the moment.

Don't be too rigid in your approach, however. It may not be possible to film everything that you'd planned to film. Be flexible and change your storyline if necessary. And don't let your preoccupation with obtaining good footage get in the way of the day's fun.

Establishing shot to introduce the characters

Mid-shot

Establishing shot

Close in on face

Establishing shot

Close in on face to start downward tilt from head...

...to feet

Variety adds interest

It is a good idea to start each sequence with an establishing shot to introduce the characters and show the audience the setting. And remember that you may want to run titles over the opening scene (see pp.228-9).

It would have been very easy to tape all the action in these sequences from a distance, but by planning everything in advance and choosing my camera angles carefully, I was able to include some quite complicated manouevres – tilts, pans, tracking shots and a range of shots from close-ups to long shots – which make them more interesting to watch.

Pan round to show the whole family

Cut to close-up

Pull out to mid-shot

Track round to show boy and sandcastle in profile

Cut to close-up

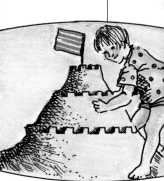

Pull out to show finished castle

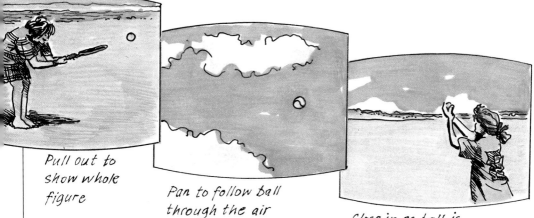

Pull out to show whole figure

Pan to follow ball through the air

Close in as ball is caught

It's all in the wrist

The sequence of pictures here resulted from a request from this boy for me to tape him. He had been practising his co-ordination with this bat and ball game for hours, and reckoned that he had it about right. 'It's all in the wrist,' he informed me. Although I don't think it would have occurred to me to tape this type of activity, it works very well on screen.

For it to have any impact, however, it is important to shoot it all as a single continuous take, since it is his ability to keep the ball bouncing on the bat that is the point of the sequence. I needed to give him plenty of room to manoeuvre, so I shot the sequence from about 2.5 metres (8-9 feet) back with the zoom range set to give me a mixture of half-length and medium close-up shots. It wasn't a straight tracking shot, though. It was more a mixture of me working the camera around him, and the boy weaving his slightly erratic path around my camera position. The result is a fluid, fun, minute's worth of tape.

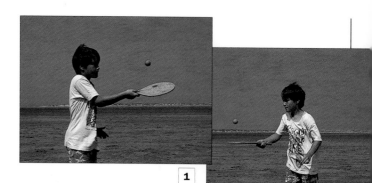

Catching a ball

As a result of the previous sequence of shots of the boy and his bat and ball, I decided to try another sequence – this time of a catch. This, however, although still simple in concept, is a lot more structured in content, and I needed to have a strategy meeting with the participants just prior to shooting. Although you might not immediately see the relevance of shooting this type of scene, the lessons of preplanning – working out camera angles and creating a coherent story with a beginning, middle and an end – can be applied to all your video work.

The sequence begins with the ball being thrown towards the bat in medium shot (*frames 1 and 2*).

Cut to close-up of girl's face (*frame 3*) as she waits for the ball to arrive. The camera then tilts down to her feet where the ball just comes into view, almost reaching the bat (*frames 4-6*).

The action picks up in a long shot, taped from the side, showing the ball being struck and sailing off into the air (*frames 7 and 8*).

This one was difficult, and I had the girls throwing the ball to each other for ages before I was satisfied that I had managed to track the flight of the ball through the air (*frames 9-11*).

The next shot is carefully framed with the catcher off to one side, thus allowing space for the ball to appear in shot and be safely caught (*frames 12-14*).

Finally I zoomed in on the catcher with her hands firmly grasped around the ball (*frame 16*). All in all, a much more complicated sequence than it might initially look, but an extremely good exercise in how to construct a sequence.

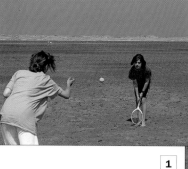
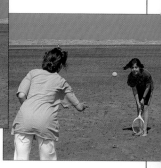

1

6

11

Demolition derby

This sequence of pictures is by way of a complete contrast to the previous set of images, which was highly structured and involved six different, preplanned shots. Here, the lad really had no interest in me or the camera at all. If I wanted to tape him, that was fine by him, but he was just going to be getting on with his own play.

The story opens with mother and child playing on a deserted stretch of beach. As the hole he is digging grows larger, he decides that it is a car – a fact that becomes blindingly obvious by the inclusion of a tennis racquet to act as the steering wheel. After a few minutes, his mother wanders off to see to one of the other children, and the action really begins. The model car was fun to build, but it was even better to tear apart. The scene was reminiscent of some anarchical demolition derby as he threw himself body and soul into his self-appointed task.

Children – Telling a Story

A POINT MADE PREVIOUSLY in this book, but one worth repeating, is that a video sequence, no matter what the subject, needs coherence – a beginning, a middle and an end. Without this discipline, any video's appeal will be extremely limited.

This sequence of shots here is of a 15-month-old baby boy's first confrontation with the sea. The story opens with the toddler being led, a little apprehensively, along the water's edge, holding firmly to his mother's hand. Then as the video unfolds,

First sequence
This initial sequence (*right*) opens with a shot of the boy's feet static in the shallow water and ends, importantly, with a similarly framed shot of them moving. In between we can see how his early apprehension dissolves as he finally releases his mother's hand. This scene is a continuous tracking shot filmed as I moved around the walking couple.

1

Second sequence
In this scene (*right*) we see a development of the one previously shot. His confidence is such that now he is happy to run off unattended into the ankle-deep water.

6

Third sequence
At this point, his mother calls to him and he checks his forward run and starts back towards the shore (*right*).

11

12

we see his confidence grow and the positive delight as he takes courage and runs off into the shallow water on his own. Eventually, pleased with his achievement, he is happy to run back to his mother's arms for comfort and praise.

There is no pretence here that this type of sequence is going to have riveting, all-round appeal – it is basically designed as family entertainment. But because of its inherent structure, as well as the controlled use of different camera angles (see pp. 68-9),

reverse shots (see pp. 72-3) and framing (see pp. 64-5), it is guaranteed to be appealing viewing for the four or five minutes of screen time the edited version takes up.

Don't, however, become so involved in filming the characters in your story that you fail to notice the setting. If some of the angles and pans here had not been properly controlled and thought through, you would have seen such distracting features as a car park, litter bins, other bathers and so on.

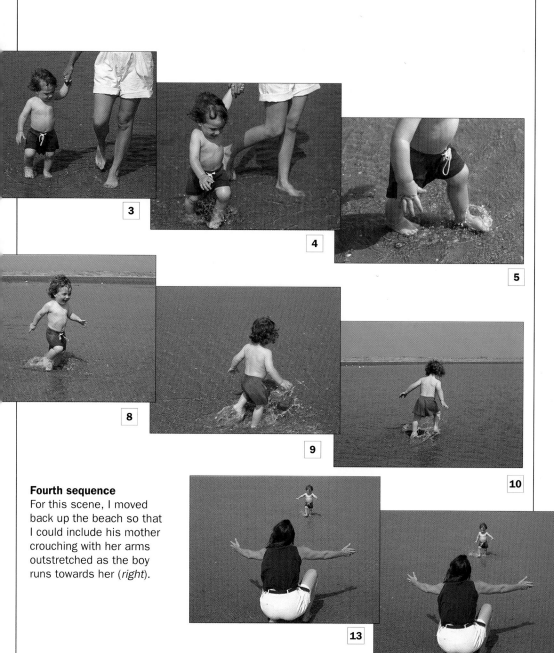

Fourth sequence
For this scene, I moved back up the beach so that I could include his mother crouching with her arms outstretched as the boy runs towards her (*right*).

15

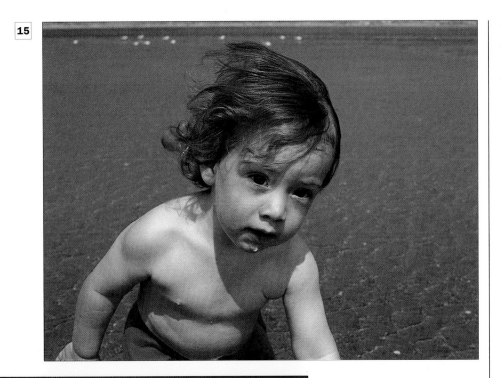

Cut-in
A change of pace was called for here, and instead of trying to zoom in on the running boy's face, which would have been a difficult as well as an unnatural shot, I cut in a close-up at the editing stage (*above*).

16

Fifth sequence – reverse shot
The previous cut-in not only provided a change of pace, but also eased the transition to this reverse shot (*above* and *right*), showing the same scene from behind the running boy. Obviously, this required a second take after I had changed camera positions.

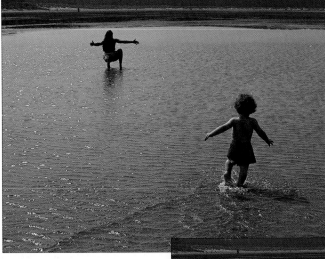

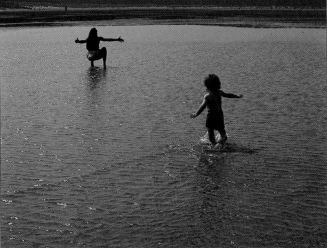

17

18

19

20

Closing in

As this video moves to its conclusion, the framing becomes tighter (*above*). Here, coming out of the previous reverse shot, I have come in tighter on the running boy to signal that he is nearing his mother, and then cut back to her crouching form again.

21

22

Sixth sequence

The climax here is the boy being scooped up by his mother, swung around and then carried off towards, and eventually past, the camera position (*above* and *right*).

23

Older children

As well as each video story having the coherent structure imposed by a defined beginning, middle and end, it is equally important that you adopt yet another discipline – that of not expecting short video sequences to do too many different things. As an example of this, with these images of a beach soccer match, I intended the tape to show the story of the game itself, specifically the children organizing the match and enjoying themselves. Certainly there were adults present on the sidelines and general vicinity, but I assiduously avoided including any of them in the sequences for fear of diluting the central theme of the children's game.

When shooting something such as a soccer match, the essence of the game is movement, so avoid too many static reaction shots. Your style of coverage always needs to be appropriate to the activity concerned.

Obviously, with only three children involved, the game was always going to be just a bit of fun, and it was this aspect I decided to highlight in the tape. It turned out that the youngest had a knack in goal and saved the majority of shots. While editing the tape down, I removed all scenes where he failed to save the goal, so giving him a perfect score sheet for the day, and adding a little bit of extra humour. The finished tape of this match lasted only four and a half minutes after editing.

Tight framing
In this tightly framed full-length shot (*right*) our star goal keeper starts the match off with a kick from goal – a plastic wind-break.

The personnel
This next sequence (*below*) introduces all the personnel. A scramble ensues in front of goal and the ball is lobbed into the distance.

1

2

3

4

Attack on goal
The ball is now retrieved and the goal is under threat. A full-length shot moving into a close-up of the ball being dribbled (*right*) gives a change of pace, as does the quick cut (*far right*) to a side-on shot.

5

6

The save
The goal keeper waits, alert and tense. Moving gracefully to his left, he snatches up the ball and drop-kicks it away to safety (*right*).

A breach of discipline
The melee in front of the goal mouth is too much for the keeper. He breaks from his position (*below*), unable to restrain himself.

7

8

9

10

11

Sanity restored
Realizing the danger, our goal keeper resumes his proper position in time for the next onslaught (*right*).

12

13

14

Saved again
Cutting away from the on-the-ball action, again we see the goal keeper composing himself. Almost caught off-guard, he recovers in close-up just in time and stops the ball with his legs (*left*).

15

Making a Nature Tape

WHEN FILMING NATURE subjects, your role should be that of passive observer. You should aim to portray your subjects in their natural state as far as possible. Be realistic, however: trying to emulate the often breathtaking expertise and photographic skill of professional wildlife teams, as explained on page 168, is out of the question for most amateur photographers.

A nature project

Embarking on a nature project with your children or a class from a nearby school is a perfect way of encouraging a caring attitude among young people, fostering in them an interest in nature conservation that, with luck, will stay with them throughout their lives.

In one of the examples you can see below, I started a project on a common grey squirrel. These acrobatic and seemingly fearless creatures make charming subjects. They are so used to people that you can approach them quite closely with a camcorder, even offering titbits of food by hand. If you are a careful observer, you will soon notice distinguishing marks that pick your squirrel out from any other that might be foraging in the same location. Once you know your subject well, attempt to follow it through its daily routine, noting where it lives and where it has buried its nuts and seeds for the lean period, which, for squirrels, tends to be the warm summer months when their natural food is in rather short supply.

This project could continue from season to season, and if you are lucky you might be rewarded with shots of the squirrel emerging from its nest with its offspring after the breeding season.

Of course, the squirrel is only one possible subject. Some large parks have herds of deer, which are not as naturally nervous of people as completely wild animals would be. Parks with such herds will almost certainly have a keeper or ranger in charge of them, and before embarking on a filming project you would be advised to introduce yourself and enlist his or her help. This way you could learn about many of the details of the animals' daily routine without having to go through a long period of observing them. And if the ranger is co-operative, you might gain access to areas of the park normally off-limits to the public. If the herd has previously been studied, then you might find that there are hides (see Box on p.166) from which you can film.

Parklands

Below are just a handful of examples of the excellent nature subjects available in many parks and parklands. Squirrels are very common and friendly, while some large parkland settings have herds of deer. And in virtually any park with a good expanse of water you can find birds such as coots and geese.

General subjects

It is often useful to have a tape on to which you transfer shots and sequences of animals you just happen to grab while out shooting generally. You never know when you might want to use such material as part of another tape as a cutaway or to justify a cut from one scene to another. On pages 168-71 dealing with falconry, you could intercut shots of a European robin, or any other bird you might have taped, to create a little drama sequence.

From the falconry scenes you could cut from a point where one of the birds is wheeling overhead crying out with its piercing call, to the robin tensing, apparently, at the sound of the falcon, and readying itself to fly off in alarm. But if you had not bothered to create the general nature tape in the first place, you might remember that you had footage of that robin *somewhere* and then spend hours reviewing old material until you finally discovered it.

Equipment

The type of equipment you need depends on the subject you are after. What will be of value in almost every case, however, will be a long zoom lens (see pp. 18-19). A focal length well beyond the range of that normally supplied on camcorders will be necessary for showing small creatures, even if they are relatively close, in any detail. The only other piece of equipment that is absolutely essential is a good tripod (see pp. 26-7). Patience is the key to success when trying for animal shots, and it is more than likely that you will want the camera supported, rock steady, for long periods of time.

Owls

While filming at a falconry centre, I took the opportunity to tape the other birds kept there (*above*). Even if they don't fit in with your storyboard (see pp. 110-11), you can build up a library of shots for use at a later date.

Bird sanctuaries

Animal sanctuaries, such as the estuarial bird sanctuary and refuge at which I took these shots (*below*), offer tremendous photographic opportunities. Many of these centres also have purpose-built hides (see Box on p. 166).

Garden opportunities

Don't ignore the opportunities afforded by your own garden – nature is alive and well there, too. Birds, butterflies, frogs, small mammals, insects and molluscs are all potential subjects. The snail here (*right*) was shot with the lens set to macro. Depth of field (see pp. 40-41) is extremely narrow at this setting, but fortunately snails don't move out of focus any too quickly.

PHOTOGRAPHIC HIDES

A hide is simply a camouflaged area from which you can film your subjects without them being aware of your presence. All wild animals are naturally cautious about any new feature of their environment, so you should construct your hide from locally available material – branches, leaves, straw or whatever is appropriate – and then clear the area for a few days until the animals have learned to accept its presence.

Construct the hide so that it encompasses you completely, so that no matter which way the animal views it, you are out of sight. In each face of the hide, clear a space just large enough for you to be able to poke your camera lens through for an unobstructed view.

Inside the hide you should have sufficient space to be able to stretch your legs out and stand up straight (ish). You will not be able to stay for any length of time in a hide that is too cramped. And once inside, make an effort to stay there for some time. Constant movement to and fro will probably frighten your subjects away.

To make your stay more comfortable, take a spare set of clothing – extra socks, woolens, scarf, and so on if the weather is cold. You will also appreciate something to eat and drink even if you are there only for a few hours.

The siting of the hide depends on what you want to film. A hide reasonably close to a bird's nesting site is one idea, but never get so close that you worry the birds, perhaps making them abandon their eggs. Animals tend to have a routine to their daily hunt for food and water, following much the same paths all the time. And so a hide close to one of these is another good idea.

Safari parks

Safari parks give you the opportunity to capture footage of animals you might otherwise have to travel thousands of miles to film. The animals quite quickly become used to the constant presence of cars, clicking shutters and whirring motors, and they will approach your camera position inside the car at very close range, sometimes too close for comfort. Even so, it is advisable to take along a more extreme telephoto zoom (see pp. 18-19) to pull in more distant detail.

Birds of Prey

NOBODY WITH AN INTEREST in natural history subjects could fail to be impressed by the breathtaking footage of eagles and hawks in flight that often feature on television wildlife programmes. The power and skill of these creatures as they first stake and then ruthlessly defend their territory, the precision with which they hunt their prey, are matched only by the tenderness and devotion they display towards their mate and their nestlings. But how many of you are aware, as you sit in the comfort of your home watching the drama of these birds'

lives, that a highly specialized camera and sound crew may have spent anything from six months to a number of years, periodically in extreme discomfort and sometimes even in physical danger, patiently taping the different scenes that go to make up an hour of screen time?

Falconry centres
It is unlikely that you will have the specialized skill, time or money to match the output of a professional film crew. But nevertheless, it is possible both to see and

Introduction
This opening sequence of three shots acts as an introduction. The first shot (*right*) in close-up of the bird with its wings outstretched is perfect for any voiceover (see p. 227) you might want to record, or just for running for 10 or 15 seconds while you speak an introduction, giving any background information you think the audience would want to know. The other two shots (*below*) introduce the two handlers and their charges.

Preparing to shoot
On the advice of the expert handlers of these birds, I spent about 20 minutes with them, allowing the birds to become used to both me and my equipment, before starting to do any taping. I had to control my natural apprehension about being so close to what could, if it wished, inflict a nasty wound. These birds are very sensitive and will immediately detect if you are nervous, unsettling them in turn.

You can see from the examples here and on the following two pages, that a pair of birds was used for the taping session. This was necessary because you can fly a single bird only so many times before it simply refuses to co-operate.

You will be extraordinarily lucky to be able to put together even a five-minute production without shooting multiple takes and then editing them together afterwards (see pp. 220-23). In fact, I spent nearly five hours producing enough material for my own five-minute production.

tape these birds with relative ease by attending one of the falconry centres to be found in many parts of the country.

These centres, devoted to the welfare of often quite rare birds, survive only by charging an admission fee and perhaps a supplementary charge for a flying exhibition when there are sufficient visitors. From a taping viewpoint, however, a private flying exhibition is to be much preferred, since then you will not have to worry about getting in other spectators' way and the rules regarding conduct will probably be more relaxed, allowing you closer access to the birds and their handlers. For this sort of privilege, however, you should expect to have to pay an extra, although not exorbitant, fee.

Camera angles

For part of the taping session the weather looked as if it might turn nasty, with threatening storm clouds building overhead. I tried to turn the situation to my advantage and to use the dramatically lit clouds as a backcloth to the falconer as he released his bird. Dropping down low to shoot and exposing for the brightest area of sky (*top right*) turned the pair into a perfect silhouette (see pp. 80-81). Since it is vital to have sufficient taped material to play with when editing, I retook the shot from the same camera angle once the sky had brightened (*bottom right*). The silhouette effect is just as good as before, but much of the drama has evaporated along with the clouds.

Potential problems

The birds of prey found at a falconry centre are not tame, although they have been conditioned to the proximity of people and have thus lost some of their natural timidity and suspicion. Also, of course, they appreciate the regular meals that are provided. But even so, they are much more difficult to tape than I thought they would be. For a start, they are unpredictable: when they leave the gloved hand of their handler, there is absolutely no way of predicting which way they will fly off. Likewise when they return – you have no way of knowing which route back they will take, especially if during their flight you have lost sight of them and can't, therefore, track their movements.

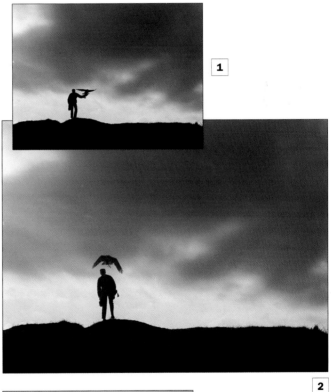

1

2

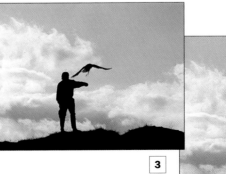

3

4

Another thing that took me by surprise was their speed. Initially I couldn't keep a flying bird in the viewfinder for more than a second or two, and attempting to keep framing consistent throughout a shot was next to impossible. With practice, however, this became a little easier, and after an hour or two I found I could track them for seconds at a time. A small victory, but for me a significant one!

Their speed also means that in one instant you have a bird with a 2-metre (6-foot) wingspan close to and, in the next, it is little more than a speck in the distance. Power zooms may be too slow to enable you to follow the birds in flight. Zooming manually may give better results. The additional angle of view offered by the lens when it is set to wide-angle (see pp. 18-19) might make it a little easier to keep the bird in the frame, but this is more than offset by the relatively small size of the subject in the viewfinder. So, don't be tempted to leave the lens zoomed back to even a moderate wide-angle setting, since the results will more than likely be disappointing.

Using tripods

One of the problems associated with a telephoto lens (or a zoom set to telephoto) is camera shake, which is always potentially more apparent as focal length increases. So here you need to make a judgement based on your own proficiency with the camcorder. Obviously, hand-holding the camera gives you more freedom to move about spontaneously and to take advantage of snatching any good shots that present themselves. If, however, these are marred by an unacceptable amount of camera shake, is the gain really worthwhile?

My preference is always to err on the side of caution and to use a tripod in situations such as this. True, I run the potential risk of missing out on some aspects of the action but, on the other hand, the footage I do capture will be rock steady and generally usable.

Coverage
The more footage you take, the more flexibility you will have to pick and choose the best material to show. When reviewing my tapes of this day, I found that on the many near flybys of the birds I had captured, the more visually arresting ones were those with clouds in shot as well, and so these (*left* and *below*) were the ones that I used predominantly when putting together the final edit.

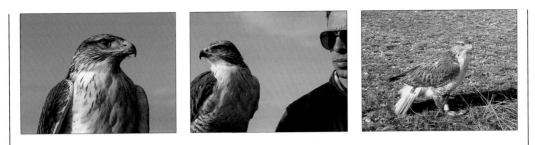

Conclusion

To finish off this short production, I thought the audience would appreciate being able to see the birds in detail – something I simply could not achieve when they were in flight for the reasons outlined on the previous pages. So the final two minutes are taken up exclusively with the birds and their respective handlers framed largely in mid-shot and, whenever possible, close-up. This worked better than I had hoped, since the birds seemed to have a real rapport with their handlers and this came through strongly. I also encouraged them to talk about their charges – their quirks and any anecdotes they had about them, as well as briefly giving as much of the birds' histories as they were aware of. I also recorded them explaining some of the intricacies of the equipment they needed to handle the birds with safety.

Gardens

GARDENS HAVE ALWAYS been a popular subject for the stills camera, but the photographer always faces the problem of trying to encapsulate the sheer variety, scope and beauty present in a garden in a single frame. Certainly, many individual pictures are beautiful images in themselves, but do they convey accurately what it is actually like to be in that particular place at that particular time? This is where the video photographer and the moving image have an unparalleled advantage.

The images on these two pages and the two that follow are not meant to portray the story of any single garden. They are taken from different tapes of a variety of locations, and I have included them to give you some basic idea of the range of approaches that are open to you.

Time of day

Most gardens look at their best in the early morning – not the crack of dawn, but certainly before the sun has climbed too high in the sky and the air become too warm. It is impossible to give precise times simply because so much depends on local circumstances. Is the garden surrounded by tall houses, for example, which might exclude the sun until quite late in the day? Is the garden facing basically north, south, east or west, since each point of the compass deter-

Setting the scene
This scene (*right*) starts in long shot showing the church fringed with trees and, in front, an herbaceous border in full flower. From the same camera position, the camera then zoomed in to a mid-shot before cutting to a close-up.

Points of interest
These two shots all have points to recommend them. In the first (*right*) there is a wide range of different textures to be explored, from the smooth, white-painted ornamental urn, down to the rounded granite cobbles, back through the image to the concrete paving slabs and grass, before reaching the stone sculpture and hedging. In the next (*far right*), there exists the potential for the camera to follow through, to take the audience into another area of the garden, either by entering through the gate into the sunshine beyond.

mines when the sun reaches particular parts of the garden? Is the surrounding area protected by a shelter belt of mature trees? All of these factors, and many more, determine the best time to tape.

Another popular time to shoot is later in the afternoon when foliage and flowers are looking fresher again after the worst of the day's heat has dissipated. It is also at this time of day that shadows start lengthening again as the sun's rays reach you from a more oblique angle, and this, too, can make for more exciting video images.

Planning your coverage

If you are planning to tape in a setting you are not familiar with, it is always advisable, before putting the camcorder to your eye, to walk around the garden first to discover exactly what it has to offer visually. If it is a large garden, then make a few notes on where particular features of interest are in relation to each other so that you can find them again quickly without wasting a lot of time. An informal shooting script (see pp. 110-11) will be of tremendous help: make sure you roughly sketch out a few camera angles you might want to try. Remember, too, that your visual perception tends to be more acute the first time you see something, so learn to trust your instincts, your first impressions.

Your coverage should include some overall, panoramic shots to give the audience a general impression of how the more detailed scenes fit into the scheme of things. If you are shooting in the grounds of a house or stately home, then try to shoot some footage of the garden from inside the building. After all, gardens are often designed so that certain aspects of them look at their best when viewed from indoors.

Linking colours
Try to make transitions from one scene to another by linking the main colour from one to the same, or a similar colour in the next. Here (*above*) you can see how easily the eye accepts the transition from the close-up of tight reddy-pink flower buds to the spectacular autumnal shades of this mature maple tree.

Contrasts
Often the visual appeal of close-up material lies in presenting contrasts. In this first image (*below*) these four delicately yellow blooms have managed to struggle through dead foliage to present a strong contrast in both colour and form to the camera. In the second, newly opened leaves, fresh and green, advance strongly as the shadowy growth behind seems to retreat from the camera.

Try to build a few surprises into your coverage. For example, the camera approaches a closed gate partly concealed in lush foliage; it swings open in front of the camera and suddenly you are in a wide expanse of less-formal garden. Likewise, the camera moves along a dark tunnel of foliage to turn a corner and discover . . . what? A statue half submerged in creepers? A tumbled down woodman's cottage? A Victorian folly built in the form of a Greek temple? Or perhaps an overgrown pond looking like a secret undisturbed for generations? You won't know unless you explore the location and plan your coverage.

Changes of pace

Perhaps changes of pace doesn't sound like an obvious objective in the context of a garden tape. But it most certainly is. If the garden contains a good variety of sculptures you could, for example, shoot a few seconds' worth of tape of all their faces. Then, when editing the tape (see pp. 220-23) you could quickly cut from face to face to make an amusing video montage (see pp. 144-7).

If a particular face lends itself to humour, you could cut from that face to what it appears to be reacting to in the garden. To contrast with this, you could show water from a fountain gently dripping on to the marbled pads of a water lily, a family of ducks creating an ever-increasing wake as they make their way across the water, picnicking families on the lawn, or a gardener dozing in the sunshine.

Pace also has to do with the types of shot you put together – close-up, mid-shot, long shot (see pp. 64-5). From an establishing long shot, for example, you could slowly zoom in to a mid-shot showing a certain aspect in more detail, before cutting to a close-up of a particular flower bed or even an individual bloom.

Long-term coverage

A large part of the appeal of a garden is that it changes all the time – subtly from week to week, but dramatically from season to season. With a little research, you can easily find out when particular plants will be at their most spectacular.

Quiet idylls
For a change of pace, what could be better than allowing the camera to linger on scenes such as this (*above*).

Formal displays
If you find this formal approach to gardening (*above right*) too garish, keep this coverage down to a minimum.

The grand scale
In large gardens, and especially those established last century, it is not unusual to find large formal pools (*right*).

Shooting against the light
Both these images (*above left* and *right*) were shot against the light – in other words, the sun was in front of the camera position illuminating the objects from the rear. The autumn yellow horse chestnut leaves were sufficiently translucent to allow some light to shine through, emphasizing their internal structure. The spreading fingers of the palm, however, were completely opaque, creating instead a very powerful silhouette (see pp. 80-81) emphasizing their external form.

Shooting with the light
In most displays of flowers you will usually be able to walk around the bed so that you can select a particular orientation of sunlight in which to shoot. These flowers (*below left* and *right*) were all shot with the light – in other words, the sun was behind the camera position illuminating the subjects frontally. In this type of lighting, colour tends to be stronger and more saturated than when shooting against the light.

Humour
You cannot predict or arrange this type of scene. Grab your opportunity when it arises. I found this image (*right*) of an old gardener sitting with his legs stretched out rigidly in front of him, apparently seeking the company of the stone bust beside him, absolutely irresistible. My main concern was to take the shot without him realizing I was there.

Indoor Sports

ALTHOUGH SHOOTING indoors at a venue such as an ice rink the action is far closer and more contained than it is outdoors at a motor bike race (see pp. 194-205), there seem to be just as many problems to be overcome.

One aspect I hadn't really appreciated before I started taping was the sheer speed with which the skaters move across the ice. One second I would have a nicely composed shot and the next second that skater was at the opposite end of the rink. Professional video crews are able to overcome this sort of problem by mounting their cameras up high, often on special hydraulic platforms almost at roof level. In this way, everything below them is relatively the same distance away, which makes framing and focusing far easier.

The other advantage of a high vantage point is that it gives you a clear, uninterrupted view of the sport. If the spectator stands are not too crowded, then you will be able to move about relatively freely, and the banked seating means that towards the rear you are up quite high – you may even be too high for your zoom to be able to come in close on the action.

Light intensity is the most serious problem you will encounter. Depending on weather conditions outside, the type of indoor lighting, the number and size of windows, light levels may even be too low to allow you to work. Even if there is generally sufficient illumination, there will inevitably be shadowy areas on the ice where the light is obstructed for some reason. Note where these are and try to avoid them when taping. Low light levels can also make for low contrast (see pp. 84-7) and visually not very pleasing results.

To increase light levels and brighten contrast you could use a booster light, but you should always check with an official first to find out if its use is permitted. You will need a high-intensity beam, and this could easily dazzle somebody on the ice if they skated too close. The beam would also be extremely narrow and not suitable for general illumination. Depending on the type of illumination used, you may also have problems with colour rendition (see pp. 36-7).

Camera angles

In the first shot (*left*) I stood on my seat to get just that little bit of extra height needed to show these two fallen novices against the plain background of the ice. In the next (*below*) I squatted down and filmed through the railing so that I could concentrate on the ice dancers' legs and feet. What you leave out can be as entertaining as what you include.

Creating tension

Because the speed-skating course is circular, by taping from just one position you will be able to obtain footage of competitors travelling in both direction. Then, by intercutting skaters travelling left to right with those skating right to left (*below*), you can create the illusion that they are converging one each other – a very useful way of building tension.

One end or the other

This shot (*left*) is from the first of a series of short takes giving a flavour of the types of activity going on at the rink on the day I was there. As soon as I had decided on a close-up at one end of the ice, the action immediately swung to the other, but the net makes an attractive foreground and the shot works just as well as an establisher.

Quiet moments

This shot (*right*) appealed to me because of the juxtaposition of the two little girls chatting quietly beneath the enormous, almost menacing, wall decoration of an ice hockey player. A good image to use as a cutaway.

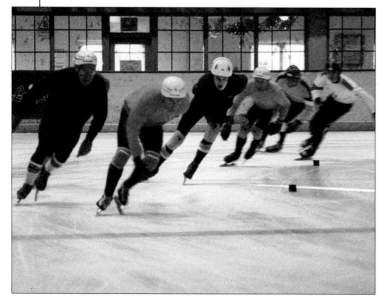

The pack

Here (*left*) the camera has captured the movement, power and concentration of this speed-skating pack as they thundered around the course. This would be an excellent shot for a short scene, before the opening titles (see pp. 228-9).

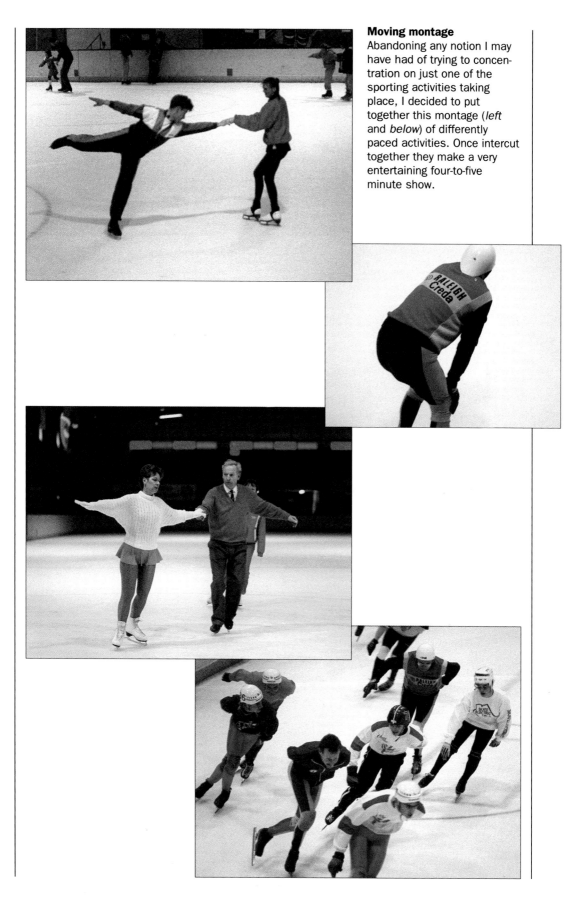

Moving montage
Abandoning any notion I may have had of trying to concentration on just one of the sporting activities taking place, I decided to put together this montage (*left* and *below*) of differently paced activities. Once intercut together they make a very entertaining four-to-five minute show.

Ten-pin Bowling

IN GENERAL, taping an indoor sporting event at a venue such as a bowling alley, where the action is extremely confined, removes many of the problems you would have encountered at the ice rink (see pp. 176-9).

As with the ice rink, however, both the level and quality of indoor lighting may cause you some difficulties. The white balance control on your camcorder (see pp. 36-7) can be set only to one type of light source at a time. So if you are confronted by mixed lighting – a combination of artificial room lighting, such as tungsten, for example, and natural light entering through windows – then you will need to decide which is the dominant illumination and calibrate the camera accordingly. This does mean that if you are covering any part of the alley lit predominantly by the other light source, then a colour cast will be evident.

For this day's shoot I set myself the project of taping of this group of retired citizens, who had formed themselves into a bowling club. Before the shoot, of course, I had made contact with one of the members of the club to ask permission to film.

The next step was to phone the manager of the bowling alley and explain my intention. He was very obliging and allowed me to walk down the unused alleys to get some head-on action shots. He even allowed me access behind the pin mechanism so that I managed to tape some excellent and very unusual camera angles.

1

2

3

4

Anatomy of the action/1

In these images (*left* and *below*), you can see the basic components of a single piece of action. First, the player selects her ball from the returns (MCU). This is followed by a back view showing the alley beyond as she lines herself up (MS), then a three-quarter shot (MLS) as she lets the ball go, and finally a cut to the pins waiting for the ball to arrive (LS). Elaborations on this could have shown her rising to her feet before selecting her ball, the pins falling and a reaction cutaway.

Anatomy of the action/2

This version (*right* and *below*) would require the more active co-operation of the participant. In the first shot you have the bowler to camera (MS), with the other three images making up the scene all filmed in a continuous take in MLS with a static camera.

1

2

3

4

Anatomy of the action/3

This version (*right*) opens with the bowler walking into shot, with the camera to the rear, off to one side, and quite low down. The scene progresses through to the release of the ball all taped from this unusual angle, and finishes with a reverse-angle shot taken from behind the pins looking back up along the alley. Of course, this last shot was staged and then edited on to the end of the other footage, but to avoid a continuity error it was important that the green ball visible at the beginning of the scene corresponded to the green ball seen coming down the alley from behind the pins.

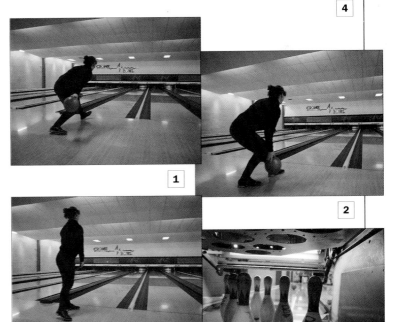

1

2

1

2

Using subject material

Always look around you to see what can be used to your advantage. The balls at a bowling alley *(below)* might seem almost too obvious to be featured but, as you can see here, their shape, colour, and reflectivity make them ideal. In the first shot, I included the neatly racked balls in the frame and waited until there was nobody visible. A few seconds of this might be useful at the editing stage to imply that the bowling alley has just opened up or is just closing down for the day. I wanted the second shot just for the colour combination of the different balls together – the lighting was not ideal, and so this type of 'colour splash' could prove to be very useful as a cutaway. In the third shot, the balls simply made an ideal frame for the main characters in the background and a perfect point to cut from to almost any other aspect of the action.

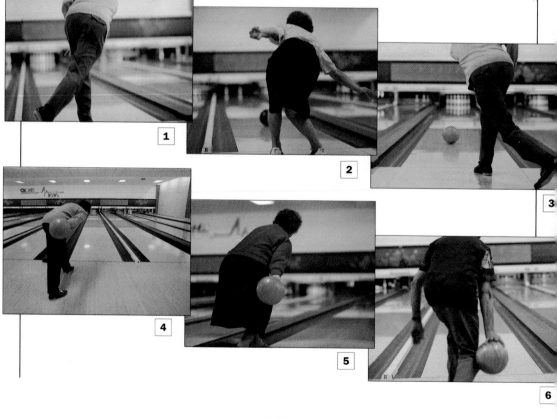

Framing techniques

These images *(below)* illustrate a variety of framing techniques that you could use to highlight the action. Often when you are taping scenes like this, it is difficult to match framing between shots. However, keeping the main action within the frame is always a good objective. Allowing the subjects to go in and out of frame, as in these shots, often produces exciting footage.

Close-ups

To keep the interest of your audience, you should include a wide range of well-motivated, different-format shots – everything from long shots to close-ups (see pp. 64-5). The images in this series of close-ups *(right* and *below)* are completely unrelated, but they are good examples of material I could edit in when cutting from an LS, MS or MCU of the different players taped at any stage during the afternoon. Interesting close-ups are always useful to have in the bag.

1

2

3

4

Cutaways

Throughout your taping of the day's activities you should stay alert to any well-composed groups or revealing points of detail that you might want to use later as cutaways *(above* and *right).* If you are not planning to edit the tape afterwards, then of course you will need to plan your cutaways so that they fit in with the last taped sequence.

Water Sports

EVERY NEW SPORTING SUBJECT carries with it a unique set of considerations for the video photographer, and thus entails a slightly different approach to filming.

Basic approaches

These two pages, and the two that follow, are both concerned with water sports – sailing and windsurfing. There are two basic approaches to subjects such as these. The first, and by far the most difficult, is to leave the shore and join your subject on the water – perhaps filming from a small motor boat. However, even the calmest stretch of water will cause a small boat to pitch to a degree that makes it difficult to obtain steady, consistently framed images. Obviously, the larger the boat you use as a platform, then the less you need worry.

The second approach is to film from a long jetty or a fixed pontoon moored some way off the shore. Using this type of location will enable you to obtain rock-steady footage. You will also have a choice of using the water as a backdrop or, when the action is close in to the shore, of shooting reverse shots looking back towards the land. The visual variety of this second approach makes the effort involved in finding a suitable location well worth while.

A caution

Water, especially salt water, is a hostile environment for your camcorder (see pp. 238-41). If you do decide to film from a boat then you need to be aware that there will always be a certain amount of water spray in the air, which could potentially affect the camera's delicate electronics and the front glass element of the lens. As a precaution, then, it is best to enclose the camcorder in a rain jacket or a strong plastic bag with a hole cut in the front to accommodate the lens, which you should protect with an ultraviolet filter (see pp. 242-3). Make sure that the plastic is not so thick that you cannot easily operate the camera controls.

Camera position

This sequence of images (*right*) follows on directly from the previous scene (*below*). The action of the boat capsizing was in danger of becoming murky in what was basically a backlit shot. So by moving camera position I managed to find a shooting angle that was more square-on to the action, and also where the front lighting produced far better colour saturation, which readily shows up in the life jackets worn by the yachtsmen struggling to right their capsized craft.

1

2

Exposure considerations

For this piece of action (*above*), the sailing boat occupies only a relatively small part of the frame. And as you can see, the sky and water were, from an exposure point of view, the dominant features in shot. The sky, obviously, is the primary light source, but what many people fail to take into account is that water reflects back a lot of light. Put these two together in the same shot, and underexposure of the main subject is likely. In a situation such as this, shoot some test footage first, play it back and then decide whether or not you need to use your comcorder's backlight-compensation facility.

1

2

3

4

4

5

6

Windsurfing

WINDSURFING IS THE TYPE of subject where there is more interest – or, at least, humour – in taping the efforts of a learner rather than those of a proficient practitioner. If you have tried this sport yourself, you will know that initially it seems impossible to keep a steady footing on a constantly shifting and slippery board while, at the same time, trying to keep a flapping plastic sheet attached to large pole from pulling (or knocking) you into the water yet again. And once the sail is under water, it is extremely heavy to pull upright.

My subject for these short tape sequences was a stranger who was more than happy to co-operate once I promised to send him a copy of the finished tape.

As a general rule, learner windsurfers will not, unless by accident, sail out very far from the shore, and so it is usually possible to obtain all the material you need from the safety of dry land. Often, too, you can obtain reverse shots – that is, with the person between you and the shore – simply by wading out a little way into the water or by shooting from a moored boat (the wash from a windsurfer's board will not cause any additional problems.

Opening sequence
This sequence (*right* and *below*) starts with a minor success – the rider upright on the board, even if he is motionless in the water. It cuts to show, inevitably, the rider in the water having fallen off and his attempts at pulling the sail out of the water while fighting to maintain his balance.

Concluding sequence
The majority of this tape, the edited length of which is only five minutes, has to do with the funnier aspects of the man's struggles to control the board and sail. To finish off, however, it is best to conclude on a high note, and this sequence (*above*) shows him having finally achieved some measure of success. In fact,

I shot this sequence quite early on before he become too tired. But for family viewing the mistakes are often more fun! At the editing stage, however (see pp. 220-3), I slotted it in at the end to make a more coherent story out of the material.

An Informal Interview

FROM YOUR OWN experience of watching television interviews, you will know that a successful programme often depends on the interviewer's ability to draw out from the interviewee personal details and reminiscences that give added colour and insight. To do this, you need to do background research on both your subject and his or her areas of interest.

Coverage and lighting

In this interview with potter and ceramics artist Lucie Rie, we both decided that her home/studio would be the ideal location. I wanted to talk to her not only about her craft, which was much in evidence throughout her home, but also about the early influences in her life, what she considered to be the major highlights and milestones, setbacks and successes that had shaped and formed her work.

One of the first things that struck me about her was her effervescence: it was almost as if she could not sit still for a moment. This immediately ruled out any notion of a formal, subject-in-an-easychair type of approach. And it also raised the question of how to set the lights in such a way that she could move freely about the room without being lost in the shadows every now and then.

To solve this I used two 500-watt photofloods reflected off the ceiling (see right). This bounced lighting was also necessary to stop 'hotspots' reflecting back from the surfaces of the glazed pottery, which would have been distracting. The rooms were not large, so this level of lighting was enough to supplement the weak daylight entering via the windows to create soft,

Setting your lights

In a situation such as this, when you need a generalized lighting scheme to allow the subject the greatest possible freedom of movement, avoid directional lighting as far as possible. If lighting is too directional, areas of shadow are almost inevitable. Instead, as shown here, set your lights so that the illumination bounces off a convenient surface, such as the ceiling. This causes the light to spread out and give an overall, softer effect.

'Noddy' shots

The term 'noddy' shot refers to a second or two of the interviewer looking intently or appearing to react to what the interviewee is saying, usually by nodding his or her head (*below*). In fact, since invariably only one camera is used for an interview, noddy shots are taken after the interview has finished and the subject departed. During editing, the shots of the interviewer are edited in to give a little variety and a change of pace. When taping a noddy shot, however, make sure the eyelines work when the two shots are juxtaposed.

detail-revealing illumination throughout. During the interview we changed rooms, but rearranging the lighting took only a few minutes.

Camera supports

Usually an interview is conducted with the subject in one place, allowing a single, fixed camera position with the video mounted on a tripod fitted with a pan-and-tilt head (see pp. 24-5). Changes in shot size are then achieved using the lens's zoom facility. But with a subject who moves around continuously, you might find a Steadicam (see p. 24) more practical.

Frame size

In many interview situations you will want to vary frame size from, say, big close-up, close-up and mid-shot (see pp. 64-5) to give visual variety and added interest. In this case, however, you can see that framing was approximately mid-shot throughout. This was because Lucie Rie was constantly referring to her magnificent pots and other ceramic pieces as she spoke.and it was important to keep both her and her work in shot to avoid having too many jarring quick cuts or endless pans from one to the other. Some other parts of the interview did dwell more on her early life and those sequences were framed more in close-up.

Making a Documentary

A VIDEO DOCUMENTARY tends to be less formal than an interview (see pp. 188-9). In a documentary the subjects tell their own stories, without the intrusion (except perhaps occasionally) of an 'outsider' asking questions. Certainly you may need to draw out from your subjects the reminiscences or information that you want; but you should avoid asking the type of question that can be satisfied with a simple 'yes' or 'no', since this will then throw the onus back on you to play the part of interviewer. When editing the tape (see pp. 220-23), you may decide to cut your questions out of the soundtrack altogether, leaving your subjects' voices to carry the storyline.

Background information

Objects relating to the story your subjects are telling are always useful: in the case of these two charming, and remarkably active, stage dance acrobats (he is over 80 and she over 70!), newspaper clippings, posters or old photographs of them in their youth, over which the sound will be played, would all give invaluable background information. As well as providing visual interest and a change of pace, these mementos are useful sources of information when you come to put together the script for the voiceover (see pp. 108-9).

A key sequence

First, you have to remember that these few frozen frames (*below* and *right*) are part of a moving sequence, full of character, as well as astonishing considering the age of the participants. This particular sequence is important to the documentary as a whole, since it shows the couple performing parts of the dance routine described, both in words and with old photographs and posters, in earlier sequences. Funnily enough, this sequence was unplanned. Initially I asked just to take some footage of them in their costumes, and posed them under a framed poster of the two of them when they were active stage performers. But once in their costumes, they insisted on going through their old routine for the camera.

Making a coherent record

When making a documentary you should try to avoid a visually cluttered setting and do not introduce anything that will confuse the story. This does not mean you have to shoot in a starkly bare environment; that would be unnatural and unattractive. But try to clear out of shot anything that might distract the audience's attention, and thus detract from the point you are trying to make or the atmosphere you are attempting to create.

Another point to consider, especially if you want to avoid masses of post-production editing, is that people rarely relate a story in a straightforward, chronological fashion. They might plunge in at some point that has particular significance to them, and then jump to something that happened years before that, before relating it to something much more contemporary.

For the sake of your audience, it is your job to keep them approximately on track. One way of doing this in an unobtrusive fashion is, before shooting, to talk to them about the high points in their career, encouraging them to give you a reasonably well-ordered history of the events you want brought out on tape. It is a form of rehearsal for the real thing; but be subtle about the prompts you feed them once you start for

real, otherwise it may sound like a flat recounting of a prepared speech.

Continuity

Finally, be sensitive to the needs of your subjects. Unless they are well used to media attention, the presence of strangers, video camera and lights will probably put them under a certain amount of strain. I find that for the sake both of your subjects, and your potential audience, you should not try for more than about 30 minutes of screen time.

If you need to spread taping over a whole day in small bites, or to tape on different days, then make sure you avoid any disconcerting jumps in continuity (see pp. 76-7). One way of avoiding this is to take a Polaroid instant picture before breaking off from the shoot and then compare the photograph with the setting just before turning the camera back on.

If you are relying on natural light for a documentary, you need to ensure that when the sun moves during the day you do not see shadows migrating around the room. This will give the audience visual clues as to the passing of time, and spoil the illusion that the production was shot during the 30-minute time frame you have compressed the footage into.

Training and Promotional Videos

ALTHOUGH THE CAMCORDER and the video medium offer you a wonderful opportunity to make entertaining videos, either of factual or fictional subjects, they have potentially many more applications than this. This is due in large part to the fact that the video tape can be played back time and time again, in real time, slow motion and freeze frame.

Video applications

One of the most obvious of these new video applications is as a sales and promotional device. Many, if not all, people travelling to a new destination on vacation or business choose their hotel or apartment on the basis of a photograph in a brochure or because it is recommended by a friend or acquaintance. Often there is no problem, but sometimes the reality falls far short of expectations and an important vacation or business trip is ruined.

A far more informed decision would be possible if you had the opportunity to view a short promotional video of the accommodation. This could include not only the type of room you would be staying in, but also the view from, say, the balcony or window, the outside of the building itself and the grounds, and any facilities you might be interested in using – the restaurants, entertainment and family rooms, for example. This type of promotional video is already commonly used by companies selling time-share accommoda-

A boon to travellers
Having more information about accommodation would help all of us make more reasoned decisions about where to stay. The tape should show a typical room (*above*) as well as aspects of the setting and facilities.

Informative sound and pictures
Museums (*right*) can benefit from selling guided video tours alongside the postcards and slide packs that have been available in many such institutions for years. A voiceover can give all the background information as the camera explores different aspects of the exhibits.

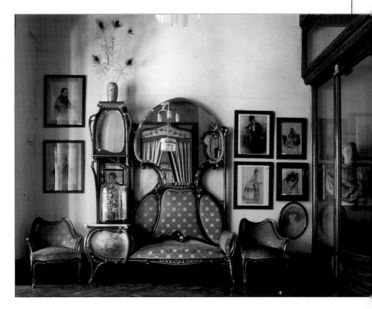

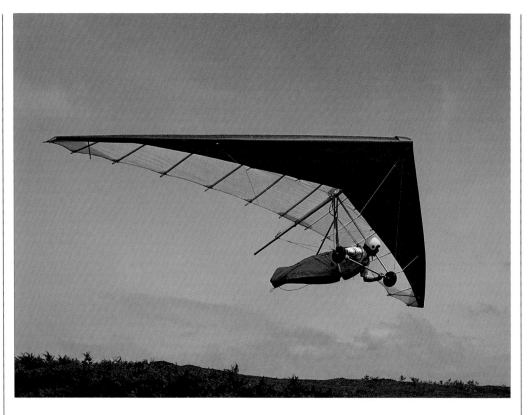

Instant feedback
Becoming proficient in such sporting activities as hang gliding (*above* and *right*) means making small yet vital adjustments to certain aspects of your technique. A video would give you that important feedback immediately after you have made the mistake.

tion. Ultimately a trip to the property should be made before signing on the dotted line, but a well-made video tour is often used to trigger any initial interest.

Another area in which video is commonly applied has to do with training. Videos are often used as a training tool in horseback riding, golf, swimming, weight training or, as shown here, hang gliding. Many sports require a high degree of fine tuning of such things as grip, posture and physical co-ordination – all things that can be videoed and played back to the subject on the spot to show how technique could be improved.

Training also covers such things as presentation and communication skills, and many companies enroll key personnel in training courses that utilize role-playing in front of a video camera. Everybody on the course then has an opportunity to view the tapes and comment on the performances of everybody else, thus providing much vitally important feedback.

Making a Sports/Action Production

SPORTING EVENTS make ideal subjects for the camcorder. Action, excitement, noise and tension are just some the characteristics that spring to mind.

Although the action may be better organized and of an extremely high standard at a professional sporting event, there is a lot to be said for attending amateur meets. At a professional match, access to the teams or individuals participating will probably be very restricted. And unless you are a professional photographer or have managed to obtain a special pass you will more than likely be confined to the spectator stands.

Things will be very different at most amateur sporting events, however. In general these events are far less formal than their professional equivalents. Spectator stands are usually smaller and closer to the action. The organizers are also often far less likely to worry about photographers straying out of the officially designated spectator areas, unless of course there is any question of danger or disruption.

The participants themselves will often be more than willing to co-operate. If you wanted to put together really in-depth coverage of an event, an interview with the winner, or the captain of the winning side, could make fascinating viewing for other fans and supporters. As with other types of video production, you should aim for as varied a coverage as possible – behind-the-scenes shots, preparation for the event itself, spectators, peripheral activities and so on.

Preparation
Sporting events are generally advertised well in advance, to commence at a fixed time and at a known location. This in itself is a great help in allowing you to prepare your method of coverage, equipment requirements, transportation, and so on.

No matter what the sporting event is, the more thoroughly you know the subject the more chance you will have of being in the right place at the right time. For a start, make sure you know the rules governing the flow of play, since they may give you an invaluable edge in second-guessing what is likely to happen next.

If at all possible, try to get to the event well before the main crush of people arrives. This way you will have a much better chance of staking out the likeliest spot to set up your camcorder.

Proper preparation also means thinking about what equipment and accessories you might need. Obviously you will want to take sufficient tape cassettes. And having worked out how many you will need, put another couple in your camera bag or in the glove compartment of the car just in case. Batteries are another consideration. No matter where the event is, it is unlikely to be conveniently located near a shop selling spares. Will you need a tripod? Or will you be able to manage with more informal camera supports, such as the boot or bonnet of your car, the top of a convenient wall, and so on (see pp. 20-27)?

If there is likely to be a lot of mud or dirt flying around, such as there was at the cross-country motor bike race covered here and on the following ten pages, then from personal experience I can warn you that you will need an ultraviolet filter on the camera at all times to protect the front element of the lens. As well, you will need a cleaning kit to keep the camera and filter from becoming too dirty.

Setting the scene
After some initial establishing shots of the track and its surroundings, I turned the camera on the race official setting up the starting gates (*below left*). Then I filmed the same official calling the bikes up to the starting line (*below centre*), and then a long shot of the bikes waiting for the flag to fall (*below right*).

If you are planning to try for an interview with a participant after or before the event, then what type of microphone should you take along (see pp. 28-9)? And will you need a microphone boom or wind jacket for the mic? All of these questions, and perhaps a few more besides, need to be sorted out to ensure that you capture the type of footage that can be turned into an exciting and a watchable tape at the end of the day.

Motor bike meet

The event you can see here is a monthly meet held (weather permitting) in the Norfolk countryside not far from my home. I've found it to be an excellent venue, being a combination track and cross-country race. The calibre of the participants is consistently high, the competition between riders intense, and the action usually furious.

My aim was to produce about a 20-minute tape – that is, 20 minutes of edited screen time. But to gather sufficient footage I had to shoot nearly four hours' worth of material. And because I wanted the final tape to encompass all that goes into a day's racing – the preparation, erecting the starting gates, the officials, mechanics, the riders before the races start, as well the races themselves – I arrived at the track in the morning well before the first flag fell.

1

2

And they're off

It took some swift footwork on my part to get back around behind the riders in time for this scene (*above*), which shows the bikes being revved up hard for the off. It's interesting to compare the colours of this scene with those of the previous one. There was not more than a few seconds between them, yet the exhaust fumes filling the air have diffused the light so

3

much that the colours are now nearly bleached out. As the scene starts, the camera is showing a mid-shot view of the riders. As they tear off, however, and the dust settles, the framing turns into a long shot concentrating more on the distant spectators on the hill in the background.

One race isn't enough

I could manage the first two scenes by moving quickly before the bikes actually left the starting line. For this one, though, shot from the specta-tor's viewpoint as the bikes hit the first bend, the timing was impossible to achieve. It is in fact a sequence from the second race of the day edited into the start of the first at post-production stage (see pp. 220-223).

1

2

Right place, right time

If you are familiar with the venue and the sport, you can predict with some accuracy where the most promising camera positions will be. Even at an unfamiliar track, there are still some things you can do.

First, look for where the biggest crowds of spectators congregate. Fans tend to gather where the best action normally occurs or where they have the best overview of the entire event. If the crowd is too great, though, you might find filming a bit difficult.

If so, your next line of action is to speak to some of the officials. Try not to approach them when they are busy with their duties. Wait until they are not busy and then explain what you are trying to do, the type of shots you are after, and ask their advice.

If that's not possible for some reason, then you can always try speaking to the riders directly. If anybody is going to know where the action is, it is the participants.

Panning and prefocusing

Because at the speed at which these bikes are moving, your panning technique has to be almost reflexive. For these shots you have to prefocus on a specific part of the track before the bikes arrive. You can't rely on the autofocus facility on your camcorder. For a start it would not react quickly enough and, secondly, until the bikes actually enter the frame the autofocus will have nothing to react to and will probably be set somewhere on infinity. In the second of these two shots, you can see that one rider is

1

2

considerably more blurred than the others. This is because objects appear to be moving more quickly the closer the subject is to the lens.

Panning and pulling focus

When panning a moving subject moving at 90° to the camera position, the subject-to-lens distance stays approximately the same throughout. However, when panning a subject moving around a bend, as in these examples, the subject-to-lens distance alters all the time. This means that in order to maintain a sharp image through the whole pan, you will need to pull focus at the same time (see pp. 42-5). This is difficult, and even the experts get it wrong on many, many occasions. So rehearse your shot and be prepared to shoot the same scene time and time again as the bikes come into frame. But when you get it right, it does look impressive on the screen.

1

2

Research pays off

These are the types of scene that make all the preparation and slogging through the mud and dust worthwhile. They are, like many of the scenes in this production, all from different races during the day's shooting. But scenes shown in sequence will be viewed by the audience as being part of a single piece of continuous action. The only thing that might give it away is if the light quality varies dramatically from shot to shot.

In these three scenes, the crowds had gathered in quite large numbers. But by choosing the right camera angle (see pp. 68-9), I was able to exclude most of them from the frame, and the images benefit greatly as a result.

Exposure override

In most situations, the camcorder's autoexposure system produces good results. There will be times, however, such as with these images, which were shot against the light, when you will need to put the camera on manual. With video, what you see in the viewfinder is what you will get on tape. If it looks right, it will be right – with one exception. Some camcorders have a contrast control for the viewfinder, so it is possible for the image to look correctly exposed when it is not.

Prior knowledge pays off

It is when you are filming a real situation that your knowledge of the sport may again bear fruit. If you are really knowledgeable you might well be able to recognize an accident in the making. The bunching at the beginning of a race is a typical example. Here you have a high concentration of machines all jockeying for the prime position. Likewise, at a sharp bend you might recognize that a particular rider is going to mount a challenge for position and that it is a risky proposition.

If you do find that some technical aspect of your camerawork is not right, don't be tempted to make a sudden correction. This often simply draws the audience's attention to the original error. Instead make any correction as gently as you can manage in the circumstances. Remember that perfect focus, perfect exposure, perfect position, and perfect framing only normally occur in television and movie dramas, where every element of the action is decided beforehand and rehearsed. At a sporting event like this, things happen extremely quickly and there will undoubtedly be incidents that you can't plan for. Stay alert to whatever is happening and concentrate on getting the best, and most varied, footage that you can.

The keys to success are anticipation, alertness and, above all, luck.

1

2

3

7

The dramatic moment

In many sporting events, but in motor cycle racing in particular, one of the great attractions is the danger inherent in the activity. Photographers, as well as the fans, are drawn to the most testing parts of the course because it is at these that the chance of seeing something go wrong is greatest.

In the general excitement of witnessing a spill, such as these two here, both of which resulted in no injuries to the riders and very little damage to their machines, it is difficult to keep your filming smooth and even. You might feel tempted to use your zoom to bring the action up closer. My advice is don't, unless you are in long shot and the details of what is going on are too far away to be clearly seen. Otherwise, leave the focal length alone and concentrate on framing – keeping the subject(s) in a consistent part of the frame from shot to shot – and on composition and, if there is time, exposure.

Thinking about editing

No matter how good the coverage, how exciting the action, how varied the imagery, a 20-minute tape of any subject matter cannot simply be a series of straight, descriptive shots edited together

The visual sophistication of your audience, finely honed by a lifetime's viewing of elaborately made television and movie productions, demands that you vary the visual pace of your coverage by using some of the editing 'tricks of the trade'. One of the easiest to achieve, and also one of the most effective, is the cutaway, in which the audience sees briefly a small detail of an aspect of the overall action. Although a completely artificial filmic convention, the cutaway paradoxically adds a sense of 'realism' to your work.

Another aspect of adding a sense of realism to your work has to do with sound levels. It may seem almost too obvious to mention, but when you visually move in close, sound levels must increase correspondingly. Likewise, when you pull back, then sound levels must fall.

It is all to easy to forget this when working with a zoom lens. Standing in one spot you can zoom in and out, producing a range of shots from long shot to close-up (see pp. 64-5). The microphone, however, continues to record a constant level of sound through-out. Matching sound level to the visuals is therefore a vital post-production editing task (see pp. 224-7). It is this sort of attention to detail that will lift your work above the run-of-the-mill amateur production.

1

2

3

Cutaway 2

Cutaways have to be used with restraint and only when the action seems to make their inclusion logical and appropriate. But they represent an excellent technique for building tension and quickening the pace. This scene (*above*) is the result of using a completely static camera – I simply prefocused the lens and let the riders flash past my position, in and out of frame. But the scene is suffici-ently long to carry two good cutaway shots. The first would be after the second shot. After seeing rider number 96 coming towards the camera position, you cut to either a close-up of a gloved hand operating the throt-tle or of a booted foot kicking down the gears in preparation for the bend. The next cutaway could be after the penultimate shot, with a close-up of dirt and mud flying out from the back wheel of a bike. This would then tie in very well with the last shot, which, as you can see, shows mud spinning away from a bike just out of shot. Believable, tension building and exciting – all the right ingredients for a successful edit.

Cutaway 3

This series of three shots (*right*) was achieved by combining a pan and tilt with a zoom. Panning invariably involves tilting as well, since it is highly unlikely that the elements you want to focus on at both the beginning and the end of a pan will be at an identical level, making some vertical adjustment of framing essential. For a cutaway with this type of imagery I would suggest a crowd shot be-tween the second and third shots. The screams and cheers of the crowd urging the riders on would lead naturally into the closest part of the zoom following as the riders negoti-ate the bend. As with the last example, the crowd shot could be taken at virtually any part of the course and at any time during the day, as long as the light qualities of the cutaway and main shot were approximately the same.

1

2

3

Cutaway 1

This sequence of three shots (*above*) is from a scene quite near the beginning of the race. In the first shot, I had the riders in frame for many seconds as they roared towards the first bend. As they came nearer it was important to pull focus, but I didn't alter focal length. The second and third shots constitute what could be called a 'whip pan' – in other words I literally had to whip the camcorder around to follow them through the bend.

At the end of the third shot, there is the perfect editing point for a cutaway. The subject that immediately comes to mind is a shot taken from a rider's POV (see pp. 66-7) showing the vibrating forks of the bike and the dirt track streaking by beneath the front wheel. Of course, you would need to enlist the friendly assistance of a rider for this, or fake it with a motor bike on a dirt track at some later time.

4

5

6

1

2

3

The motor bike meet – a general overview

At any type of sporting event, much the best plan is simply to gather together sufficient good and varied material that can be edited down to give your audience an enjoyable 20-minute overview of the day's activities.

The images here and on the following two pages are very edited highlights of my day's shoot. They are just individual examples of shots from different scenes roughly assembled to give you an idea of how the action can be paced to give a very subjective viewpoint. The order in which you see the scenes here is not by any means definitive – other photographers presented with identical material might well choose a different order, drop some scenes completely, and include other I omitted. There is no formula; there is no right or wrong way; you design your own choice of programme.

Plan of the course

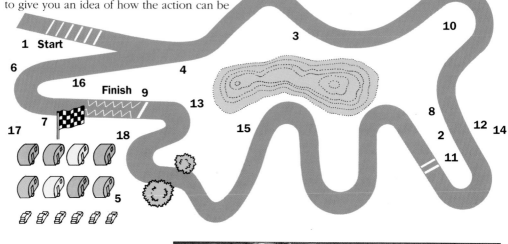

Scene 1
Establishing shot (*right*). This lets the audience see where the action is to take place. The length of the scene would depend on whether you intended to run introductory titles or to add some form of narration afterwards.

Scene 2
Bikes jockeying for position before the start of the first race (*above*). Lots of activity, sound, tension building.

Scene 3
Bike jumping and camera pans to keep it in frame (*above*). Bring up sound of crowd cheering as engine screams.

Scene 4
First cutaway (*above*) implies danger by cutting to scene of ambulance men intently watching the race.

Scene 5
Different race now, panned shot of bikes racing off from the starting line (*above*).

Scene 6
Between races – a change of pace to show riders and their crews relaxing while they can (*above*). Nice domestic touch with pet dog tethered to the bike transporter – helps to give a more rounded coverage.

Scene 7
Part of a pan showing bikes negotiating a corner (*below*). As wheels bite into ground, dirt flies everywhere.

Scene 8
Part of another pan, but a much slower one (*left*).

Scene 9
Good dramatic shot of bike with both wheels off the ground (*right*).

Scene 10
A pan (*above*), moving the camera to keep the rider in frame for a second or two. This close to the action at the speed the riders are going, a static shot at 45° to the camera position would result in an unintelligible blur.

Scene 13
An unusual camera angle (*right*) helps add drama to your coverage. I was, in fact, down a shallow gully running alongside this part of the course, shooting up at the riders.

Scene 14
Follow through is an important camera technique. Here I captured the bikes hitting the ground after a jump (*below*).

Scene 11
Pan (*above*). The going was soft and there was a good chance of a bike spinning out.

Scene 12
If you can, always try to fill the frame – especially with dramatic images (*above*).

Scene 15

A change of pace here. I shot this scene of a rider getting in some last-minute practice between races (*right*) and, I suspect, working off some of his nerves before the start. You could also use this type of material as a cutaway.

Scene 16

These sorts of pans (*above*) are more difficult than they first look. For them to work well you need to keep framing consistent throughout – no easy matter at the speed they are travelling.

Scene 17

Another excellent point in your production for a voiceover of narration. A between-races shot of a rider talking to an official (*left*). Shows the general informality and good humour typical of these types of event.

Scene 18

Near the end of this 20-minute production now. The light is beginning to fail, the day is drawing to a close, and the bikes are riding off into the sunset – well, almost. In fact, they are approaching a dramatically backlit yellow flag indicating a fallen rider ahead (*above*). This type of scene makes a perfect backdrop for your finishing titles (see pp. 228-9) or the conclusion of your narration.

Making a Fictional Drama Production

THERE TENDS TO BE a general reluctance among amateur videomakers to script and then shoot their own fictional dramas. Often the reason given is that they see the camcorder as a tool simply for recording candid footage of family, friends, vacations, and so on, or for set pieces, such as weddings. This is a pity, since the techniques and disciplines involved in shooting a scripted production, even a loosely scripted one, will flow through into all of your work, making everything you tape more professional, more entertaining and certainly less of a hit- and-miss affair.

Where to shoot

An idea for your own fictional drama does not have to be complicated. Far better indeed is something very simple, a plot involving a minimum of locations and just two or three characters. The choice of whether to shoot indoors or out can be tricky, though. Shooting sufficient tape even for a four- or five-minute production could easily stretch over two days. So if you opt for an outdoor setting

you have the vagaries of the weather to consider (remember, possibly over a two-day period), as well as the often frequent shifts in light quality and intensity from minute to minute.

If you decide on an indoor setting, you could well find that light levels are sufficiently poor for the room (or rooms) to need artificial lighting to avoid excessively 'grainy' images (see p. 82-3). This will involve you in either buying or hiring lighting units. But you will then have total control over this very important aspect of image quality, since it is lighting that most often affects mood and atmosphere.

Another point to bear in mind if taping indoors is that you may need to set the white-balance control of your camera (see pp. 36-7) for whatever artificial light source you have selected. This means that any natural illumination entering through windows might cause a colour cast. Thinking ahead and selecting the appropriate camera angles to avoid the natural light source should minimize this particular problem.

THE
FORBIDDEN
FOREST

Starring Rosie & Martha

STORY CHECKLIST

Name of production:

Location:

Date:

Time:

Personnel

a) Actors:

b) Crew:

Equipment checklist:

- Camcorder
- Spare tapes
- Filters
- Special fx equipment
- Headphones

- Spare batteries
- Tripod
- Additional lighting
- Microphones

Continuity checklist: (in the space below note all details of weather conditions, actors' clothing, props, etc that might have an effect on continuity)

Story checklist

The idea of creating such a form, photo-copying it for every production, and then filling it in religiously is to ensure that you leave nothing to chance. Nothing is more demoralizing than, when on location miles from anywhere, finding that you have run out of tapes or your camera batteries have suddenly died. Nor do you want to find later at the post-production stage that a basic continuity error has written off a whole day's shooting.

The Forbidden Forest

The images on these pages, plus those on pages 210-11, represent just the bare bones of a simple fictional drama production. In this format, I intended that the edited tape should run for only about four minutes.

The storyline

Two little sisters, Martha and Rosie, decide to have a picnic in the fields nearby their home. Their mother warns them, as she does every time they go out alone, that under no circumstances should they enter the Forbidden Forest that runs at the back of their house. The girls are never told why the forest is dangerous, but they know that everybody in the region speaks in hushed tones of 'mysterious happenings' and the 'strange noises' that can be heard coming from that area of heavily wooded hillside.

Naturally, on this occasion curiosity gets the better of them and they decide that as long as they don't go *too* far into the forest, not much can happen to them. And, after all, it's a bright, sunny day, and everybody knows that 'mysterious happenings' only ever occur at the dead of night night.

So with this simple storyline, the stage is set for an adventure of a lifetime, as the girls blunder into a world populated with people and dinosaurs thought extinct for tens of millions of years.

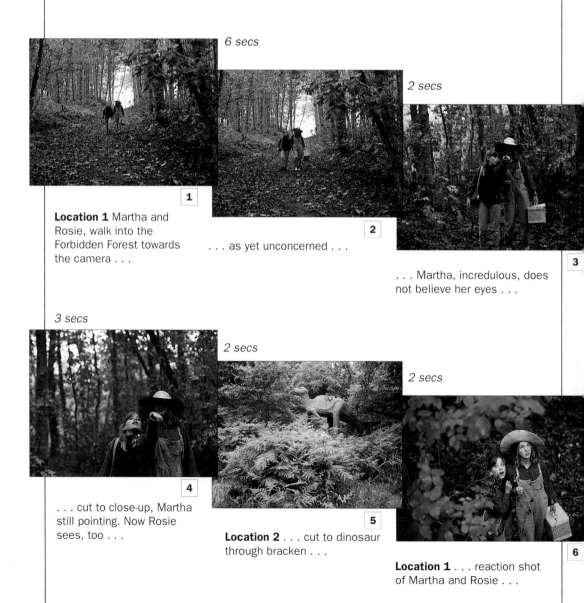

6 secs

2 secs

1

Location 1 Martha and Rosie, walk into the Forbidden Forest towards the camera . . .

. . . as yet unconcerned . . .

2

3

. . . Martha, incredulous, does not believe her eyes . . .

3 secs

2 secs

2 secs

4

. . . cut to close-up, Martha still pointing. Now Rosie sees, too . . .

Location 2 . . . cut to dinosaur through bracken . . .

5

6

Location 1 . . . reaction shot of Martha and Rosie . . .

Location 1

This plot occurred to me largely because of the proximity of the Dinosaur Natural History Park to my home near Norwich in England. In your case, a plot idea might be triggered by a circus, fun fair, boating lake, dry ski slope, or a row of run-down buildings – in other words, whatever your imagination can make of your surroundings.

Fortunately when I asked for permission to shoot at the dinosaur park it was summer and the weather was good. Unfortunately, because of this the maintenance schedule was very heavy and the owners would not let me have private access before the public was admitted. As a result, all of the shots had to be taken from camera angles that excluded bystanders.

Location 2

If you look closely at the pictures on these pages you will notice that at no time do the sisters and the dinosaurs appear in the same shot. This is because all of the shots of the girls were taken at a completely different location, on day two of shooting. As I wasn't shooting the scene in order, I had to plan things very carefully in advance to ensure I got the shots I needed. The location I chose for the second day's shooting was a wood adjoining a park, again very close to my home. I had to ensure, however, that both the types and densities of trees at each location were about the same in order to marry the two sets of scenes together at the post-production editing stage (see pp. 220-23).

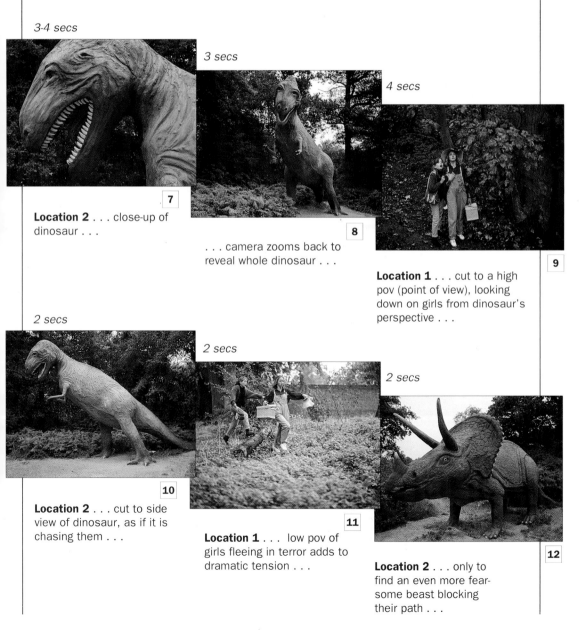

3-4 secs

7

Location 2 . . . close-up of dinosaur . . .

3 secs

8

. . . camera zooms back to reveal whole dinosaur . . .

4 secs

9

Location 1 . . . cut to a high pov (point of view), looking down on girls from dinosaur's perspective . . .

2 secs

10

Location 2 . . . cut to side view of dinosaur, as if it is chasing them . . .

2 secs

11

Location 1 . . . low pov of girls fleeing in terror adds to dramatic tension . . .

2 secs

12

Location 2 . . . only to find an even more fearsome beast blocking their path . . .

2 secs

Location 1 . . . reaction shot of Martha to second dinosaur . . .

13

1 sec

14

Location 2 . . . extreme close-up of dinosaur's eye . . .

2 secs

1

Location 1 . . . Rosie now sees the second threat . . .

2 secs

Location 2 . . . head-on view of second dinosaur, as if it has turned to chase them . . .

16

1 sec

17

. . . in quick succession . . .

1 sec

18

. . . two views of yet another prehistoric creature . . .

Sound

Unless you have a good microphone (see pp. 28-9) and, ideally, the help of a sound recordist, it is difficult to record good-quality sound on location. If you have disconnected the microphone and recorded the scenes mute, then at the editing stage you have the option to create a soundtrack consisting of woodland noises – wind rustling through the leaf canopy, bird calls, snapping twigs as your characters move around, distant barking dogs, and so on. Disconnecting the microphone also means you don't have to worry about unwanted sounds – aeroplanes flying overhead, or other people's conversations – intruding on your carefully planned production.

Also, with a short production such as this, it does not appear too contrived that the audience never sees lip-synchronized sound. Thus you can mix brief snatches of dialogue at the editing stage, timing the soundtrack so that the characters have their back to the camera or their faces turned away while the words are spoken. This obviously is not ideal and will never be as professional as lip-synchronized sound, but in the context of a short, amateur production, it is perfectly acceptable.

2 secs

Location 1 . . . Rosie is now nearly distraught as she turns to find another monster closing in . . .

3 secs

Location 2 . . .
camera zooms in . . .

4 secs

6 secs

20-30 secs depending on length of credits

. . . to close-up of dinosaur . . .

Location 1 . . . at last the girls blunder on to the path out of the forest and run for safety.

Fade-out and roll credits.

Elaborations

As it is presented here, these scenes make a coherent story of about four minutes' viewing time. However, I also shot other scenes, not included in this edit, that bring total the viewing time up to 15 minutes – the longest I would suggest you try if you are a single-camera operator with no back-up and support personnel. These extra scenes give the audience more information about the sisters before they enter the Forbidden Forest, and also introduce more prehistoric frights for them to encounter once inside.

Manipulating Mood and Atmosphere

O N THE PREVIOUS six pages you saw how a short, four-minute fictional drama could be created. Except for the very first scene of the sisters, Martha and Rosie, entering the Forbidden Forest, the action was very pacy, consisting largely of brief snatches of reaction shots, zooms and cuts. In the screen time intended for that production, it achieves more or less everything that is possible without forcing the storyline unnaturally.

If you are observant in your viewing of television and movie dramas, however, you will know that many productions start by introducing the main characters in an entirely innocent setting, laying the groundwork for what is to come so that when the action does commence, the contrast is all the more startling.

The shots from the two scenes you can see here were taped with the intention of editing them on to the beginning of the basic four-

Sequence 1 1

2

3

Sequence 2 1

2

minute drama, thus lengthening it by a little less than two minutes. They show the sisters walking away from their home, finding a picnic spot, deciding – despite their mother's warning – to enter the Forbidden Forest, packing up and setting off. In the second scene the audience is inside the forest and immediately aware of why this area is so feared locally. Although as yet Martha and Rosie are not conscious of the danger, the audience has a pretty good idea of what is developing.

Use of lenses and lighting/1
Going back to the first scene, which is shot in long, continuous takes, the lens has been zoomed back to a wide-angle setting. This gives the impression of space and airiness as the perspective is opened out, revealing the innocence of the setting. Note also that the light is soft, full and all-revealing. There is nothing to be concerned about here! Thus the audience has received the clues intended for them.

Use of lenses and lighting/2
Once inside the forest all this changes. We go from wide-angle to normal and telephoto settings on the zoom. Immediately the perspective changes: the trees are close; we can see the campsite of prehistoric people; the camera zooms in closer to pick out individuals. Everything seems confined, threatening. To accompany this contrast of mood and atmosphere, the lighting is also different. Dark shadows now dominate, hiding who knows what terrifying sights from the camera's lens.

4

5

6

4

Linking image
I planned this final shot (*right*) to allow the scene to be edited on to the beginning of the drama on pages 206-11. Having picked this figure out, the audience will accept that whatever appears next is a POV shot of what that character is seeing – the sisters walking into the forest.

5

An Alternative Ending

DON'T BE CERTAIN that it's in the bag until you see the final tape assembled, with all the major scenes in at least approximately the right sequence. It might only be then that you realize that what you saw in your mind's eye at the time of shooting does not work strongly on screen. You must thus make sure you cover yourself at the time of shooting, perhaps by taping extra scenes that develop alternative plot treatments, and so on. It might be many weeks, for example, after the end of shooting that you have a rough-cut tape for preview. Then, if you find that you are not happy with something, your actors might not be available, the weather almost certainly will not be the same as at the time of the original shoot, and even discrepancies such as the amount of foliage on trees and bushes may mean that you will not be able successfully to integrate new footage into your fictional drama. As ever, the sucess of your video production will depend very largely on how much pre-planning you have done.

Covering your options

If you go back to the original production laid out over pages 206-11 you will see that the drama there ended with Martha and Rosie finding the path out of the Forbidden Forest and running for home, but still within the forest itself. As an ending, that is the one I prefer. But it did occur to me that from the audience's point of view, a preferable ending might be the girls actually free of that dark, mysterious place and back out in the sunshine again. Hence, the scene you can see here (*below*). Your reason for deciding on a new ending might also be more mundane, more pragmatic: the credits you want to use, say, may simply look better against the lighter, brighter background of the alternative.

One of the last shots of the original edit shows the hat falling off the head of one of the sisters. In order to use this new ending then, I would have to ensure that I edited it in before the hat flew off – otherwise there would be a very obvious continuity error.

1

2

3

Static camera

In this alternative ending (*above* and *right*), I have the sisters back out in the light, free of the forest, and running for their lives. The camera position is static, but nevertheless it is still a complicated shot, combining a pan, zoom and tilt. With this type of shot, you will need to rehearse the camera and lens movements many times before committing them to tape.

Angled camera

These two shots show one of the tricks of the trade. In the first example (*above*) you can see the traditional type of treatment with the camera mounted square-on to the action. In the second shot (*right*), the camera is angled to give the scene more impact. This will be accepted readily enough by the audience as long as it is not overdone. It is also a way of adding realism as if the camera is jerking and tilting as if keeping up with a running figure. This angled type of shot is known as a Dutch tilt.

CINEMATIC CONVENTION

There are myriad conventions that have grown up with the cinema and been adopted in turn by television. Like all good conventions, we are not aware of them consciously; they simply form part of our visual language. One of these is demonstrated here.

Number one: when you introduce characters in a scene, they enter from right to left (as you view the screen). Number two: when you want characters to leave a scene, they exit from left to right. The classic exception to this is the western cliché when, having righted the wrongs and laid the bad guys to rest, the hero exits into the distance centre screen, growing steadily smaller until he is finally swallowed up in the light of the setting sun. Well, that's the convention!

215

Summary

A T THE END OF THIS LONG chapter dealing with the particular problems and difficulties, as well as the opportunities and rewards, of taping a wide variety of different subjects, it is a good idea to summarize just some of the conclusions that have been reached.

Balance and perspective
For video coverage meant basically for 'home consumption' – in other words, just family and friends – don't allow the taping of the event to become the dominant feature. After all, you don't want your most abiding memories of your daughter's wedding or a family vacation to be your mad scrambling for the most favourable shooting positions. Nor do you want to spoil other people's enjoyment of that occasion, whatever it might be, by your constant calling for retakes of the last piece of action.

Balance also implies putting yourself in the audience's position and imagining what is going to hold their interest longer, and structuring your coverage accordingly. For example, if you intend to shoot the afternoon's activities of a group of surfboard riders, then the audience is likely to be more interested in the action in the water than the riders waxing their boards beforehand.

Selectivity
Usually, any video tape you shoot is meant for an audience of some description, thus you need to bear in mind that what may be fascinating to you personally, may be of only limited appeal to somebody else. Even the most devoted grandparents, for example, may begin to whither as you load the second three-hour tape of little Rodney's and Anna's joint birthday party into the machine.

Preplanning
Keep firmly in your mind when taping that your audience will have been conditioned by their experience of television and the movies to expect certain basic standards from your audiovisual offering. Thus, always give even the most simple scene some moments' thought before committing it to tape, so that it has a minimum a discernible beginning, middle and an end.

For a more structured product, such as an interview or a fictional drama, then you will need to go through a far more elaborate procedure. This could involve some or all of the following: plot and script development, storyboarding, location scouting, set building, gathering a crew and cast together, sound testing and recording, budgeting, rehearsals and editing.

Equipment
Another aspect of preplanning involves ensuring that your equipment is always serviceable, that batteries are fresh or battery pack recharged, lens and filters are clean, that correct cables and plugs are to hand, and that you have adequate tape (and then some) to cover the amount of shooting you envisage for that session.

Coverage
If you don't plan to edit your material afterwards, then make sure that you have a clear notion of how your coverage of events should develop so that it is logical and sequential. If later editing is certain, then make sure that your coverage of all aspects of the events, including cutaways, reverse shots, POVs, and so on is adequate to allow you the greatest possible flexibility when assembling rough and fine cuts.

Use of shots
To make your tape entertaining you will have to exhibit a certain professionalism in your handling of different types of shot. For example, the basic shots of close-up, mid-shot and long shot should often all be used (although not necessarily in the same short scene), each one motivated by either the storyline or the audience's 'need to know'. For example, moving from mid-shot into a close-up or even a big close-up so that the audience can see the emotion on the father's or mother's face as the ring is slipped on to the bride's finger at the wedding ceremony; using a long shot so that the audience has some idea of the geography of the location in which the later action will take place.

Bear in mind, however, that you should not stay in long shot for an undue length of time: the normal television screen is not large compared with a movie screen, and so any detail you want the audience to see will more than likely be so small from a normal viewing distance that it will pass completely unnoticed.

Continuity

Always pay attention to continuity, so that in one scene your main character is not, for example, seen wearing reading glasses and in the next sunglasses, or that the flowers in a vase in the background to a scene do not inexplicably change type, from roses to carnations, when seen a few minutes later.

Another aspect of continuity that is easy to get wrong is crossing the line. Remember that if you cross the line of the action while shooting, the direction of the action will appear to reverse and the geography of the shot will become confused.

Sound

All the time you are taping, keep some of your attention on the noises that are going on around you. Nothing will spoil the atmosphere quicker if, as the two lovers are about to whisper their undying love for each other (while dressed appropriately for a nineteenth-century period piece), a car alarm is heard faintly shrieking in the background.

The sound you record must also be appropriate for the type of shot you are employing. For example, as you slowly zoom into a mid-shot or close-up from a long shot, then any noise or sound associated with those visuals must also increase in volume accordingly.

Steady images and constant framing

No matter how good your conception and realization of plot and characterization, location and lighting, atmosphere and sound, unsteady images and inconsistent framing will mark down your efforts heavily. Unless it is physically impossible for some reason, then always mount the camcorder on a tripod or Steadicam, and ensure that when you are tracking, for example, the subject always occupies the same area of the frame (unless the tracking is intended to lag behind to accomplish the subject making an exit). Inconsistent framing is even more disconcerting, however, when you are shooting a static subject, since then the image seems inexplicably to weave all over the screen.

Composition

There is always the risk that you become so absorbed in the content of your main subject that you fail to notice the setting in which the action is taking place. What makes for an interesting, watchable image on the screen is a combination of elements, part of which, and only part, is the action itself.

Check in the viewfinder that the foreground is making a positive contribution to the overall imagery. Make sure, also, that there is nothing in the background that could detract from the action. Try out different camera positions to see which one brings all the elements of the scene together in the most beneficial way. Perhaps the action would look better from a slightly high camera position – standing on a park bench might help. Or, alternatively, squatting down or shooting from the low side of a hill up at your subject, might frame it against the sky and produce a more dramatically rendered silhouette.

Panning, tilting and zooming

Pans and tilts to encompass a broad or tall subject, or to reveal piecemeal a subject to the audience, are two often used techniques with a camcorder. But to carry them off properly always rehearse the shot so that you know where it will begin and end. You may also have to focus the camera manually if all the elements of the pan or tilt are not at the same distance from the camera. Otherwise, the autofocus may be constantly shifting the lens, searching for the best point of focus throughout the movement.

Zooming the lens while taping is a technique you should use sparingly, since it does not relate to natural vision in any way. Regard it as a special effect, and introduce it into your work only when that effect is justified.

Special effects

This category of filmic devices takes in such things as zooming, as well as the use of filters, manipulating the weather, fire and explosions, as well as post-production tricks, such as fades, wipes, and dissolves. The general rule is to keep weather effects, fires and explosions to a minimum. They are time-consuming to produce, expensive to set up and difficult to carry off convincingly.

Special effects filters are inexpensive to buy, but this should not encourage their use. With the exception of polarizing and ultraviolet filters (which do not really fall into this category) they all look obvious and artificial. Occasionally a starburst or prism filter can be used effectively if seen on screen for quite short periods.

Correcting mistakes

If while filming the camera slips out of focus or you carry a pan or tilt on too far, then avoid the impulse to make sudden corrections, since this will only draw attention to the problem. Correct mistakes slowly and smoothly and it is possible that it will look intentional.

THE POST-PRODUCTION PROCESS

Your work does not end once the video has been shot. Improvements can almost always be made. This chapter examines the intricacies of post- production work, from the very basic copying of tapes to adding soundtracks and electronic special effects.

Editing

To EXPLAIN THE SUBTLETIES and techniques of video editing would take a whole book to itself. It's that important. No matter how accomplished you are as a cameraman, no matter how sophisticated your direction, you won't be able to produce a high-standard video production until you've mastered the mechanics (or rather, electronics) of editing.

Editing, simply, is rearranging the material you have already shot into your desired running order. The raw material should already be recorded and recorded well. There is nothing the editor can do to make up for poorly shot or constructed raw video. You should also have shot more material than you need to give yourself plenty of scope in editing. Aim for a shooting ratio of three to one at the very least, but five to one or even ten to one is preferable. (The shooting ratio is the proportion of recorded video to final edited video.) If the location director has failed to shoot a vital cutaway, the editor cannot magic it out of thin air.

On a second level, you will have to edit for effect – to condense time, to show parallel action and to create atmosphere. But before you can practise the creative aspects of editing, you must first master the basics.

Basic techniques

Whether you are tidying up your holiday video or producing a potential award winner, the theory of editing remains the same. It is basically very simple. And while certain types of equipment simplify it even further, you can edit using any camcorder (which acts as the player, or master, machine) and television.

Your camcorder's instruction manual will show you how to connect it to a VCR for editing, usually by using AV (Scart or phono) connectors. By running an RF lead from the VCR to the televison's aerial socket, you can view the recorder picture as it is recording and the player machine's picture while you are searching for the scenes. Having two televisions would obviously enable you to view both recorder and player images.

Your starting point is the original shooting script. From this, construct a 'paper edit' – a check list of the shots in the order you want to re-record them and their position on the tape (using the real time or linear tape counter). You can now 'assemble edit' (make a 'rough cut') onto the VCR tape by using the tape transport controls to locate these scenes.

Do this by first setting the recorder to pause/record at the point where the new scene is to begin (the edit-in point). Then set the player to play/pause at the beginning of the new scene. Release the two pauses simultaneously to begin the dub and press stop (not pause) when it is completed.

Once you have located the next scene, repeat the procedure, having first played through the recorded scene to locate the edit-in point of the next scene.

Virtually all VCRs these days (and certainly all that are dedicated to editing) have a backspace or pre-roll edit facility (see pages 33 and 61) which ensures that all joins will be noiseless by backspacing to record over the last few frames of the previous sequence. This means that the previous scene must be the corresponding number of frames longer than you need. This can involve a laborious and complicated counting process and not everyone will have equipment suitable to carry it out. However, five frames (the average amount by which a VCR backspaces) amounts to only one-fifth of a second, so the margin of error will worry only the most dedicated of video-makers.

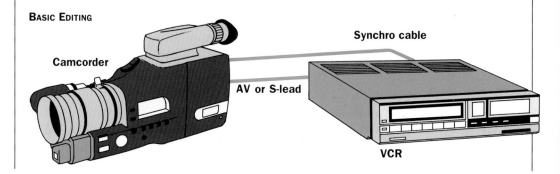

BASIC EDITING

Camcorder

Synchro cable

AV or S-lead

VCR

The problem of unsynchronized backspacing can also be eliminated by using a camcorder and VCR of the same make which share the same socketry (see page 244-5). By synchro-linking the two by means of a special cable, backspace times are automatically compensated for.

Advanced techniques

When you become more skilled at editing, a camcorder becomes unsuitable as a player machine because the tape transport controls are not usually good enough to enable you to locate the edit-in points precisely. A proper edit VCR is generally much better suited as the master (player) machine. Edit VCRs (see p. 33) have a jog/shuttle dial which makes frame location both accurate and easy. Used in conjunction with an edit controller (see pp. 31-2), an edit VCR removes much of the repetitiveness from editing.

The edit controller is connected between the master and player VCRs, synchronizing with both via the control track pulses (see Box). It usually has a jog/shuttle dial which controls tape transport in the player. These units have a memory which can store as many as 99 scenes.

CONTROL TRACK AND TAPE BLACKING

As a camcorder or VCR records, it lays down a pulse every frame on the edge of the tape – the control track. When recording from one tape to another there must be a continuous control track on each tape, otherwise the two video signals will not be able to synchronize and there will be white noise at the edit-in point of the new scene.

This often occurs when camcorder footage is recorded from stop (as opposed to from pause/record). The control pulses take about five seconds to stabilize so when you are shooting your original material you should start recording at least five seconds before you want the shot to start on your edited tape.

Alternatively, the tape can be 'blacked'. Recording the whole tape with the lens cap on ensures that the control track is laid continuously. A tape can also be blacked in a video recorder either by connecting a camcorder or by pressing record with the auxiliary input selected. Once the continuous control track has been laid, you can then record over the blacked tape.

ADVANCED EDITING

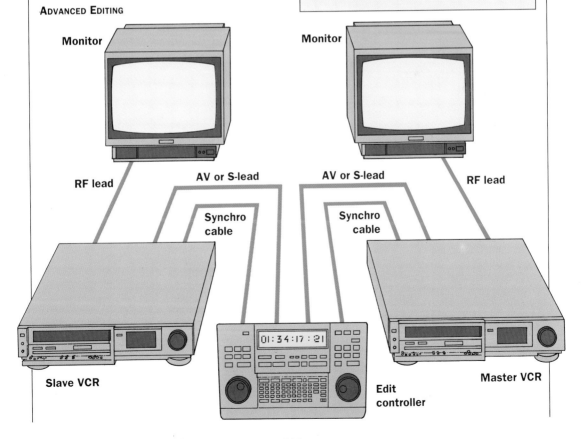

Monitor — RF lead — AV or S-lead — Synchro cable — Slave VCR — Edit controller — Synchro cable — AV or S-lead — Monitor — RF lead — Master VCR

Following your paper edit, you can fine-programme the edit-in and edit-out points of each scene into the memory of the edit controller and assign it a number. Once all the scenes have been memorized, key in the new running order. The edit controller then operates the player and recorder machines simultaneously, shuttling back and forth between the selected scenes. If the cutting on some of the scenes is less than perfect, these can be re-programmed and the controller can repeat the sequence. Repeated tape transportation can stretch the tape so that the control pulse no longer corresponds to the original frame. Because they use the control track to locate parts of the tape, these edit controllers can therefore be innaccurate by up to several frames. However the new generation of edit controllers, using either VITC or RCTC timecodes (see Box), are accurate to within one frame and are set to revolutionize amateur video-making. Computer edit systems perform a smiliar job.

Creative editing

Mastering the mechanics of editing has nothing whatsoever to do with its creative application. A person might be a very adroit button pusher, but totally bereft of visual imagination. Knowing how to construct a sequence artistically and grammatically is the true test of the video editor and there is no substitute for experience.

In the world of domestic video-making, spontaneity is the keyword. Most camcorder users do not set out on their day trips or annual holidays with the intention of making a video production; they just want a record of happy family occasions. The video that results is often a mish-mash of unconnected images. The editor has to know how to make them flow.

The first step is knowing what to cut out. Anything poorly focused, poorly exposed or suffering from camera shake should be consigned to the electronic waste bin for a start.

Only shots that have some relevance to the story should remain, and that story must be properly constructed with a beginning, middle and end. Just because you have over three hours of holiday video, you don't have to produce a 25-minute finished production. You could make three or four 10-minute films about different aspects of the holiday.

Where possible, begin with a long (wide) establishing shot encompassing the whole of the scene. Then scour the tape for more detailed shots of one of those activities – perhaps a vendor hawking his wares. Follow the long shot of the whole street scene with a medium-long shot of your chosen street trader talking to a group of people. Then cut to a mid-shot of him, followed by a reverse angle of the crowd. There will always be room for cutaways and cut-ins. You could cut in on the trader's hands as he exchanges

TIMECODES

Both Vertical Interval Timecode (VITC) and Rewriteable Consumer Timecode (RCTC) give the amateur video-maker true frame accuracy for the first time. Both systems (VITC is used by Super-VHS, RCTC by Hi8) code each frame with an eight-digit number corresponding to hours, minutes, seconds and frames. The timecode is recorded on tape by the camcorder and then read by the edit controller.

These signals are actually recorded with the video signal, not on a separate part of the tape as with the control track pulses. It is this separation of control signal and video signal that leads to editing innaccuracy when long tape becomes stretched through repeated tape transportation.

The main difference between VITC and RCTC is that RCTC can be added to a tape that has already been recorded, but VITC can only be added as the camcorder records.

OFF-LINE AND ON-LINE EDITING

The tape that comes out of your camcorder with all the raw footage on it and then goes into the player VCR for editing is the edit master tape – the tape from which all assemble edits are made. However, it is very unwise to use your edit master for all your rough editing. One press of a wrong button and you could find a vital shot on the master ruined.

Make a straight copy of the master first. It is from this 'off-line' tape that you work out the paper edit (the rough scene order); and it is from this 'off-line' tape that the scenes are assembled and one or more rough cuts produced.

With the programme stored in the edit controller's memory, you can go back 'on-line' to the original master tape and make the finished copy from that.

Off-line editing is particularly recommended when using VITC or RCTC; the timecode information of the off- and on-line tapes will be identical.

goods for money, or cutaway to the faces of the punters as they register enthusiasm or contempt for what he is selling.

You should be on the lookout for this sort of basic storyline both when editing and, even more importantly, when shooting in the first place.

Linking scenes

Scenes often have to be linked together. This is done by closing one scene and opening the next with action that is similar in structure.

Take, for instance, an amateur drama production about a domestic murder. In one scene, we see the murderer climbing the stairs and putting his hand round the door handle. We now cut to the other side of the door. The door flies open and the police charge in to find the body of a woman.

This is clever editing on several levels. One, it doesn't do what the audience is expecting. Two, it creates suspense. Three, it condenses time – the scene of the actual murder and the police being called are quite legitimately avoided without loss to the narrative of the movie.

Linking scenes can be symbolic – a young boy in a Royal Air Force uniform raising his right arm as he waves goodbye to his father is followed by a similarly structured shot of a man in German uniform giving the Nazi salute. They can be humorous: cut from a schoolboy yawning at his desk to a gorilla yawning in the zoo; or they can be just a useful device for linking two otherwise unconnected scenes.

Condensing time is an important aspect of creative editing simply because there is not enough time available to act out events in real time. One effective way to achieve this is with cutaways of a clock face showing different times.

But there are other situations when time must be condensed. If, for instance, an actor says that he is popping out to the bank, there is no need to show him leaving the house, walking along the high street, queuing up and making his withdrawal. Cut out all that. The scene after he states his intention to go to the bank could show the money being handed over by the cashier. Or you could even follow this first scene with one showing the use to which he is putting the money. For example, a man says to his wife that he must go to the bank. The next scene shows him paying cash for an airline ticket to South America after he has withdrawn all their savings. Not everything has to be spelled out in black and white. Successful editing is as much about knowing what to omit as about what to leave in.

THE DOS AND DONT'S OF EDITING

It can't be said often enough that you must have a sound knowledge of how a movie flows together. You may be brimming with innovative, creative ideas, but unless you have mastered the basics, they will come to nothing.

• Avoid jump cuts (see pp. 60-61) and intercutting where a person suddenly appears to be in a different part of the frame.

• Avoid cutting that crosses the line – i.e. where the direction of motion of a subject is reversed by editing (see pp. 70-71).

• Maintain continuity of action. This type of continuity is more subtle and difficult to achieve than the usually understood 'make-sure-your-actor-wears-the- same-tie' definition of continuity. This means that any action made by the actors in one shot should be continued in the next one.

If an actor raises his right hand to his head and you cut as he is raising it, the following shot must pick up with his hand in the same position. Unless you are very experienced it is better, though less natural, not to cut on action. In this example, do not cut until the actor's hand has reached his head.

• Think carefully about shot length. If the subject is new and contains a lot of visual information, you can afford to linger over it. If the subject has been seen previously in the production, or is very static (e.g. a close-up of a statue, as opposed to a long shot of that same statue in a formal garden setting, with many other elements which demand the viewer's attention), you will probably not need to hold it for so long. Cutting too quickly, however, before your audience has had time to assimilate the information on screen, can be very disconcerting to watch.

To help you decide on the correct shot length, review your video at the proper speed when editing rather than using the fast forward button.

• And finally, shoot to edit. Always have some idea of how you want to construct your production so that you can shoot with the end result in mind.

Soundtracks

JUST AS YOU MAY WANT to edit your video images, so the recorded soundtrack may not be the one you want in the final production. You may wish to add music and sound effects, or be forced to re-record at least some of the sound because editing the pictures has made it disjointed. However, be warned: you will not be able to re-record dialogue and lip-synch it effectively to the image. Dialogue must be recorded at the time of shooting.

Sound mixers and audio dub

The simplest way to add sound is to use an inexpensive sound mixer. A sound mixer has inputs for a microphone (to add a commentary), the camcorder (which contains the original sound) and cassette or record player or even CD player. Slider level controls allow you to mix the sound inputs together to the desired level and volumes.

The sound mixer is connected between the camcorder and a VCR and adds the new soundtrack as you make a copy of the edited tape. Using a sound mixer means that you will not have to lose the original soundtrack.

However, if you are adding sound from a single source, you don't need a sound mixer. If you have a VCR with an audio-dub facility, you can add sound quite simply. You can also dub on extra sound on a camcorder with audio dub. But you will lose the original sound if the camera is mono only, since audio dubbing erases the mono sound. And a video with simulated sound effects or music only, without any of the original soundtrack, can seem very unnatural.

Audio dubbing is used when you have a stereo camera that will mix with the original sound or when you want to paper over sound which has been disjointed by editing. Shots taken during a holiday, for example, may benefit from the addition of suitable music such as Asian music for an Asian market, but the atmospheric chitter-chatter should be left in. And at a disco, when in-camera editing has cut the song to pieces, it is a simple matter to dub in continuous music.

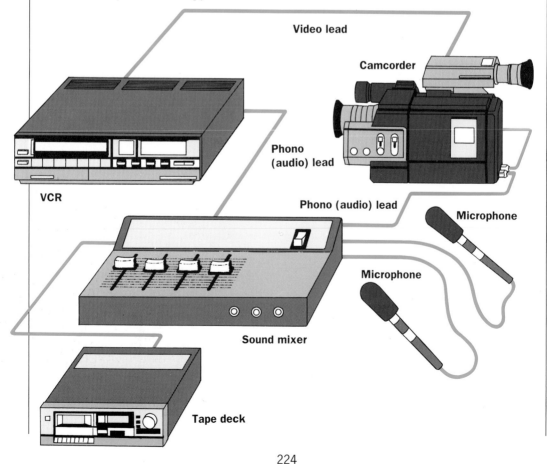

Video lead

Camcorder

Phono
(audio) lead

VCR

Phono (audio) lead

Microphone

Microphone

Sound mixer

Tape deck

Adding a soundtrack

If you are editing a video production to a high standard, the soundtrack should be much more than just something to 'paper over the cracks'. It should be an integral part of the programme. Commentary, music and effects may all need to be added or maintained.

Again, you'll need to do this through an audio mixer or, if you're really serious, through a semi-professional mixing desk.

A commentary should not be recorded live by talking into the mic as you will have many other things to concentrate on. Record the commentary onto a tape recorder as you watch the edited tape, leaving enough space between each section to press the unit's pause button. Now connect the tape recorder to one of the sound mixer's audio inputs. As you copy the edited tape from the player to the recorder VCR (the sound mixer is connected between the two), release the audio tape recorder's pause to dub on sections of the commentary, at the same time fading down the volume of the live sound so that the commentary dominates.

If music and effects are to be added, you may need to go through another process. Swap the edited tape for the tape which contains the mixed sound. This now acts as the new edit master, although it has lost a generation's worth of quality. Slot a tape containing your sound effects in the correct order into the tape deck.

To preserve the picture quality of the original edit master, audio dub from the new edit master (in the player VCR) to the old edit master (in the recorder VCR) adding the music and effects and adjusting their volume as you go. What you are doing in this method is mixing the sound from the original edited tape onto a second tape and then recording it back onto that original edit master.

However, this is very difficult. Synchronization is vitally important and the two machines must start simultaneously from the same point. You will need excellent equipment with precise tape transport control (VITC or RCTC timecodes would be ideal). It is best to rehearse on a copy of the master tape first of all.

Alternatively, you could make a second copy of the edit master by merely copying the first copy as you add the sound. This is simpler and more reliable, but has the disadvantage that the picture quality of the master is degraded even further.

There is a third option. Connect two audio cassettes (one with the commentary, one with music and effects) to the sound mixer and add both to the master edit tape at the same time. However, you may find that the normal complement of human limbs is not enough to cope with operating the numerous pause and level controls that this requires.

Successful soundtracking is an art as sophisticated as video editing. And when you are soundtracking, remember that using audio dub will erase all or part of the original soundtrack whereas mixing through a sound mixer will just add to whatever's there.

Sound effects

On most occasions, the sound recorded live will be suitable for inclusion in the final production, especially if your video is for home consumption only. It is only when you join a club and start entering competitions that you may find that you need to simulate certain sound effects.

This usually arises because the sound has become disjointed or is simply not loud enough to be heard by the audience. This is particularly true in cases where the sound has to 'overact'. Suppose, for example, you are videoing a horror film. One shot shows a heavy Victorian front door opening slowly. On video it creaks, but doesn't 'creeeak'. To bring this audio effect home to the audience, you will have to dub it in later, using anything that makes a horribly squeaky creaking sound.

Many seemingly unobtainable sounds can be created quite easily. Use the obvious coconut shells for horse's hooves, fingers in a bowl of water for waterfowl, open and close an umbrella for a large bird in flight and, for really gory sound effects (I'll leave these to your imagination), drop squelchy cooked spaghetti on a hard surface.

AUDIO RECORDING

VHS mono This is recorded separately from the video signal and so can be replaced easily.

VHS stereo This cannot be over-dubbed. Extra sound (added using the audio-dub function) replaces the mono recording and a stereo camcorder will offer the choice of mono (new sound) or stereo (old sound) playback.

FM mono/stereo Found on 8 mm camcorders, this cannot be over-dubbed.

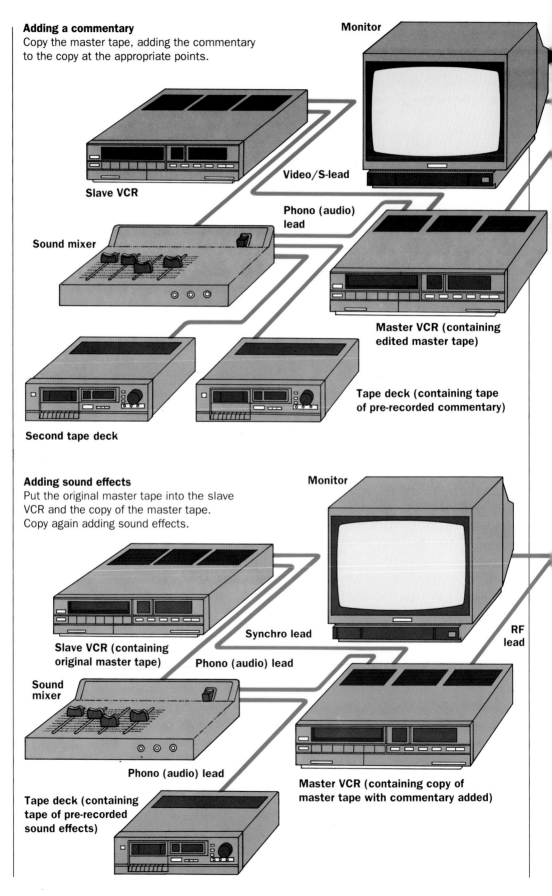

Adding a commentary
Copy the master tape, adding the commentary
to the copy at the appropriate points.

Monitor

Slave VCR

Video/S-lead

Phono (audio)
lead

Sound mixer

Master VCR (containing
edited master tape)

Tape deck (containing tape
of pre-recorded commentary)

Second tape deck

Adding sound effects
Put the original master tape into the slave
VCR and the copy of the master tape.
Copy again adding sound effects.

Monitor

Slave VCR (containing
original master tape)

Synchro lead

Phono (audio) lead

RF
lead

Sound
mixer

Phono (audio) lead

Tape deck (containing
tape of pre-recorded
sound effects)

Master VCR (containing copy of
master tape with commentary added)

WRITING VOICEOVERS AND COMMENTARIES

The major failing of many amateur voiceovers and commentaries is that they appear to be designed to state the blindingly obvious. Take, for example, a video tour of a new house. As the camera enters a room which, from the evidence of cooker, washing machine, sink, pots and pans, is obviously the kitchen, the last thing the viewer needs to be told, either by the voiceover or an actor delivering the narrative, is, 'this is the kitchen'. The whole point of a voiceover or commentary is to convey information that is not obvious from the moving image. Once you have realized this fact, you're halfway to writing a good script.

But the script still has to be written, and that takes a certain amount of skill. If you have the gift of the gab or the pen, all well and good, but do follow a few simple guidelines:

• Learn to recognize the difference between the written and the spoken word. Many people adopt a sort of pomposity when they write that they would never dream of using when speaking. They use 'purchase' instead of 'buy'. Write the commentary colloquially, as it would be spoken (which may often be in a form that is gramatically incorrect).

• Resist the temptation to string lots of multisyllabic adjectives together. Keep it simple.

• Be miserly with your words and only write when it adds something to the image. Otherwise, shut up and let the pictures do the talking. If the voiceover dominates, it is wrong.

• When delivering your voiceover, be yourself. Too many people who have naturally jaunty voices sound monotonous when delivering a prepared speech. If necessary, overact, even if it sounds slightly ridiculous to your ears. But don't go overboard on humour. Comedy is a very specialized area and many of your potential viewers may not share your sense of humour.

It goes without saying that a voiceover should be thoroughly rehearsed. With the script in front of you and the video running on a monitor, you should be able to get your script to a reasonable standard ready for a take. But the reading can be made a whole lot easier by marking up the script to show which words you want to emphasize and where you want to pause.

Curiously, the broadcasting industry doesn't have a conventional system of notation – apart from writing 'pause' on the script or comments on the margin – but you can easily invent your own system. The sample of script below, from a low-budget video documentary, shows one way of doing this.

> Until three years ago, over 25 productions a year were performed at the Palace Theatre; / but that was before subsidence was discovered. ||
>
> Since then, Health and Safety Authorities have ordered that the premises be closed down. No one has accepted responsibility for the repairs, / despite the fact that everyone acknowledges the building's historic significance. ||
>
> It is up to you whether the Palace Theatre re-opens. // Join the Friends of the Palace Theatre and ensure that the boards are trod once more in this town.

≡ Indicates that a word should be stressed for emphasis.

--- Indicates that a whole phrase should be emphasized by slowing down the delivery.

/ A natural breathing point. This will often coincide with a comma or semi-colon in the written script.

|| Hard pause – between sentences, to add rhythm to the delivery.

ʒ Soft pause – in the middle of a sentence or between sentences to help keep the delivery flowing.

Titles

ANY PRODUCTION THAT is intended to be seen by people other than just close family or friends should be properly credited. It is only right that those people who gave their time, expertise, knowledge, or facilities to help you make your video should receive thanks. In fact, it might in some cases even be a condition of the help or facilities being made available to you. In the trade, these credits at the end of a movie are known as 'titles'.

Types of titles

Throughout filming, bear in mind that you will need some footage to use as the background for the final titles sequence. Footage such as this could even come from the out-takes generated by the editing process. (This is assuming, of course, that you don't simply run the titles over the last scene as it plays out on screen.)

Another way of handling the titles is to fade out to a suitable colour or tone from the last scene and then run the titles sequence against this plain background. And instead of using a plain colour or tone, consider using, say, a textured surface as the background – a stone wall, for example, or peeling paint on a weathered piece of wood, or even a close-up of a poster relevant to the story. The choice really is limitless.

Choice of type style

No matter what you finally decide to use as the background, you must ensure that the style of type face is easily legible. This means choosing lettering that contrasts well with whatever else is on the screen. There is no need to have a fixed position for the titles, however. You might want to alter where they appear each time depending on how the tone or colour values of the back-

Dry-transfer lettering

Dry-transfer lettering (*top*) comes in sheets of upper and lower case letters of the alphabet (with more letter 'e's, for example, than 'x's), numerals, punctuation marks, and so on. You need to buy a different sheet for different type sizes or if you want to mix type faces.

Stencils

Also available from stationers or artists' suppliers are stencil templates (*above*). These also come in different type styles, and they have the advantage of being reusable.

Lighting

Once your titles are complete, you will need to tape them so that they can be edited into position. Ensure that the camcorder is completely square-on to the lettering and that it is evenly lit by lights of equal strength positioned equidistance either side. A titling stand (*above*) is the best way to achieve this.

ground scene change. For example, some dark-lettered titles might show up well against a light sky and also against a white painted building, as well as against an article of light-coloured clothing being worn by one of the characters.

Mid-film titles

Sometimes you may need to use titles in the middle of a film – to indicate how much time has elapsed ('three years later'), for example, or to signal a change of location. These titles are produced in exactly the same way.

Colour of lettering

Colour and contrast is so dense (*below*) that you would need to use white lettering.

Digital image superimposer

One of the simplest and most effective methods of titling a video production is to use the digital image superimposer found on most camcorders, especially the cheaper mass market models. The beauty of this method is that your title can be hand-written so that you don't need to go to the bother of using transfer lettering or stencils. But the title must be contrasty so use thick black felt pen on a white background. Once you've written the title, simply point the camera at it so that it fills the frame and then press the memory button. The title is then memorized and can be recalled in a choice of eight colours (or reversed out of a coloured background) at the press of another button while you are recording. Some models even vary the density of the title from transluscent to opaque. But the digital superimposer is not limited to just titles. You can use cut-out shapes (such as binocular or heart shapes) as a simple way of adding a vignette to your image.

Framing

For a simple caption, such as THE END on scenes like these (*right*), make sure your framing leaves sufficient space so that the lettering doesn't look cramped.

Texture

The interesting textures (*right*) make this type of image ideal for superimposing lettering on.

Choice of style

Colours are so muted (*above*) and the contrast so low, that almost any style of titles would be appropriate.

Rostrum Camera Techniques

THE CAMCORDER can be turned to many uses. As well as the obvious subjects such as weddings, holidays and the serious amateur production, video is a great documentary medium. Effective documentary material does not necessarily have to consist entirely of moving images. Local and family history are ideal documentary subjects, and both these are likely to involve recording a great deal of printed documentary material. Similarly, you may want to video small objects such as fossils or coins.

Copystands are made specifically for this and are very similar to those used in still photography. They consist of a baseboard with a stem at the centre of one side. The camcorder is attached to this, pointing downwards over the centre of the board, and can be moved up or down. On either side of the board are two lights, the position of which is variable.

Flat subjects – pages from a magazine or document, for example – are placed on the baseboard and lit evenly from the sides with each lamp placed at an angle of 45°. This ensures that there are no unwanted shadows.

However, subjects such as jewellery or fossils generally benefit from more dynamic lighting. Experiment with the position of the lights until there is a pleasing play of illumination and shadow. For the starkest of images, turn one light off altogether. These lights are low temperature, so set the white balance to the indoor pre-set or, even better, adjust it manually.

Raise or lower the camcorder until the subject fills the screen, using a medium or short telephoto focal length for best perspective. There should be no need to enter macro for this kind of shooting.

Constructing your own rostrum set-up

Purpose-built copystands are quite expensive, however, so you may want to construct a rostrum set-up yourself.

Set the camcorder on a tripod facing a wall. The wall should be bathed in natural light hitting it at 90° (in which case, ensure your shadow doesn't fall over the subject) or lit from either side by two lamps placed at 45°.

Table lamps would do, but it helps if they are the same intensity. If they are not, position them at different distances until the wall is evenly lit from both sides. The wall acts as the baseboard; and pages, documents or even photographs can be attached to it.

Small objects clearly cannot be treated in this way. They should be placed on a table top covered with a draped sheet, or on a board placed on the floor. Then experiment with your tripod to see if you can shoot directly down onto them or from as steep an angle as possible. If you can't manage this, shoot from the side with the object propped up vertically.

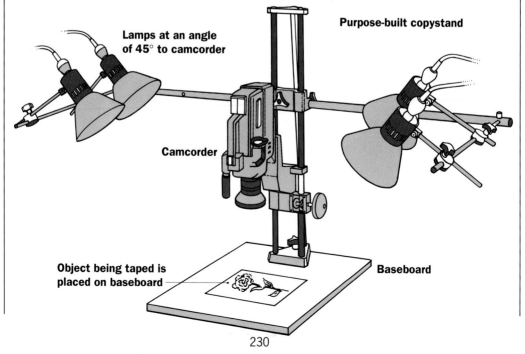

Lamps at an angle of 45° to camcorder

Purpose-built copystand

Camcorder

Object being taped is placed on baseboard

Baseboard

Slide/Cine to Video Transfer

FOR MANY PEOPLE, buying a camcorder is their first excursion into the world of amateur film-making. Others, however, will have years and years of experience of cine cameras behind them; and to go with that will be yards and yards and even more yards of old cine film. Someday, they will probably want to transfer those memories to video tape.

The easiest way to have cine film copied is to have it done professionally, but be warned: some operators do not use professional equipment and the results can be variable.

Film can also be transferred to video in your own home using either a transfer box or transfer screen, also called telecine units. Both operate on the same principle. A cine projector plays the film onto one screen of the telecine unit. This is reflected onto a second screen at an angle of about 45°. The camcorder is positioned to video the image on this screen. Many telecine untis can accommodate enprints as well.

The process is quite straightforward, but there are five main problem areas:

The first is that film and video are played back at different speeds: video at 25 frames per second (fps) and cine film at 18 or 24 fps. The result is flicker as the camcorder records the blackout between frames of film. This can be eliminated on 24 fps film by increasing the projector's speed to 25 fps and reduced for 18 fps film by reducing the projector's speed to $16 \frac{2}{3}$ fps.

The centre of the projected image will appear disproportionately bright because of the projector bulb. This can be eliminated by fixing a small black spot, held in place by clingfilm, cotton thread or cardboard, over the centre of the projector lens. As the spot is positioned so close to the lens, it will cut out most of the extra bright light, but will not cast a shadow or block off the image.

Exposure can be poor and this isn't helped by the lack of an exposure lock on most camcorders. If your model has full manual f-stops or an exposure lock, expose for the highlights. Otherwise, trial and error are the order of the day.

Experimentation is also necessary to get the white balance right. The camcorder's automatic white balance will be receiving confusing signals – daylight colours from the film image, but low-temperature light from the

Telecine unit

projector bulb. Use the manual white balance lock or the pre-sets to find the setting that gives the best results and try out colour correction filters too. A magenta filter placed over the camcorder lens will improve colours.

Finally the whine of the projector can often intrude into the camcorder's soundtrack. Insulate the camcorder against the sound by erecting barriers between it and the projector. If you can find some way of running the sound from the projector into a sound mixer and then into the camcorder (if it will accept an audio line in), so much the better. One telecine transfer box even comes with its own built-in audio mixer.

SLIDE COPYING

Slides can be copied onto video by a special copying attachment, much like an SLR duplicating lens. The barrel-like unit fits onto the camcorder's lens and the slide is slotted into this. However, the same problems of white balance and exposure as beset cine transfer apply. Again, you should experiment to get the best results.

If your camcorder has a nega-posi switch (which records pictures in their negative image), picture negatives can be put on tape as a positive picture in the same way.

Post-production special effects

ALTHOUGH ALL CAMCORDERS allow an in-camera fade, and some of the more advanced models now offer digital effects too, most special effects such as fades or wipes are created during the post-production stage with specialist equipment.

With a very careful paper edit (see pp.220-23), you could add the effects to the master tape before you edit the footage into the new running order. More usually, however, effects are added after the tape has been edited. The edited tape is put into the master (player) VCR and the special effects generator is connected between the master VCR and the slave (recorder) VCR in the same way as a sound mixer or edit controller (see pp. 220-23 and 224-7). Special effects are then added at the appropriate points as the edited tape is copied again. This inevitably involves losing a generation of quality, although this is less pronounced if the original master tape is a high-band format.

Creating a dissolve

The most natural way of linking two scenes – the dissolve, in which one image gradually dissolves into the next frame – is impossible for the amateur on a limited budget (although some of the newer camcorders, with digital effects, give a primitive kind of dissolve). To dissolve, you have to mix two video signals together. While audio signals can be mixed easily, video signals won't lock together. To create a dissolve, you need to use a genlock or a digital mixer. A genlock synchronizes the scan rate of two video signals while a digital mixer uses a 'frame store', holding the last frame in its memory and allowing an incoming signal to lock onto this.

A digital mixer is several grades up from the cheap and basic so-called 'video mixers' which are little more than enhancers with a fader built in. Like most post-production equipment, it is connected between the player and recorder VCRs. A digital mixer

Dissolve
Above and *right*: A dissolve mixed with a reversed (negative) image. Dissolves can be achieved only by using a digital mixer or genlock to stabilize the two video signals.

offers several other special effects:

Fade This fades the image in or out to black (sometimes white, sometimes a variety of colours).

Scroll Titles roll up or down the screen, just as they do on film credits.

Wipe function On cheaper, non-digital mixers, these are reserved for titles. The caption on screen can be made to wipe left or right, up or down, meaning that it will gradually disappear in this direction. Most sophisticated units offer wipe patterns in which, for example, a title disappears from a box expanding from its centre.

Digital wipes Because a digital mixer can synchronize video signals, it will also allow you to wipe between video images in a variety of shapes and patterns. For instance, you can have one image disappearing in a circular pattern to reveal a second image behind.

Pixelation The image is carved up into tiny squares.

Slow motion While many camcorders or VCRs offer slow motion replay, this is through normal tape transportation using the video heads and can be jerky and unnatural. Digital slow motion is very smooth.

Solarization The image is painted in block colours.

Strobe Portions of the video are eliminated to give a jerky effect.

Above: Solarization.
Below: Solarized image mixed wih a circular wipe to reveal a second image underneath.
Bottom: Pixelation.

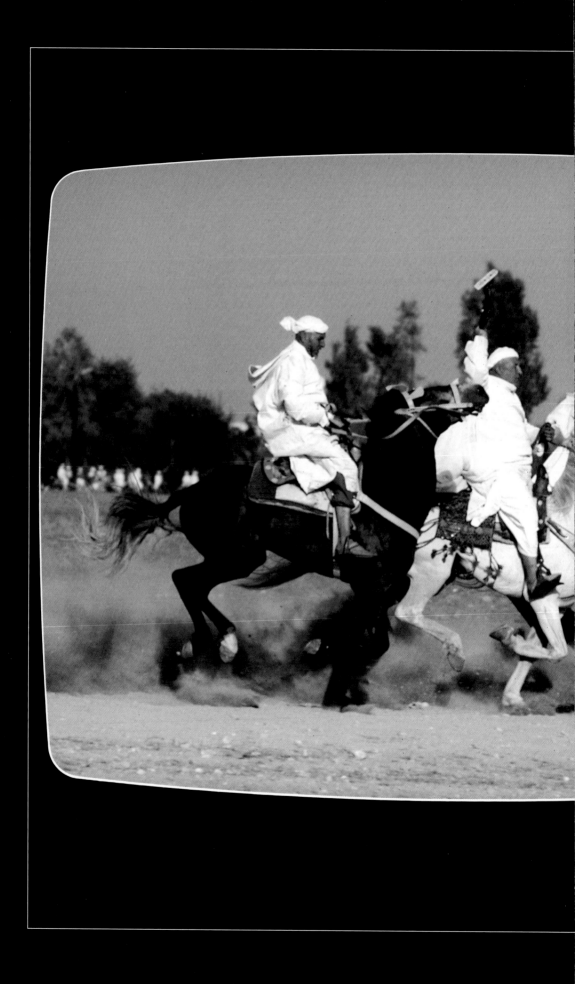

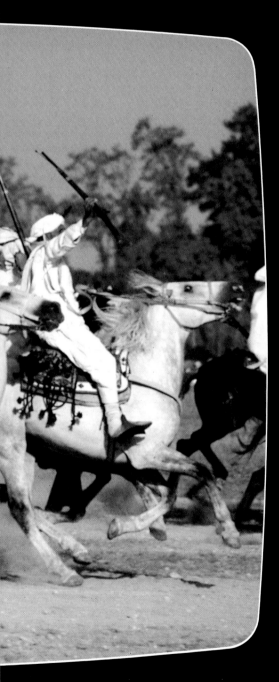

OUT-TAKES

This chapter examines topics outside the video-making process which are, nevertheless, useful additions to the video-maker's armoury.

Make-up

THE CAMERA TENDS to be mercilessly critical and revealing of those facial imperfections of one type or another we all have. A slight puffiness under the eyes, for example, can take on the proportions of full-blown bags; enlarged pores in the creases at the side of the nose can appear to be deep pits; a slightly mottled skin tone can translate as a condition needing urgent medical attention. Hence, the need for make-up when appearing in front of the lens.

Carefully applied make-up may be necessary not just to disguise a less-than-perfect face but also to highlight a subject's good features, such as bone structure, shape of eyes, forehead, nose, and so on. This applies to male as well as female subjects, although when dealing with a male subject the make-up usually needs to be 'invisible' – just sufficient to do the job, but not so much as to be obvious.

Make-up is not used only for drama productions. Sometimes a little is necessary even in an interview situation (see pp. 188-9). If, for example, your subject has particularly blonde eyebrows and eye lashes, these may need darkening just a touch to stop them disappearing altogether. Lips, too, often need defining and colouring slightly to prevent the subject appearing anaemic.

Another occasion when make-up is often essential is when photographing a man's bald head. Bald heads are notoriously difficult to have featured in shot, since they tend to reflect back any light source you are using. They may do this even when lit by direct sunlight. The simple way to stop this is first to remove any perspiration and then apply just a little face powder to take the sheen off the skin.

Before
Here you can see the subject before any make-up has been applied (*above*). As you can see, her skin is less than perfect and her eyes are slightly puffy. It helps the make-up artist if the subject gets a good night's sleep the day before the shoot. Before anything else, first thoroughly cleanse the face and apply a moisturizer.

Step 1
After moisturizing, the first step is to apply a base foundation (*above*). Choose a colour as close as possible to the subject's natural skin colour. Apply the foundation evenly with a wedge sponge, making sure it is blended well into the hairline and down on to the neck. (Make sure you don't leave tide marks.)

Step 2
Now you can start to apply any corrective make-up that may be necessary, using a concealer to cover blemishes and to mask shadows under the eyes (*above*). If necessary, shade under the jawline and cheek bones with a darker colour to emphasize the bone structure. Remember that anything made lighter stands out, while anything made darker tends to be less prominent.

Step 3
Define the shape of the eyes using a fine brush and, probably, a black or brown liner or a liquid liner (*above*). Draw a fine line from the inner corner of the eye, along the top of the eyelid, bringing the line up slightly at the outer corner to lift the eye. Under the eye, draw a very soft, smudged line, blending it well with the eye lashes.

Step 4
When applying eyeshadow it is usually best to stick with natural colours, such as soft browns or pinks, and avoid blues and greens. Brush the powder over the lids and up into the line of the brow. To enhance the natural eye shape, use a matte grey colour in the eye socket, blending it well into the outer corners and upper eye line.

Step 5
This subject has well-defined, dark eyebrows that required no eyebrow pencil, except a little sculpting around the edges (*above*). Apply plenty of mascara to the top and bottom eyelashes, using an eyelash comb to separate the individual lashes. Avoid blobs and clogging.

Step 6
Lightly brush on blusher powder using a fat brush (*above*). To enhance bone structure, use a darker colour under the cheekbones and a lighter colour on top. Avoid unnatural hard lines, however.

Step 7
Outline and define the shape of the lips with a lipstick pencil before filling in the lips with a slightly lighter shade using brush-on colour (*above*). Add lip gloss to create a highlight once the subject is lit.

After
Here is the finished face (*above*), with the subject's hair styled long and straight and her fringe lifted off her face and pushed to one side.

Fantasy make-up
If natural realism is not the object of the make-up exercise (*left*), then just about anything goes. Although this fantasy make-up is bizarre, the basic principles outlined on these pages have still been used to create the effect.

Hazards of the Natural Elements

I T IS ALL TOO EASY simply to put the camera away when conditions are less than ideal, but some of the most dynamic footage is produced when the natural elements are at their most dramatic. Far from being 'less than ideal', mist, rain, fog, intense heat, sea, sand, dust, and so on can become the very components that help to lift the scene out of the ordinary and create mood and atmosphere.

Unfortunately, however, conditions such as these can be extremely hazardous for the delicate inner workings of your camcorder; but if you take a few reasonable, common-sense precautions to ensure no disasters occur, the potential rewards of shooting in what could be described as unfriendly conditions are immense.

First, a little light rain falling on a camcorder is unlikely to be a problem. Ensure, however, that as soon as you can you thoroughly wipe the camera's casing with a clean (preferably lint-free) cloth. It would be unwise to use a camcorder unprotected in a heavy downpour. Instead, wrap the camera in a clear-plastic bag with a hole cut in the front for the lens to poke through. And if you keep an ultraviolet (UV) filter (see pp. 242-3) on the lens at all times, you will protect its delicate glass outer surface from harm. These same precautions basically apply to very sandy or dusty conditions, too. And they are particularly apposite if salt water, such as sea spray, is involved. Salt is extremely corrosive: keep your camera away from it.

High altitude and cold
The higher you climb above sea level the more ultraviolet (UV) light there is in the atmosphere (*above*). Photographically, UV tends to make colours appear bluer and lighter than they would at sea level. You can overcome this, at least partly, by using a UV filter over the camera lens. Another thing you can do is, as far as possible, restrict yourself to close-ups and mid-shots. The less atmosphere the lens has to 'look through', the less UV is

apparent. The other aspect of cold conditions you need to be aware of is that ordinary camera batteries, even if fresh, can abruptly cease working. Special batteries designed to operate in cold conditions are available from professional camera stores. If you will be encountering prolonged, severely cold conditions, then you should have your camera serviced specifically before departure so that non-freeze lubricants can be applied to all moving parts.

Rain

Rain, often accompanied by high winds and, in this example (*above*), a wild sea, makes for excellent footage. But you need to keep your camcorder as dry as possible to prevent damage. A UV filter will certainly help to protect the delicate front element of your lens, and you can wrap the body of the camera in a spare article of clothing (a scarf, perhaps) or, if you know in advance of the likelihood of rain, a clean plastic bag. If you are in a car, you could always try shooting from behind a closed window. The success of this depends largely on how clean and optically free of distortion the glass is, and which way the wind is blowing. A heavily rain-spattered window will produce seriously degraded pictures – although even this can be quite atmospheric.

Pools and beaches

If you worry about every possible danger that could befall your equipment, then you are going to make yourself a very unhappy photographer. Splashes of water at the beach or a pool, or sand blowing around (*right*), are part and parcel of the location. But as long as you wipe the body of the camera clean immediately afterwards and keep the lens protected with a filter, no lasting damage is likely to occur. It is often possible to tape simply by keeping your subject well framed with the lens zoomed out to its maximum extension. If this is likely to cause a problem with depth of field (see pp. 40-41), then move in closer with the camera wrapped inside a plastic bag.

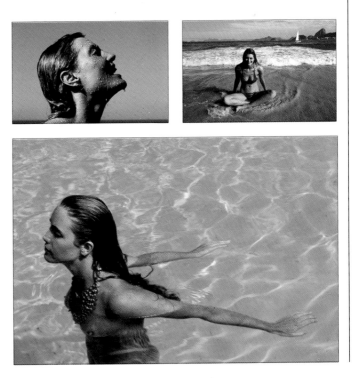

CAMERA CASES

Accidents to a camcorder are most likely to occur when you are not actually using the camera. Walking down the road, for example, it could easily receive a heavy and damaging knock against a wall or tree, or it could fall from a table or chair when you stop somewhere for lunch. The car is another potentially dangerous place – a sudden stop could send your camcorder flying off the back seat or window shelf.

The best way to prevent this type of accidental damage is to keep your camcorder in a protective case when it is not in use. The ideal case should combine rigidity with lightness of construction, and it should be large enough to accommodate a few essential accessories, all safely confined within their own compartments. If the case is strong enough, you could perhaps even stand on it when you need extra height for a shot.

Protection for your camcorder

When not actually being used, it is a good idea to keep your camcorder in a camera case, such as this (*right*). This case is rigidly made , yet is still light enough not to be a burden,. As well as the camcorder, it is sufficiently large to accommodate spare cassettes of tape, spare batteries, lens filters, cables, a microphone cover for windy conditions, battery charger, headphones, lens tissues, cleaning cloth and carry strap.

Sea, spray, and mist

If your venue is going to be the pitching deck of a sailing yacht or the grand falls of Niagara, then certain precautions will be necessary. First, cut a hole in one face of a strong plastic bag just large enough for the front of your lens to poke through. With the camera inside, carefully seal all the edges and then place a UV filter over the protruding lens. You should still be able to feel and operate all the camera controls in the normal way. For the deck of the yacht, it is also a good idea to attach a short, tethered line to your safety jacket. In this way you will be able to gain some extra stability by planting your feet securely and leaning out against the line until it becomes taut.

Heat and humidity

The main problem you are likely to encounter in extremely hot or humid conditions (*below*) is condensation forming on the camera. Condensation will not be a problem, though, if both your camera (specifically the lens) and the surrounding air are at about the same temperature. So before using the camera, leave it to come up to the ambient air temperature before shooting any tape. This will probably take about half an hour. This is particularly necessary if you are staying in an air-conditioned room on vacation or if your home is air-conditioned. There could, in these circumstances, be a massive difference between the temperature of the air inside and that outside.

Dust and sand

Keep a UV (or even a clear-glass) filter over your lens at all times; and the farther away from the action you can stand and still achieve the framing you want, then the less dust there will be to worry about. However, as soon as you find a clean, protected site, then clean down all the outside surfaces of the camera before turning to carry out a routine maintenance check on accessible inside compartments.

Filters

FILTERS ARE DISCS or squares made of glass or gelatine that fit over the front of the camcorder lens. There are two types – correction filters and special effects filters.

Correction filters

These are used to 'correct' the light coming in through the lens in order to improve the appearance of the scene in a natural way. Examples of this type are ultraviolet (UV) and polarizing filters. A UV filter is completely colourless and its purpose is to remove some of the ultraviolet light entering the lens, excessive amounts of which tend to make a scene look hazy and washed out. High concentrations of UV light are quite common on the coast and in mountainous regions, and is most noticeable as an effect known as 'aerial perspective'. This is when distant objects become progressively lighter in tone and more blue in colour. You can leave a UV permanently in place to protect the lens.

A polarizing filter has a more noticeable effect on image quality. It, too, removes excessive UV light, but it also removes polarized light from scenes. This is the type of light responsible for reflections in glass or from water. When using a polarizer, point the camcorder at the source of the reflection and rotate the filter in its mount until you see the reflection disappear. Its other principal use is in strengthening the contrast between clouds and their surrounding sky, making the blues appear much bluer and the whites much whiter.

Special effects filters

There are literally dozens of different types of special effects filters available in camera stores. These range from quite useful graduated colour filters, through to centre spot, prism and starburst filters. Used occasionally, and with the appropriate subjects, this type of filter does have a valuable, if limited, application in video photography. But because they do have such an obvious presence, you should use them sparingly and only when their use really adds something positive to your video.

Without polarizer

Polarizing filter
A polarizer (*right*) is ideal for sky effects where you want a dramatic difference between sky and clouds. But even on a dull day, it can help lift contrast and generally brighten the scene.

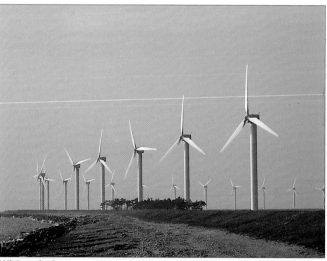

With polarizer

Graduated filters
Graduated filters have a tinted half that gradually fades into clear glass. Here two different-coloured filters have been used simultaneously to give this wind farm a futuristic, post-holocaust look. A single graduated filter is usually used to tint the colour of the sky and leave the land unchanged.

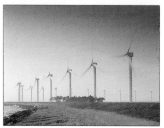

Two filters

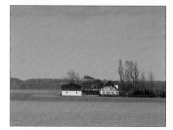

One filter

Filter mounts

Glass filters are usually disc shaped and fixed in a threaded metal rim that you simply screw into the threaded end of your camera lens. Different lenses, however, have different diameter mounting threads, so you must buy a filter of the correct size. If you have more than one lens with different diameter threads, you may be able to buy a screw-in adaptor ring to avoid having to buy the same type of filter for each size of lens.

Gelatine filters tend to come in large squares and are usually part of a kit consisting of a special square filter holder, which pushes on to the front of the lens. Gelatine filters are softer and more prone to damage than glass types, but the advantage is that one filter can be used to fit all sizes of lens.

Spectra filters

These spectacular filters have a grid of lines etched into their surface to break the light up into its spectral colours (*right*).

Starburst filters

Working along the same lines as spectra filters, starburst filters turn all point sources of light into mini starbursts (*below*). These filters are particularly effective with street lighting and car headlights.

Prism filters

Prism filters cause the image to repeat in various configurations (*above*).

Mix and match

For the occasional very spectacular image you can use a variety of filters on the lens for the same shot (*left*). Here, I used a vario starburst filter plus a cross-screen filter. This could be a powerful effect for a dream sequence, for example, or what the city might look like to a drugged person.

Camcorder care

IT GOES WITHOUT SAYING that you should take care of your camcorder. Don't drop it; don't keep it in extreme temperatures or humidities; don't drop it in the swimming pool. All these are stating the obvious. But what isn't quite so obvious is that the insides of the camcorder need just as much care.

Remove the tape cassette, if loaded, and make sure the compartment is clean and free from dust.

Dust on the record and playback heads is one of the biggest causes of poor images and picture dropout. This can result in snow on the picture, picture break-up or hiss, woolly sound or picture bend and rolling.

Dust can be removed either by the automatic self-cleaning mechanism built into some new models, or by using a head-cleaning tape. Head cleaners work by attracting the dust from the heads onto the specially moistened tape. While they generally do an excellent job at unclogging the recording heads, a service by a qualified engineer is recommended.

Batteries　Camcorders are heavy users of power and so it is best to replace existing batteries if they have been installed for even a few months (depending on the level of usage), as well as buy a fresh set to take along as spares. Always buy batteries from a busy stockist. In this way you can be fairly certain that the batteries have not been lying around on the shelves for perhaps many months.

Terminals　With the batteries out of the battery compartment, look closely at the terminals to make sure they are clean. Old, spent batteries may leak a corrosive substance that can literally destroy the camera's electrics.

External cleaning　First, thoroughly clean the outside casing using a soft lint-free cloth. Pay particular attention to any grooves and awkward corners where dust and dirt can accumulate. Next, check that the front element of the lens is free from dirt, grease, finger marks, and so on. You can buy lens-cleaning fluid from camera stores, but you should use this only as a last resort with extremely dirty lenses. Acid-free lens tissues are a better option in most circumstances. There's no point having a clean lens, however, if your filters are grimy, so check that these are also in good condition. As a precaution, leave a colourless ultraviolet (UV) filter on the lens at all time (see pp. 242-3).

Electrical systems　Operate the power zoom button and check that the lens moves in and out smoothly and to its fullest extents. Also check that the white balance is working by setting it in a variety of different lighting conditions, running off some tape in each, and playing it back via the television. Run the same sort of checks on all electrically operated features of your camcorder, paying particular attention to how the camera copes with different exposure levels.

If any aspect of your camera's operation gives you cause for concern, return it to a qualified engineer for servicing.

Connections

Camcorders and VCRs are sleek, stylish pieces of electronic equipment. However, they won't connect together without resorting to the proverbial plate of spaghetti to hook up all the relevant sockets

All camcorders can be replayed by connecting them straight to a TV via an AV (audio-visual) lead. And these connectors are also used to link VCRs, edit controllers, enhancers, mixers and other pieces of video equipment.

Connectors for low-band formats　For low-band formats (VHS and 8mm), dedicated AV leads (as opposed to the RF aerial lead) give the best image quality. There are three types of AV connectors commonly used on camcorders and other video equipment: phono, Scart and 8-pin.

Phono leads carry video and audio signals separately, and so two leads are needed (three for stereo connections). Phono connectors are standard issue throughout the AV industry and you will also find them on Hi-Fis and CD players. Phono leads are also used with a sound mixer.

The Scart, or Euroconnector, is the rectangular 21-pin plug/socket carried on virtually all modern equipment. However, because most camcorders cannot take a line in to enable them to record direct from another source, there are no Scart sockets on camcorders.

CHARGING BATTERIES

Camcorders use nickel cadmium (NiCad) batteries, which have an average running time of about half an hour. The battery that comes with the camcorder when you buy it rarely runs for more than 45 minutes, although you can buy batteries that give an hour or more. However, not every battery will fit every camcorder. Camcorders run on 6, 9.6 or 12 volts, so batteries must be of a compatible voltage.

But the biggest problem with camcorder NiCad batteries is that very few people understand how to charge them properly. Many users simply take their battery out of the camcorder at the end of a day's shooting and give it a full recharge, whether the battery is empty or not. This can have disastrous consequences in terms of the battery's running time.

NiCad batteries suffer from a memory effect. If a battery is recharged while still one-quarter full, that quarter charge is lost.

The maximum charge the battery can accept is three-quarters so it is only operating at 75 per cent efficiency. Now, if the battery is again recharged while still one-quarter full, that quarter of the new maximum efficiency (75 per cent of the original) is again lost. So after two charges, the battery is operating at just under 57 per cent of its full potential.

It is not unusual for a battery to be so abused in its charging cycle that the camcorder will cut out after just five minutes' use.

Many manufacturers are now taking steps to eradicate this problem. Some of the charging boxes supplied with the camcorder now have a discharge button, and you can also buy dischargers to fully drain a battery of its memory effect. If you do not have the facilities to do this, always make sure you discharge the battery fully by leaving the camcorder on until the battery cuts out to ensure that the memory effect does not develop.

Eight-pin video connectors are used by two of the largest camcorder manufacturers. However, unlike with Scart and phono connectors, there is no standard arrangement for the connecting pins in an 8-pin plug – so a JVC connector cannot be used with a Panasonic camcorder. Although the configuration of the pins within the plug is the same, the pins carry different parts of the AV signal. So using a non-compatible connector could result, for instance, in losing the left-hand audio channel.

Connectors for high-band video formats For high-band formats (S-VHS and Hi8), you will need an S-lead. Fortunately, there is a standard connector. An S-lead carries picture information only – so the audio signal should be routed through an audio phono lead.

Aerial connection A tape can also be replayed on TV from a camcorder by tuning the camcorder into a spare TV channel in the same way that a VCR is tuned in. To do this, use the RF (radio frequency) leads (also called co-axial cable) that are supplied with virtually all models.

These are the same leads that a TV aerial uses, so the RF lead from the camcorder should be connected to the TV's aerial socket. However, routing the picture through RF leads gives an inferior image of under 250 lines of horizontal resolution.

Synchronization cables To avoid back-space problems (see pp. 33 and 61) you will have to connect your VCRs and camcorder with an additional synchro-cable via the pause of remote socket.

Future developments

VIDEOTAPE IN ITS CURRENT form will survive into the twenty-first century, but not much further. Within the next decade, we should see the introduction of a digital video format with the ability to store information on tape, smart card or floppy disc. Video tape seems the most likely option.

A digital recording medium with no moving parts means there is virtually unlimited scope for miniaturization. Some sources in Japan are talking about a camcorder little larger than a packet of cigarettes.

The overall worldwide trend is towards miniaturization and high-band formats (S-VHS and Hi8). In Japan, all cameras are high-band and around 70 per cent are palmcorders. More and more companies are developing ultra-compact camcorders, and the price is falling all the time. While there will still be a place for the conventionally styled camcorder in the short term, it seems likely that all budget camcorders will be of the palmcorder type in the very near future. Miniaturization will be aided by current research into a $\frac{1}{4}$ inch imaging chip.

However, there is a problem with producing palmcorders in high-band-formats. It is generally accepted that a high-band format camcorder should resolve 400 lines of horizontal resolution. However, the small $\frac{1}{3}$ in CCD that most palmcorders use can only register 330 lines. While many customers have accepted this limitation (NTSC, the TV system used in Japan, the USA and many other countries, has a broadcast quality of 330 lines), it has been deemed unacceptable for the UK market (PAL has 400 lines).

Only camcorders with a $\frac{1}{2}$ in chip will be S-VHS or Hi8. However, normal-style high-band camcorders should soon become more common.

More camcorders are likely to include domestic timecoding and there should be more compatible editing equipment available. It also seems possible that the main Japanese manufacturers will turn their attention to producing basic, but efficient, editing equipment for the casual user, giving the opportunity to produce competent videos without a large capital outlay.

Digital effects are also becoming common on top-of-the-range cameras and have just begun to find their way onto palmcorders. The first camcorders adopting the new interchangeable lens standard are already on the market and more should follow soon. Colour viewfinders seem certain to find favour with both the manufacturers and the public, even though they are treated with a certain amount of cynicism by serious users.

International TV Standards

THERE ARE THREE TV standards in use around the world (with minor variations) and the sad truth is that they are incompatible with each other. So if you have relatives abroad, you may not be able to send them a video letter.

Britain, much of western Europe and most of the British Commonwealth use the PAL system (Phase Alternation by Line); the USA, most of the Americas and Japan use NTSC (National Television Standards committee); France, eastern Europe, Russia and the republics of the former Soviet Union and parts of Africa and the Middle East use SECAM (Séquentiel Couleur à Mémoire). In addition to this, Brazil and Argentina use versions of PAL. The table below gives the standards in use on most of the world's major countries.

NTSC is totally incompatible with PAL and SECAM. However, PAL VHS tapes can be played back in black and white in a SECAM VCR, and PAL 8mm is fully compatible with SECAM. There is also no difference in the PAL and SECAM high-band format specifications.

There is one Panasonic machine that can transcode between all three standards, but if you do have friends or relatives abroad using a different TV standard, the only cost efficient way of communicating with them is to have the tapes transcoded professionally.

COUNTRIES WHICH USE
THE PAL STANDARD

Algeria	Greece	Nigeria	UK (PAL I)
Argentina	Hong Kong (PAL I)	Norway	Uruguay
Australia	Iceland	Pakistan	Yemen
Austria	India	Paraguay	Yugoslavia
Bahrein	Indonesia	Portugal	Zambia
Bangladesh	Ireland (Eire) (PAL I)	Singapore	Zimbabwe
Belgium	Israel	South Africa (PAL I)	
Brazil (PAL M)	Italy	Spain	
Canary Islands	Kenya	Sri Lanka	
Channel Islands	Kuwait	Sudan	
(PAL I)	Liberia	Sweden	
China	Liechtenstein	Switzerland	
Cyprus	Madeira	Tanzania (PAL I)	
Denmark	Malaysia	Thailand	
Finland	Malta	Tibet	
Germany (West)	Mozambique (PAL I)	Turkey	
Ghana	Netherlands	Uganda	
Gibraltar	New Zealand	UAE	

COUNTRIES WHICH USE
THE NTSC STANDARD

Bahamas	Hawaii
Barbados	Honduras
Bermuda	Jamaica
Bolivia	Japan
Burma	Korea (South)
Canada	Mexico
Chile	Nicaragua
Colombia	Panama
Cuba	Peru
Ecuador	Philippines
El Salvador	Puerto Rico
Greenland	Taiwan
Guam	USA
Haiti	Venezuela

COUNTRIES WHICH USE
THE SECAM STANDARD

Albania	Madagascar
Bulgaria	Monaco
Czechoslovakia	Mongolia
Egypt	Morocco
France	Poland
Germany (East)	Romania
Hungary	Russia
Iran	Saudi Arabia
Iraq	Tunisia
Laos	Zaire
Lebanon	

Glossary

A

AGC Abbreviation for Automatic Gain Control. Camcorders have separate electronic circuits, known as AGCs, for both sound and vision. When either falls below a predetermined level, the relevant AGC cuts in to boost the signal. Unless they can be disabled, it means effectively that night-time shooting and intentionally quiet scenes are impossible to record.

Aperture Adjustable hole in the lens through which light passes before reaching the CCD.

Audio dubbing Replacing all or part of a tape's soundtrack with a commentary, sound effects, music and so on.

Available light The light that is naturally present in a scene, indoors or outdoors, such as the sun, ordinary domestic tungsten, fluorescent tubes, and so on. The term does not cover supplementary lighting used to facilitate filming.

B

Barn doors A lighting accessory consisting of a set of four hinged flaps set around a floodlight or spotlight to help control the spread of light from that source. Each flap can be moved into the light beam independently of the others.

Boom A long pole used to support a microphone or, sometimes, a light. It is used when a fixed microphone or light would be seen by the camera or when a moving subject is being filmed.

C

CCD Abbreviation for Charge-Coupled Device. A photoconductive semiconductor chip responsive to the different wavelengths and intensities of light falling on it from the lens. In response to this electromagnetic stimulation, the CCD generates an electronic video signal, which is passed on to the record heads. The CCD performs the same function as a camera pick-up tube found in older video recorders and camcorders.

Character generator A feature found on many camcorders that allows you to produce basic alphanumeric characters on screen

Close-up A term, often abbreviated to CU, used to describe the framing of an image confined to the equivalent of a head-and-shoulders shot. Variations of this term include BCU (big close-up), which describes a shot where the equivalent of a face alone would fill the frame.

Contrast range The difference in luminosity between the brightest highlights and the deepest shadows in a scene. Where contrast is excessive, the camcorder's automatic exposure control may not be able to record both extremes with correctly exposed detail. In such a situation, you should either change camera angles to exclude one or other of the extremes from the frame or reduce the contrast range by, for example, introducing supplementary lighting into the shadow areas.

Control track A reserved strip running the length of the video tape containing electronically coded pulses of information that control tape playback.

Crabbing A type of shot where the camera moves sideways across the line of the action.

Crossing the line Moving the camera from one side of an imaginary line – created by, for example, the movement of the action – to the other. Unless care is taken, action shot on one side of the line will appear to be moving in the opposite direction to action shot on the other.

Cut An instruction from the director to halt the action. A cut is also the abrupt transition from one shot to another, without an intervening dissolve, fade, wipe, and so on.

Cutaway A shot inserted into a scene that is not central to that scene but which contains information designed to increase the audience's understanding of the action.

D

Depth of field The variable zone of acceptably sharp focus both in front of and behind the point of true focus. The extent of this zone is dependent on the aperture of the lens being used, the distance of the subject from the camera, and the focal length setting of the lens. Since the majority of camcorders do not have an adjustable aperture, depth of field can be controlled only by your choice of focus distance and focal length.

Dissolve The gradual transition from one shot to another created by overlapping the imagery from the tail end of the first shot with the beginning of the next.

Dolby The trade name of an electronic audio circuit designed to filter out the distortion, described as tape hiss, commonly associated with narrow-width recording tape.

Dolly A camera mount with wheels designed to allow the camera to move smoothly along with or around the action. A dolly is usually used in a studio environment, since the ground over which it travels must be completely even. On elaborate productions, special boards, or even miniature railroad tracks, are laid down when on location for the dolly to move over.

E

Edit controller An editing device used to transfer recorded material from one tape into a different running order on another tape. The edit controller's memory can store about a hundred scenes, each with an assigned number. The controller can then be programmed to rerecord these scenes in any desired sequence.

Electronic viewfinder A tiny television screen with its own cathode ray tube that allows you to see the image encompassed by the lens. Most viewfinders give a black and white image, although colour viewfinders are becoming more popular.

Establishing shot An image at the beginning of a sequence designed to inform the audience of where the action is taking place. It helps to give the audience a coherent sense of the geography in which the following action is to take place.

Eyeline The direction in which a character in a scene is looking. When cutting from one face to another, it is important to ensure that the eyelines correspond or it will appear that they are looking in different directions.

F

Fade A transition between scenes in which the image fades in from black or white or out to black or white.

Fine cut The final stage of an edited video in which all the original material is assembled in the correct order and running at the correct length.

Floodlight A photographic light that produces a wide spread of illumination. Some measure of control is possible by changing the size and shape of reflector dish fitted behind the bulb.

Follow focus Manually adjusting the focus ring of the lens while the tape is running in order to keep a moving subject in sharp focus.

H

Headroom The space above a person's head when viewed on screen.

Hotspot A localized area of intense highlight.

I

Insert edit A facility found on some camcorders that allows you to record new material over old. You can preset precisely where you want the new material to end and the camcorder will stop when the tape counter reaches that point.

Interval recording A type of time-lapse facility that records a few seconds worth of video at preset intervals.

Iris diaphragm A device within or behind the lens consisting of a set of interleaving blades that control the size of the aperture.

J K

Jump cut A cut between scenes in which the audience is made aware that there is an unaccounted for gap in visual continuity.

Key light The principal source of illumination (to the front of the subject) in a three-point lighting set-up, consisting also of a backlight and a fill light.

L

Lead space The space left in front of a character or object seen on screen as they move across the frame.

Lighting bar A bar suspended above the action from which overhead lights are hung.

Long shot A term, often abbreviated to LS, used to describe the framing of an image containing at least the equivalent of a full-length human figure Variations of this term include ELS (extreme long shot), which describes a shot in which the full figure occupies only a small part of.the frame.

M N

Master shot A shot containing the principal action of the scene into which cutaway shots can be edited.

Mid-shot A term, often abbreviated to MS, used to describe the framing of an image confined to the equivalent of the human figure seen from the waist up. Variations of this term include MMS (medium mid-shot), which is between mid-shot and close-up.

Noddy shot A shot, usually employed in interview situations, in which the interviewer is seen nodding in apparent agreement with or understanding of what the interviewee is saying. These shots are invariably taped after the interview has finished and are edited in later.

Noise Visual or audio interference to the signal from an electrical or physical source.

NTSC Abreviation for National Television Standards Committee – the TV standard used in the USA, most of the Americas and Japan.

P

PAL Abbreviation for Phase Alternation Line – the information encoding system used for television throughout Europe (except France) and most Commonwealth countries.

Palmcorder A small, lightweight camcorder that can be held easily in the palm of the hand.

Panning Moving the camera horizontally while taping in order to present a panorama or to keep a moving subject in frame.

Perspective A system of imparting to the two dimensional image recorded by the camcorder a sense of depth and distance.

Pixel One of thousands of light-sensitive squares that make up the surface of a CCD.

Pixelation A special effect in which the image is divided into tiny squares.

Posterization A special effects in which the image is rendered in distinct blocks of colour with no graduation or shading of one hue into another.

POV Abbreviation for Point Of View – a type of shot where the camera takes a character's position to inform the audience of what that person can see and hear.

R

Reaction shot A shot of a character's reaction to the some aspect of the action. It is often filmed as a cutaway – hence its other name of reaction cutaway – and inserted later during editing.

Reverse shot A shot that shows the action from the opposite direction of the previous shot.

Rostrum camera A static, mounted camera used to record images of maps, photographs, coins, artwork and other non-moving subjects for insertion into a tape.

Rough cut The early stages of the editing process in which original material is copied and assembled experimentally in different sequences in order to arrive at the final fine cut.

S

Scrolling Titles that move up or down the screen, often seen at the beginning and end of a production.

SECAM Abbreviation for Séquential Couleur à Mémoire – the TV standard used in France, eastern Europe (including the countries of the former Soviet Union), parts of Africa and the Middle East.

Snoot Conical-shaped lighting accessory that fits over the front of a spotlight or floodlight to produce a very narrow beam of light.

Solarization A special effects technique in which the image is massively overexposed to produce areas of brilliant white and colour-fringed, dense shadows.

Special effects generator A control device that allows the video signal to be manipulated in order to create a range of special effects, including fades, dissolves, wipes, pixelation, solarization and posterization.

Spotlight A sealed photographic lighting unit producing a narrow, intense beam of light. A built-in lens at the front allows some adjustment of beam width.

Steadicam The trade name for a special body harness that allows the camera operator a wide range of movement, achievable normally only with a dolly, while producing almost completely steady images.

Storyboard A series of drawings mapping out in detail not only shot sequences, but also framing and camera angles.

T

Three-shot A shot in which three people are seen in the frame. Anything more than a three-shot is regarded as a crowd shot.

Tilting Moving the camera vertically in order to reveal piecemeal a tall subject to the audience or to follow the action.

Time code A feature found on semi-professional camcorders, in which a number is laid down on the tape corresponding to each frame. This gives unsurpassed accuracy when editing.

Tracking A type of shot in which the camera moves in order to keep up with the action. This is a difficult technique to carry off smoothly without the help of a dolly or Steadicam.

Tripod A three-legged camera support with a central column to allow fine adjustments to the height of the camera. On top of the central column is the tripod head, on to which the camcorder is screwed. Good-quality heads permit smooth pan-and-tilt movements.

Two-shot A shot in which two people are seen in the frame.

V

VCR Abbreviation for Video Cassette Recorder.

Voiceover A narrator's voice heard by the audience while the speaker is not in vision. A voiceover is often used to give supplementary information to the audience, information that should not be apparent from the visuals. The script for a voiceover needs to be precisely timed so that at each point it is relevant to what is on screen.

W Z

White balance An adjustment that allows the camcorder to record colours (especially skin tones) accurately under different types of illumination. On most modern camcorders the white balance control operates automatically.

Wipe A special effects technique that involves the gradual exclusion of the image on the screen by the succeeding image. Non-digital wipes only allow a straight horizontal or vertical wipe, whereas a digital mixer can produce more sophisticated effects with one image, for example, disappearing in a circular shape to reveal the next image behind it.

Zoom A lens in which some of the internal elements move in order to produce a range of different focal lengths.

Zooming in and out Moving the lens from wide-angle to telephoto, or from telephoto to wide-angle.

Index

Acknowledgements

The author and publishers are grateful to the following for their assistance in producing this book:

Sebastian Hedgecoe, who worked and advised on so many areas within this book; Jonathan Hilton and Ian MacQuillin for their technical expertise; Nick Bracegirdle; Bressingham Steam Museum; Nils Burman; Rosie Church; Christine Church; Cromer Centre; East of England Ice Rink; Nina Ghan; Alan Glover; Auberon Hedgecoe; Paula Metcalf Make-up; 'New England' rock group; Alan Osborne; Dean O'Leary and Mike Raphael at the Raptor Trust; Sandra Reynolds Model Agency, Norwich; Sheringham Players and Sheringham Smugglers; Richard Skelton; Martha Turville-Petre; Waller's Timber Mill; Elaine Winkworth; Ray Woolcock.

For the loan of equipment:
Artem Visual Effects; Audience International; Canon UK Ltd; JVC UK Ltd; Lamba plc; Panasonic UK Ltd; Philips UK Ltd; Samuelson Communications; Scene Dock; Sennheiser UK Ltd; Shepperton Studios; Sony UK Ltd; Tasco Distributors plc; C.Z. Scientific Instruments Ltd.

Photographic credits:
Panasonic UK Ltd (p.233); Sony UK Ltd (p.32); equipment photography by Geoff Dann; all other photographs by John Hedgecoe.

Artwork credits:
Madeleine David (pp.150-51); Steve Wooster (pp.110-11); all other diagrams by David Ashby.

Index compiled by Richard Bird.